PHOTOGRAPHY'S ORIENTALISM

Getty Research Institute
Issues & Debates

PHOTOGRAPHY'S ORIENTALISM

NEW ESSAYS ON
COLONIAL REPRESENTATION

Edited by
ALI BEHDAD and **LUKE GARTLAN**

THE GETTY RESEARCH INSTITUTE PUBLICATIONS PROGRAM

Thomas W. Gaehtgens, *Director, Getty Research Institute*
Gail Feigenbaum, *Associate Director*

© 2013 J. Paul Getty Trust
Published by the Getty Research Institute, Los Angeles
Getty Publications
1200 Getty Center Drive, Suite 500
Los Angeles, California 90049-1682
www.getty.edu/publications

Laura M. Santiago, *Manuscript Editor*
Jim Drobka, *Designer*
Stacy Miyagawa, *Production Coordinator*
Diane Franco, *Typesetter*
Stuart Smith, *Series Designer*

Type composed in Minion and Trade Gothic
Printed in Hong Kong

17 16 15 14 13 5 4 3 2 1

Library of Congress Cataloging-in-Publication Data
Photography's Orientalism : new essays on colonial representation / edited by Ali Behdad and Luke Gartlan.
 pages cm. — (Issues & debates)
 Includes bibliographical references and index.
 "This volume evolved from "Zoom out: the making and the unmaking of the 'Orient' through photography,"
held at the Getty Research Institute, Los Angeles, May 6–7, 2010"—ECIP data view.
 ISBN 978-1-60606-151-0
 1. Orientalism in art—Middle East. 2. Imperialism in art. 3. Art—Political aspects—Middle East. 4.
Photography—Middle East—History—19th century. I. Behdad, Ali, 1961– editor of compilation. II. Gartlan,
Luke, editor of compilation. III. Series: Issues & debates.
 NX650.E85P49 2013
 778.9'9956—dc23
 2013003130

Front cover: Rudolf Lehnert and Ernst Landrock, Boy with flowers (detail), 1920s. See p. 29.
Back cover: Francis Frith, The Pyramids of Giza, Egypt, 1857. See p. 117.

This volume evolved from "Zoom Out: The Making and the Unmaking of the 'Orient' through Photography,"
held at the Getty Research Institute, Los Angeles, May 6–7, 2010.

CONTENTS

ACKNOWLEDGMENTS

We would like to thank all the participants in the Orientalist photography workshop who diligently came to every meeting, selected images for our viewing, shared their thoughtful observations, and conceptualized the symposium organized at the Getty Research Institute (GRI) in May 2010. As well, we wish to express our gratitude to Thomas Gaehtgens, director of the GRI; Andrew Perchuk, deputy director of the GRI; and Katja Zelljadt, then director of the Scholars Program, for their encouragement and support of our project. Special thanks go to Anne Lacoste, Beth Guynn, Nancy Micklewright, Rebecca Peabody, and Roy Messineo, the co-organizers of the symposium at the Getty. Without their intellectual and organizational contributions, the symposium would have not been possible. Finally, we wish to thank Gail Feigenbaum, Rebecca Peabody, and Melanie Lazar for generously supporting the publication of this volume.

—Ali Behdad and Luke Gartlan

ALI BEHDAD AND LUKE GARTLAN

INTRODUCTION

Historians of photography have generally assigned only marginal importance to the work of the many European photographers who traveled in the Middle East (or the "Orient") in the nineteenth century, and even less to the various traditions of indigenous photography that emerged in the region soon after the introduction of the daguerreotype in 1839. However, the Middle East played a critical role in the development of photography both as a new technology and as an art form. At the same time, photography was key to the evolution and maintenance of Europe's distinctively Orientalist vision of the Middle East, where Orientalism is broadly understood as a Western tradition and style of thought, imagery, and language used to represent the Middle East for European audiences.

As several essays in this volume remind us, a crucial link between the history of photography and Europe's knowledge about the Middle East has existed since the invention of the daguerreotype. In his introduction of Louis-Jacques-Mandé Daguerre's invention to the Chambre des députés, Dominique François Arago spoke of the great advantages of the new medium as a means of reproduction and documentation for Egyptologists and Orientalists, and recommended that the Institut d'Égypte be equipped immediately with the new visual technology. Arago underscored the efficiency and fidelity of the new medium as a means to document the hieroglyphs and monuments of the Middle East. In subsequent decades, many European photographers followed Arago's suggestion and, with the support of various governmental institutions, traveled to the Middle East to amass portfolios of Egyptian antiquity and the sites of the holy lands, making the region one of the principal training grounds for the early practice of photography.

By suggesting that the Middle East served as a crucial site for the early practice of photography, we intend much more than a technical acquisition and refinement of its processes, its strategies of commercial practice and distribution, or even its pictorial themes and genres. Indeed, the very difficulties confronted by travel photographers—the unfamiliar environmental conditions and logistical challenges referred to ad nauseam in their travelogues—constantly reinscribed the region and its peoples within colonialist narratives of adversity

overcome and heroic endeavor. As the versatility of photography was enhanced through new technologies of reproduction, such as the calotype, the collodion process, and, later, gelatin-based processes, these photographers were able to mass-produce images to incite and satisfy the demands of the burgeoning tourist industry in the region as well as ordinary armchair travelers in Europe whose desire for exoticism transformed them into voracious collectors of Orientalist imagery. The development of modern techniques of photography thus fueled a new exoticist desire for visual contact with the rest of the world.

Alongside the Orientalist archive of photography produced by Europeans, there are also various indigenous archives throughout the Middle East and India. Most but not necessarily all such archives were produced by local and resident artists and amateur photographers, for soon after its introduction in Europe, the art and technology of photography was taken up by the wealthy and the powerful in the region, representing themselves, local monuments, and people of lower classes and their practices in often exoticizing and eroticizing fashion. Ottoman and Qajar rulers during the second half of the nineteenth century, for example, embraced photography not only to foreground their social status and dynastic power but also to represent their historical monuments and diverse populations. In addition, like their European counterparts, local artists engaged in what one might call "photo-exoticism," a mode of representation that reduced people of the lower classes to (ethnographic) types while reproducing stock images of harem women. Locally produced photographs of the Middle East, as products of contact zones, were in dialogue with the Orientalist archive and, as such, both informed and were informed by aesthetic concerns and thematic choices of Orientalist photography in Europe. At the same time, as Mary Roberts and Esra Akcan elaborate in their contributions to this volume, indigenous and local photographers in the Middle East were not merely imitators of European Orientalism, for they were also active participants in the production of counterrepresentations that resisted the stereotypical images of the Middle East.

Although a few art historians, such as Nissan Perez and Bahattin Öztuncay, have provided taxonomic accounts of European and non-European photographers active in the Middle East, there has been no in-depth cultural study of their works.[1] To fill this critical gap, *Photography's Orientalism* focuses on the intertextual and intervisual relationship between photographic, literary, and historical representations of the Middle East. The essays elaborate the productive and indivisible relationship between arts and politics by unpacking the connection between European presence in the Middle East and aesthetic representations of the region produced by traveling and resident photographers. Attentive to the artistic and aesthetic dimensions of photography, the essays

consider the social, cultural, and political aspects of the Orientalist photograph. In this way, the volume aims both to broaden the scope of analyses of European representations of other cultures as well as to contribute to studies of the historical development of photography.

Photography's Orientalism does not assume the fixed nature of either term in the volume's title; rather, it questions the criteria that define both photography and Orientalism while interrogating their entangled histories, interrelations, and continued legacies. The intention is neither to privilege photography's role nor to dismiss its particular protean characteristics as a visual and material object but to invigorate critical debates about photography's relations to Orientalism and the historical forms of Orientalism's debt to photography. The historical and theoretical nature of their association frames this volume of essays but receives its most overt examination in the opening two essays. For Ali Behdad, the recent tendency of some photographic historians to elide the politics of Orientalism in favor of a return to business-as-usual aesthetic analysis underscores the critical need to assert the photograph's status as both illustrative and constitutive of notions of "the Orient." The camera was the latest device conscripted to the task of Orientalist knowledge production, whether in the formation of a state archive or a tourist album, a newspaper cover or a picture postcard. By contrast, Christopher Pinney questions the efficacy of the camera for the discursive operations of Orientalism, arguing that photography always had the potential to disrupt—or "disturb"—those same mechanisms of colonial authority that wished to mobilize its use. Instead of the master's tools dismantling the master's house, the possibility emerges that the colonial state could never claim, however much it entertained the notion, to be the custodian of the technology.

Since the publication of Edward Said's seminal book *Orientalism* in 1978, some scholars of visual culture have also elaborated the difference between Western photographic representations of the Middle East and Middle Easterners' photographic self-representations of their societies in binary terms, as expressions of power and resistance, respectively. On the one hand, some art historians and cultural critics have defined European representations of non-European and colonized people as examples of colonial exoticism and domination. For instance, in his important book *The Colonial Harem,* Malek Alloula describes early-twentieth-century French postcards of the Maghreb as "the fertilizer of the colonial vision."[2] In a similar vein, art historians Julia Ballerini and Keri A. Berg have adopted a Saidian model to critically study early French photographs of Egypt as signifiers of the unequal gaze between the European colonizer and the colonized Middle East, describing the camera as a violent means of visual appropriation.[3] On the other hand, some art

historians of non-Western cultures have theorized indigenous artistic representations in terms of resistance to the West and imperialism. Zeynep Çelik, for example, has argued that Ottoman photographic representations of Turkey at the World's Columbian Exposition, held in Chicago in 1893, "included oppositional perspectives to challenge Orientalist constructions" of Ottoman society.[4] Similarly, Mary Roberts has argued that "photography was harnessed by the Ottoman leaders as a medium for presenting a revised collective self-image to Europe" and that critics ought "to consider its subversive relationship to existing Orientalist photographic codes."[5]

The essays in this volume wish to complicate and advance the aesthetic, theoretical, and historical implications of these approaches by calling into question the Manichaean relation between Western and non-Western photographic representations of the Middle East. Although Orientalism—understood as a network of aesthetic, cultural, economic, and political relationships that cross national and historical boundaries—is indispensable to an understanding of nineteenth- and twentieth-century photography of the Middle East, such images cannot be viewed merely as a reflection of Europeans' racial prejudice against "Orientals," nor should we assume that the photographs of the Middle East by European artists simply validate Euro-imperial dominance over the region. At the same time, it would be a great scholarly error to view local photographic representations in the Middle East as merely derivative of their Western counterparts, just as it would be equally erroneous to consider them either as oppositional practices working against Orientalist aesthetics or as "pure" or "authentic" articulations of the vernacular cultures in the region. Put otherwise, photographic representations of the Middle East do not entail a binary visual structure between the Europeans as active agents and "Orientals" as passive objects of representation. And just as Western photographic representations of the Middle East are not all expressions of colonial power, indigenous practices of photography do not necessarily constitute a locus of resistance to Orientalism.

An emphasis on the subtle interventions and multiple histories of localized photographic practices and forms of circulation disputes the application of such polarized frameworks to the interpretation of Orientalist photographs, but it also questions the narrow range of photographers and photographs that have dominated scholarship in the field. As Luke Gartlan argues in his essay, the narrow scholarly focus on Anglo-French Orientalism has impeded art historians and cultural critics from exploring cross-cultural encounters and histories of photography in other regions. Indeed, throughout this volume, the authors invite us to examine long-neglected photographers and archives and to question the criteria for assessment of those few well-known photographers who

found favor in the mid-twentieth-century surveys of the medium.[6] In many cases, a privileged handful of photographers, invariably Western European and often skilled in their own self-promotion, retain a canonical status that has proven remarkably resilient to the forceful revisionist critiques of photographic historians. Writing in the early 1980s, Abigail Solomon-Godeau was one scholar to question the art historical criteria of aesthetic value that framed the assessment of European travel photographers active in the Middle East and lionized, then as now, by an art market eager to embrace the latest discovery. "In the great rush to discover the art of photography's past," Solomon-Godeau argued, "we run the risk of destroying its history."[7] Since the publication of such critical approaches, art historians have reconsidered the work of photographers such as Maxime Du Camp, Roger Fenton, and Francis Frith, but the scholarship devoted to such figures stands in stark contrast to the millions of anonymous photographs that remain neglected in repositories around the world. Faced with a seemingly endless, dispersed corpus of visual materials, photographic historians must remain vigilant about the internal differences and histories of archives and about their modes of production and intended purposes, lest the sheer mass of material impose its own logic that occludes the complexities of its subject matter.[8] *Photography's Orientalism* offers nuanced and historicized readings of various photographic archives, especially the Pierre de Gigord collection of photographs of the Ottoman Empire and the Republic of Turkey and the Ken and Jenny Jacobson Orientalist photography collection, both held at the Getty Research Institute, by way of offering new areas for critical studies of photographic representations of the Middle East.

Three contributors to this volume investigate the role of photography in the context of the Ottoman Empire. Whereas much past scholarship has concentrated on European photographers in the Ottoman Empire, Mary Roberts, Nancy Micklewright, and Esra Akcan contribute to an ongoing shift in academic attention toward local photographers and regional applications of photography. Taken together, these essays attest to Mounira Khemir's claim of "the openness of a visual technology as the generator of new meanings in new hands."[9] Mary Roberts examines Sultan Abdülaziz's adoption of photographic portraiture for the assertion of regal authority over the Ottoman Empire and its subjects. In contrast to the Orientalist photographs produced for the burgeoning tourist market, Roberts argues that these imperial portraits exemplify a counterdiscursive use of photography directed at both domestic and international audiences. Whereas Roberts evaluates the imperial applications of photography for the statecraft of the Ottoman Empire, Nancy Micklewright explores a range of official and vernacular photographs that resist ready classification as Orientalist imagery and have generally evaded the scrutiny of scholars.

To redress this imbalance, Micklewright highlights the modern subjects and visual manipulations apparent in a selection of images that assert the domestic uses of photography. Contra to the exoticizing thematics and pictorial devices of the Orientalist photograph, with its painted backdrops, studio props, coerced models, and signifiers of cultural otherness, Micklewright demonstrates the popular incorporation of the camera into the everyday lives and practices of Ottoman society.

Several contributors to this volume emphasize the significance of pictorial formats and materiality to the meanings that accrued from photographs of the Middle East. Esra Akcan's analysis of panoramic "views" of the Bosporus, for example, not only expands on the critical assessment of photography's centrality to the Ottoman Empire, and specifically Istanbul, but also raises the issue of the photograph's role in the construction of "a specific perception that marked the city as panoramic." Akcan argues that such a perception was part and parcel of the Ottoman album's sequence of photographs of the Bosporus, which invited local viewers to assess each photograph within the context of their intimate, firsthand knowledge of the city. Such photographs are neither fixed testaments of the ideological assumptions of their producers nor impartial records of a past cityscape, but rather visual materials of inherent interpretative uncertainty, open to continued reassessment and reclamation by later generations and alternative voices. Akcan's emphasis on the twentieth-century significations of these photographs, particularly for the writers and intellectuals of Istanbul, highlights their potential to acquire political and cultural meanings unenvisioned by their initial producers and owners.

Like Akcan, Darcy Grimaldo Grigsby addresses a subject familiar to innumerable nineteenth-century photographic albums: the ancient pyramids of Egypt. However, Grigsby's essay principally concerns the discontinuities of visual perception that apply to this popular subject as perceived in the stereoview. With particular acuity, Grigsby examines, using Douglas Nickel's apposite phrase, "the specular strangeness of the stereo image,"[10] and, in particular, the inability of the stereoview to account for the scale of these monuments without the perceptual loss of their constituent parts into a generalized form. Drawing on the writings of such astute nineteenth-century commentators as Lady Elizabeth Eastlake and Oliver Wendell Holmes, Grigsby attends to the phenomenological experience of looking at stereoviews of the Pyramids, calling our attention to the perceptual discrepancies and spatial distortions of their representations.

Whereas Grigsby focuses on the phenomenological implications of photographic representations of Egyptian antiquity, Gartlan in his contribution to the volume draws critical attention to the leisurely photographic pursuits of

Europeans in Egypt. He considers the significance of photography for a group of Austrian artists who visited Cairo in the mid-nineteenth century and elaborates the ways these more casual European tourists participated in (re)producing an Orientalist view of the region. At the same time, Gartlan explores the productive function of group photography in male bonding, arguing cogently that the homoerotics of Orientalism, while potentially resistant to normative ideals of colonial masculinity and sexuality, remains forgetful of the colonial relations of power in which it is inscribed. Put otherwise, he suggests, homoerotic desire colludes in the operations of Orientalism through an erasure of the condition of its possibility and expression in the colonial periphery.

Although the majority of essays in this volume examine the work of nineteenth-century photographers active in the Middle East, the final three essays challenge such spatial and temporal parameters used to define Orientalist photography. As Said famously argued, the "Orient" was, and is, less a place with defined political borders than the product of an "imaginative geography" that could just as well find expression in the photographic studios of the European capitals as the cities of the Middle East. While some photographic historians, such as Gordon Baldwin, have highlighted the Orientalized worlds fabricated in the nineteenth-century studios of London and Paris, the temporal parameters of Orientalism have received much less scrutiny.[11] In their varied case studies, Hannah Feldman, Rob Linrothe, and John Tagg maintain that the discourses of Orientalism are not restricted to a temporal period or geographic location but remain pertinent to subsequent practices of visual representation after the era of so-called decolonization. One aim of this volume is to foster debate that attends to the transcultural histories and postcolonial resonances of photography, both within and across the geographic region of the Middle East. Hannah Feldman's analysis of a suite of photographs produced in the final year of the Algerian War of Independence complicates any claim that Orientalist photography constitutes a practice restricted to the nineteenth and early twentieth centuries. On the contrary, her examination of photographs of the Algerian war and its diasporic protests in France attests to the continued resilience of the camera's colonialist representations, transposed into the context of the French state. Yet Feldman also argues for the necessity of a critical framework registering the "subaltern agency" of the diasporic communities depicted in these photographs as testaments that assert their rights to the ideals of citizenship.

While the cultural contexts of their respective subjects could hardly be more diverse, Rob Linrothe and John Tagg share a concern with the contemporary politics and attendant identities that accompany the display of historic photographs. Whether suggestive of notions of personal selfhood in a Tibetan Buddhist monastery or the curatorial erasure of imperial violence in an

exhibition of photographs in New York, both contributors emphasize the relevance of colonial-era photographs for current audiences and for perceptions of past and present. Taking as his starting point two early-twentieth-century photographic portraits of a Tibetan Buddhist monk, Linrothe explores the reception and continued significance of these photographs for present-day Tibetan Buddhist monastic communities in the Indian state of Jammu and Kashmir. His study demonstrates the centrality of colonial-era photographs to the ritual practices and identities of Tibetan monastic communities based in northern India and the potential of fieldwork to dislodge some of the most entrenched theoretical assumptions of Western photographic theory.

In contrast to the portrait photographs displayed in consort with sculptures and paintings in the chambers of a Tibetan Buddhist spiritual leader, John Tagg examines the specific modes of display and curatorial selection that accompanied a major exhibition of British calotype photography held at the Metropolitan Museum of Art in New York in 2007. Tagg highlights the exhibition's predilection for a historical narrative that eschewed questions of the nationalist and imperialist framework of its subject, reaffirming the continued relevance of Solomon-Godeau's caution against the preeminence afforded aesthetic judgments for accounts of photography's history. By emphasizing the British Empire's uses of the camera in India, Tagg questions the historical occlusions that framed the exhibition and its detachment of photographs from the social contexts that informed and enabled their production and reception. In doing so, Tagg reasserts the fundamental centrality of empire to the study of photography's history.

To close this volume with a critique of a major exhibition is particularly germane because of the uncertain position of photography in exhibitions of Orientalist visual culture over the last thirty years. With each exhibition, the emphasis given to photographs has changed, and in more recent years photographs have been excluded altogether from such major exhibitions as *The Lure of the East,* held at Tate Britain in 2008, and *L'Orientalisme en Europe: De Delacroix à Matisse* at the Musées royaux des beaux-arts de Belgique, in 2010.[12] As Christine Riding has noted in her behind-the-scenes account of the curatorial rationale for *The Lure of the East,* the decision to arrange the galleries according to genres "foregrounded the theoretical premise of the exhibition as primarily an exploration of how artists—that is painters and watercolorists not photographers—adapted long-established conventions and practice to new subjects and environments."[13] As a parallel phenomenon, some photography curators have countered with major exhibitions devoted to Orientalist photographs.[14] Yet as many of the contributors to this volume contend, this

dissociation of photography from other visual forms and cultural products remains deeply problematic, not least given the inevitable use of digital photography to advertise these very same exhibitions with poster and billboard reproductions of selected images that qualify for consideration, on the basis of medium, as the sanctioned works of *artists*. Irrespective of such institutional decisions, the broad range of contributors to this volume—including art historians, visual anthropologists, cultural theorists, and photographic historians—attests to the breadth of disciplines that are galvanized in debate and recognition of photography's significance in the historical exchanges between Europe and the Middle East.

This collection of essays aims to promote awareness of the variety and complexities of the interrelated histories of Orientalism and photography by engaging central issues and inviting critical debate pertaining to the "Orientalist" photograph. The essays attend to the uneven encounter between the photographer and the photographed by questioning the monolithic dualism of power and resistance that have marked many postcolonial readings of the visual archive of Orientalism. By challenging the distinctions typically drawn in contrapuntal readings between visual and discursive materials, the essays demonstrate the value of an ascending mode of critical analysis, underscoring the wider historical determinations of photographic representation of the Middle East and beyond. In this way, this volume charts a course beyond the modalities of the general and the generalized that long have characterized conventional studies of photography's Orientalism and addresses the pressing need for more sustained consideration of the affinities between discursive and visual formations of Orientalism.

Notes

1. Nissan N. Perez, *Focus East: Early Photography in the Near East, 1839–1885* (New York: Harry Abrams, 1988); and Bahattin Öztuncay, *The Photographers of Constantinople: Pioneers, Studios and Artists from 19th-Century Istanbul,* 2 vols. (Istanbul: Aygaz, 2003).

2. Malek Alloula, *The Colonial Harem,* trans. Myrna Godzich and Wlad Godzich (Minneapolis: Univ. of Minnesota Press, 1986), 4.

3. Julia Ballerini, "Rewriting the Nubian Figure in the Photograph: Maxime Du Camp's 'Cultural Hypochondria,'" in Eleanor Hight and Gary Sampson, eds., *Colonialist Photography: Imag(in)ing Race and Place* (London: Routledge, 2002), 30–50; and Keri A. Berg, "The Imperialist Lens: Du Camp, Salzmann, and Early French Photography," *Early Popular Visual Culture* 6, no. 1 (2008): 1–17.

4. Zeynep Çelik, "Speaking Back to Orientalist Discourse at the World's Columbian Exposition," in Holly Edwards, ed., *Noble Dreams, Wicked Pleasures: Orientalism in America, 1870–1930,* exh. cat. (Princeton, N.J.: Princeton Univ. Press, 2000), 77.

5. Mary Roberts, *Intimate Outsiders: The Harem in Ottoman and Orientalist Art and Travel Literature* (Durham, N.C.: Duke Univ. Press, 2007), 144, 146.

6. For example, Helmut and Alison Gernsheim, in the preface to *The History of Photography*, listed a number of British travel photographers who remain familiar to any history or auction catalog; Helmut Gernsheim and Alison Gernsheim, *The History of Photography: From the Earliest Use of the Camera Obscura in the Eleventh Century up to 1914* (London: Oxford Univ. Press, 1955), vii–viii.

7. Abigail Solomon-Godeau, "A Photographer in Jerusalem, 1855: Auguste Salzmann and His Times," *October* 18 (1981): 107, reprinted in idem, *Photography at the Dock: Essays on Photographic History, Institutions, and Practices* (Minneapolis: Univ. of Minnesota Press, 1991), 168.

8. On the challenges faced by historians of photography, see Nancy Micklewright, "Orientalism and Photography," in Zeynep İnankur, Reina Lewis, and Mary Roberts, eds., *The Politics and Poetics of Place: Ottoman Istanbul and British Orientalism* (Istanbul: Pera Müzesi, 2011), 100–102.

9. Mounira Khemir, "The Orient in the Photographers' Mirror: From Constantinople to Mecca," in Roger Benjamin, ed., *Orientalism: Delacroix to Klee*, exh. cat. (Sydney: Art Gallery of New South Wales, 1997), 195.

10. Douglas Nickel, *Francis Frith in Egypt and Palestine: A Victorian Photographer Abroad* (Princeton, N.J.: Princeton Univ. Press, 2004), 74.

11. Gordon Baldwin, *Roger Fenton: Pasha and Bayadère* (Los Angeles: J. Paul Getty Museum, 1996), esp. 1–6.

12. For the exhibition catalogs, see Nicholas Tromans, ed., *The Lure of the East: British Orientalist Painting*, exh. cat. (London: Tate Britain, 2008); and Davy Depelchin and Roger Diederen, eds., *L'Orientalisme en Europe: De Delacroix à Matisse*, exh. cat. (Paris: Hazan, 2010). These exhibitions stand in marked contrast to the prominence afforded photography in earlier exhibitions of Orientalism, notably Benjamin, *Orientalism;* and Edwards, *Noble Dreams.*

13. Christine Riding, "Staging *The Lure of the East:* Exhibition Making and Orientalism," in Zeynep İnankur, Reina Lewis, and Mary Roberts, eds., *The Politics and Poetics of Place: Ottoman Istanbul and British Orientalism* (Istanbul: Pera Müzesi, 2011), 33.

14. For example, see Bodo von Dewitz, *An den süssen Ufern Asiens: Ägypten, Palästina, Osmanisches Reich: Reiseziele des 19. Jahrhunderts in frühen Photographien*, exh. cat. (Cologne: Agfa Foto-Historama, 1988); and Alfried Wieczorek, Calude W. Sui, and Michael Tellenbach, eds., *Ins Heilige Land: Pilgerstätten von Mekka und Medina bis Jerusalem: Photographien aus dem 19. Jahrhundert aus den Sammlungen der Reiss-Engelhorn-Museen*, 2nd ed., exh. cat. (Mannheim, Ger.: Reiss-Engelhorn-Museen, 2008).

ALI BEHDAD

THE ORIENTALIST PHOTOGRAPH

This essay is a reflexive attempt to bring into dialogue the rhetoric of the Orientalist image with a historical understanding of its emergence in the mid-nineteenth century. Organized as a series of fragmentary reflections, it sketches a visual description of what I call the Orientalist photograph, a sketch that engages its form as much as its politics; it is at once a historical account and a formal elaboration of a particular form of iconography. My aim here is to offer not an exhaustive inventory of the features of the Orientalist photograph but a preliminary description of some of its discontinuous and scattered traits, situating them specifically in the historical context of their formation. An Orientalist photograph, I wish to suggest, is an imaginary construct, though always historically and aesthetically contingent; it is marked by iconic fractures and ideological fissures yet is nonetheless regulated by a visual regime that naturalizes its particular mode of representation. Put otherwise, the discontinuous representations of the "Orient" and its people are linked and actualized through an ideology of denotative exoticism. In the Orientalist photograph, the fragmented images of the geographic region encompassing the Middle East and North Africa are unified through a system of ideological denotations, which figures it as a network of exotic signifiers.

Motivating my aim in elaborating what one may call the "visual regularities"[1] of Orientalist photography have been recent claims by some art historians and literary scholars that Orientalism no longer provides a viable conceptual framework to study nineteenth-century representations of the Middle East by European writers, travelers, and photographers. Indeed, in light of the wide-ranging influence of Edward Said's seminal book *Orientalism* (1978), it is remarkable how much critical energy has been expended in recent years to demonstrate that Said's book misrepresents or inadequately represents the project of Orientalism. To be sure, *Orientalism* has always attracted perhaps more than its fair share of critics. Just a few years after its publication, scholars such as Ajaz Ahmad and James Clifford challenged *Orientalism*'s "high humanism," took issue with its use of Michel Foucault's theory of knowledge-power, and questioned its omission of German and Russian Orientalism.[2] What distinguishes recent criticism of *Orientalism*, however, is that it emanates from a

broader rejection of the field of postcolonialism itself, and indeed of the project of political critique of literary and artistic expressions altogether. Recent art historical discussions of nineteenth-century photographic representations of the Middle East provide an exemplary case of such recent anti-Saidianism.

"In contemporary writing about nineteenth-century photography of the Middle East," writes Michelle L. Woodward, "it has become almost a cliché to describe many of these images as 'Orientalist'—that is, reflecting or propagating a system of representation that creates an essentialized difference between the 'Orient' and the 'West.'"[3] This claim aptly captures the predominant anti-Saidian sentiment among art historians and curators who work on representations of the Middle East created by both European and indigenous painters and photographers. To be sure, responses to Said's discussion of Orientalism as a discourse of colonial power among art historians and museum curators span the critical spectrum, from more rigorous and subtle critiques articulated from the Left to the sometimes facile and reactionary from those of an opposing political orientation. On one side are art historians such as Zeynep Çelik, Mary Roberts, and Woodward, who argue that "the trend to extend Said's analysis to apply equally to visual representations has…been used too broadly, obscuring nuances and inconsistencies, not only between different photographers' bodies of work but also within them."[4] These scholars typically aim to constructively revise Orientalism to encompass "a disparate and disputed set of discursive constructions" while at the same time acknowledging "Orientals" as "participants in the production of counternarratives or resistant images."[5] On the other side are writers such as John MacKenzie and Ken Jacobson, who betray a marked suspicion of "theory" and seek to return the term *Orientalism* to its prior usage as an art historical term that could be deployed without suggestion of a broader political or ideological critique. In *Orientalism: History, Theory, and the Arts,* MacKenzie argues against Linda Nochlin that "there is little evidence of a necessary coherence between the imposition of direct imperial rule and the visual arts," claiming that "Orientalism celebrates cultural proximity, historical parallelism and religious familiarity [with the Middle East and North Africa] rather than true 'Otherness.'"[6] Given such perceived "misconceptions inherent in postcolonialist analysis," Jacobson similarly suggests that "a return to more traditional methods is desirable for the study of 19th- and early-20th-century photography in North Africa and the Near East," urging commentators to focus more single-mindedly on the "notable aesthetic, as well as documentary and historical merit" when analyzing visual representations.[7]

In what follows, I argue that Orientalism should be understood not merely as an ideological discourse of power or as a neutral art historical term but rather as a network of aesthetic, economic, and political relationships that

cross national and historical boundaries. Understood in this way, Orientalism is indispensable to the understanding of nineteenth-century photography of the Middle East. Whether considered in the context of their production and dissemination in the nineteenth century or in relation to their current afterlives as collectable objects or archives, photographs of the "Orient" become meaningful and legible only if they are considered in terms of the geopolitical distinctions, economic interests, and cultural assumptions about the Middle East and its people. While insisting that Orientalism offers a crucial perspective from which to comprehend the meaning and significance of photographic representations of the Middle East, I do not mean to suggest that such images should be understood merely as a reflection of Europeans' racial prejudice against "Orientals" or that these images simply validate European, imperial dominance over the region. Nor would I wish to argue that Orientalist photography entails a binary visual structure between the Europeans as active agents and "Orientals" as passive objects of representation. Rather, I hope to provide an alternative view of Orientalist photography that focuses on nodes and ties that bind artists, collectors, and museums across historical and national boundaries, all of which are productive of a distinctly exotic vision of the region, a vision at once embraced and perpetuated by the elite in the Middle East. Indigenous photography in and of itself, I maintain, does not constitute an oppositional locus or resistant iconography, for it too belongs to the Orientalist network that mediates its vocabulary and thematics of representation.[8] A network theory of Orientalism concerns itself neither with the motivations of individual artists nor with the attributes of art objects; instead, it studies the symmetrical and asymmetrical relations between discrete objects, specific individuals, and concrete practices.

History Matters

A crucial link between the history of photography and Europe's knowledge about the Middle East has existed since the invention of the daguerreotype in 1839. Significantly, at the very meeting in which Louis-Jacques-Mandé Daguerre's invention was introduced to the Chambre des députés, the presenter, Dominique François Arago, commented upon "the extraordinary advantages that could have been derived from so exact and rapid a means of reproduction during the expedition to Egypt."[9] He then recommended that the French government immediately equip various institutions of knowledge-gathering about the Middle East, such as the Institut d'Égypte, with the new technology to further the project of Orientalism. It should come as no surprise that only eighty days after this meeting, a group of French painters and scholars led by Horace Vernet, an Orientalist genre painter who had traveled to Algeria with

the French army in 1833, and the daguerreotypist Frédéric Goupil-Fesquet went to Egypt to photograph Egyptian antiquity. Nor is it a coincidence that as early as 1846, Daguerre's British counterpart, William Henry Fox Talbot, published a pamphlet titled "The Talbotype Applied to Hieroglyphics," which was distributed among archaeologists and Orientalists.[10] Indeed, in subsequent decades, many early European traveling photographers such as John Cramb, Francis Frith, Maxime Du Camp, and Auguste Salzmann followed Arago's suggestion and traveled to the Middle East to photograph various places and monuments, making the Middle East one of the original and most popular sites for the practice of photography.

Art historians and museum curators have generally treated early amateur and expeditionary images of the Middle East either as distinct artistic expressions of individual photographers or as documentary projects to provide European audiences, in particular archaeologists and Egyptologists, with truthful images of the Holy Land and Egyptian antiquity.[11] What these approaches conceal is the network of relations that enabled the production of these images in the first place as well as the politico-cultural context, which made them so rapaciously consumable as visual and exotic objects. That the representations of the "Orient" figured so prominently in the early history of photography, specifically in England and France, speaks to the network of aesthetic, economic, and political relations between Western Europe and the Middle East, a network that provided the logistical means and conceptual paradigms for various photographic projects. Indeed, the photographic projects of Du Camp, Félix Teynard, or Salzmann would have never been realized were it not for the great interest in Middle Eastern antiquity generated by Napoleon's 1798 expedition to Egypt and the subsequent establishment of the Institut d'Égypte; the intellectual and artistic contributions of earlier Orientalist scholars, painters, and travelers; and the sponsorship of the French government and institutions. Du Camp, for instance, belonged to the Orientalist institution Société Orientale; had a government commission from the Ministère de l'agriculture et du commerce to photograph historic monuments in Egypt, Palestine, and Syria; was trained prior to his journey by Gustave Le Gray and Alexis de Lagrange to produce good negatives; was accompanied by Gustave Flaubert, who fancifully documented their trip; and was finally able to publish his photographs in 1851 using the printing process developed by Louis Désiré Blanquart-Evrard—photographs that became immediately successful because of the popular and scholarly interest in Orientalism. Far from being the result of a manic obsession with photography, as Flaubert claimed, Du Camp's images are products of a network of individual and institutional relationships that not only determined the content of his photographs but also provided

Fig. 1.
Maxime Du Camp
(French, 1822–94).
Ruins of Denderah, 1849, albumen print, 16.5 × 21.9 cm (6½ × 8⅝ in.). From Maxime Du Camp, *Égypte, Nubie, Syrie: Paysages et Monuments*, vol. 1 (1851). University of California, Los Angeles, Charles E. Young Research Library.

Fig. 2.
Francis Frith
(English, 1822–98).
The Town and Lake of Tiberias, from the North, 1857, albumen print, page: 31.1 × 43.8 cm (12¼ × 17¼ in.); image: 15.2 × 22.5 cm (6 × 8⅞ in.). From Francis Frith, *Egypt and Palestine Photographed and Described*, vol. 1 (London: J.S. Virtue, 1858–59), n.p. Los Angeles, Getty Research Institute.

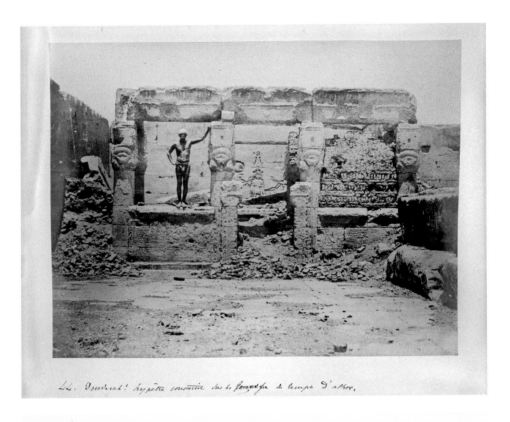

44. Denderah: hypêtre construit sur la terrasse du temple d'Athor.

Frith Photo 1857.

THE TOWN AND LAKE OF TIBERIAS,

From the North.

the technical knowledge and logistical support to execute them (fig. 1). Du Camp's *Égypte, Nubie, Syrie: Paysages et Monuments* is thus impregnated by a web of textual and visual traces that inscribe it within the iconography of Orientalism. As in Frith's *Egypt and Palestine Photographed and Described* (fig. 2), Du Camp's photographs in the book, which became an instant success in spite of its costliness, are accompanied by texts containing verbatim extracts from eighteenth- and early-nineteenth-century Orientalist travel narratives in order to make these images meaningful and legible. These textual precursors function not merely as explications for photographic representations of the "Orient"; they also determine what is worthy of photography in the Middle East. Put otherwise, the earlier travel narratives play a mediating role for the practice of Orientalist photography.

Circulation

The relation between Orientalist painting and photography is not that of a linear influence but of a circular reciprocity. Even a cursory glance at early Orientalist photography reveals its indebtedness to the conventions of Orientalist romantic paintings: Jacques Moulin's erotic and ethnographic photographs of the Orient explicitly borrow from the works of romantic painters Georges Auguste, Richard Parkes Bonington, and Eugène Delacroix, just as Wilhelm Hammerschmidt's and Francis Frith's photographs of Egyptian antiquity and the monuments of the Holy Land relied on the topographical works of English painters such as David Roberts. That Orientalist photography's subject matters and formal concerns were mediated by a particular painterly tradition should come as no surprise, since some of the early photographers of the Orient, including Roger Fenton, Auguste Salzmann, and Horace Vernet, were accomplished painters or began their careers as (Orientalist) painters but switched to photography because the new medium provided them with a more efficient means of realistic representation. More surprisingly, however, are the ways in which photography altered Orientalist genre painting, transforming its techniques and turning its romantic reveries into realist fantasies. As was predicted by Daguerre in 1839, since the mid-nineteenth century, Orientalist painters such as Léon Belly, Ludwig Deutsch, Jean-Léon Gérôme, and William Holman Hunt became increasingly dependent on the works of amateur and professional photographers of the Orient such as Henri Béchard, G. Lékégian, Abdullah Frères, and J. Pascal Sébah to create what is considered documentary realism. That Théophile Gautier compared the new documentary realism and its precise techniques to the objective precision of photography points to the crucial mediating role of the Orientalist photograph.[12]

The complicity between Orientalist painting and photography at once complicates notions of artistic influence, originality, and origin, compelling us to consider Orientalist representation as a network of artistic and discursive relations. The critical attitude among art historians and museum curators toward Edward Said's discussion of Orientalism as a discourse of colonial power has been at the cost of ignoring the crucial nodes and ties that bind artists, archaeologists, writers, and travelers, which are productive of a distinctly exotic vision of the region. Frith's *Egypt and Palestine* provides an early example of the idea of Orientalism as a network. The juxtaposition of his photographs with their descriptions after each image points to the supplementarity of textuality and visuality in the field of Orientalism. Frith's texts are peppered with references to the works of other travelers, archaeologists, and Orientalists. Consider the following quotation from Albert Smith, an accomplished traveler at the time, which Frith offers by way of describing the role of photography in providing truthful images of other worlds:

> Artists and writers will study effect, rather than graphic truth. The florid description of some modern book of travel is as different from the actual impressions of ninety-nine people out of a hundred, allowing all these persons to possess average education, perception, and intellect, when painting in their minds the same subject, as the artfully tinted lithograph, or picturesque engraving of the portfolio, or annual, is from the faithful photograph.

Frith responds to this claim by pointing out:

> Yet it does not follow, O Albert Smith, that a photograph, because it is not "over-coloured," is therefore *faithful*. I am all too deeply enamoured of the gorgeous, sunny East, to feign that my insipid, colourless pictures are by any means *just* to her spiritual charms. But indeed, I hold it to be impossible, by any means, fully and truthfully to inform the mind of scenes which are wholly foreign to the eye. There is no effectual substitute for actual travel, but it is my ambition to provide for those to whom circumstances forbid that luxury, *faithful* representations of the scenes I have witnessed, and I shall endeavour to make the simple truthfulness of the Camera, a guide for my Pen.[13]

The passage provides an example of how early photographic projects were in dialogue with travel writing and other Orientalist representations. Frith's response foregrounds the complementary relationship between the camera and the pen, photography and witnessing. On the one hand, the supplementary

relation between the photographer, archaeologists, and earlier travelers to the region suggests that what became worthy of photographing in the Orient was mediated through earlier descriptions and interests in holy sites and antiquity. On the other hand, by photographically re-presenting these sites, Frith provides further evidence for their studies while at the same time popularizing Orientalism as a discourse. While reaffirming the value of travel and firsthand observation, Frith points to the value of photography as a substitute for the Orientalist journey. For him, the Orientalist photograph has a supplementary function, providing the viewer with a visual experience of the Orient otherwise unavailable for most people. Orientalist photography, therefore, neither displaced its painterly counterpart nor did it outdate its textual precursor, but joined them in making Orientalism thrive as a dominant mode of representation.

Mediation

If early- and mid-nineteenth-century European travelogues and Orientalist genre paintings defined what was worthy of photographing in the Orient, the Oriental photograph in turn powerfully mediated the vision of every traveler who went to the Orient. Evelyn Waugh's description of the scene of his arrival to Constantinople offers a salient example of this mediation:

> It was getting dark by the time that we came back to the mouth of the Golden Horn. A low sea mist was hanging about the town, drifting and mingling with the smoke from the chimneys. The domes and towers stood out indistinctly, but even in their obscurity formed a tremendous prospect; just as the sun was on the horizon, it broke through the clouds, and, in the most dramatic way possible, threw out a great splash of golden light over the minarets of St. Sophia. At least, I think it was St. Sophia. It is one of the delights of one's first arrival by sea at Constantinople to attempt to identify this great church from the photographs among which we have all been nurtured.[14]

European travelers were nurtured as early as the 1850s by images of Constantinople, Jerusalem, and Egypt by pioneer photographers such as James Robertson, Du Camp, Teynard, and Salzmann. The Orientalist photograph democratized the access to Orientalist representation by liberating it from its elite confinement in the salon. The Orientalist photograph was thus not merely an expression of a European desire for the Orient but also *productive* of the lure of the East. Unlike the phantasmagoric image repertoire of *Arabian Nights*

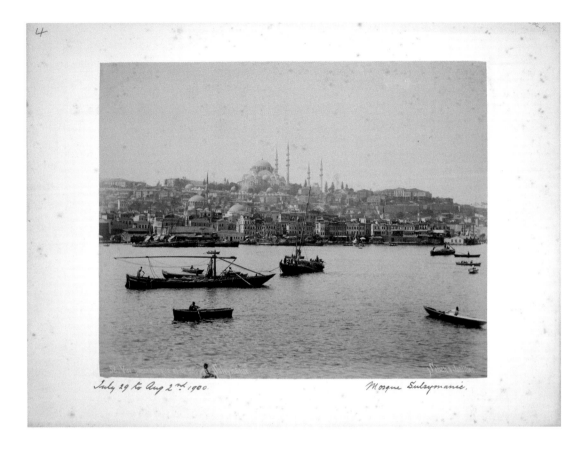

July 29 to Aug 2nd 1900. *Mosque Suleymanie.*

that had mediated and then disillusioned earlier travelers like Gérard de Nerval and Flaubert, the Orientalist photograph was constitutive of the Oriental real that made the traveler's encounter with the reality of the Orient more meaningful, albeit somewhat déjà vu. And unlike the intertext of *Arabian Nights* or the romantic paintings of Delacroix, the Orientalist photograph did not counter the traveler's own experience of the Oriental real by making it seem banal but rather enhanced it through the pleasure of identification (fig. 3). The photographic image was not merely an indexical reference point for the Orientalist traveler but the mediator of his or her desire for the Orient. The Orientalist photograph thus "nurtured" the desire for the Orient, helping its development as a cultural phenomenon throughout the West.

Photography's potential for the development of Orientalism was widely acknowledged early on. For example, in a review of Maxime Du Camp's *Égypte, Nubie, Syrie: Paysages et Monuments*, Louis de Cormenin wrote,

A daguerrian excursion is thus fortuitous from the dual points of view of eternal art and the written voyage [*voyage cursif*], above all when this excursion is undertaken in little-known, unique, and strange countries of

Fig. 3.
Sébah & Joaillier
(Ottoman photography studio, 1888–ca. 1950).
Vue panoramique de la mosquée Suleymanié, ca. 1890s, albumen print, 21 × 26.8 cm (8¼ × 10⅝ in.). Los Angeles, Getty Research Institute.

which science possesses only insufficient data. Nor is it rash to say that the publication of Maxime Du Camp completes, in brief and comprehensible fashion, the works of Denon and des Champollion-Figeac, and opens a new way of investigation to Orientalists, just as it offers a horizon particular to artists' studies. Art, as much as science, can gain precious information from [such photographs]. The intellectual movement directed toward the Orient can, from now on, take it as the helping hand [*vade mecum*] of its research, and the most intelligent and the most definitive of guides.[15]

In this paragraph, Cormenin underscores the importance of photography not just to the project of Orientalism but more broadly to the production of "scientific" knowledge about non-European societies. As well, the new medium of photography, which is viewed as a smart "helping hand," is valued for its potential contribution to arts and sciences. In other words, photographic works such as Du Camp's were appreciated both for completing the research and artistic projects of earlier Orientalists and for laying the foundation for new ways to explore and represent the Orient and other non-Western societies visually, thus perpetuating the Orientalist desire for knowledge and power.

Preservation

In the introduction to his collection of Holy Land photographs published in 1898, Adrien Bonfils, one of the most prolific and distinguished photographers in Lebanon, wrote:

In this century of steam and electricity everything is being transformed… even places: already in the ancient Plain of Sharon is heard the whistle of the locomotive.… The moment is probably not far off, when the holy Mount of Olives and Tabor will each possess its funicular like Mt Righi [outside Lucerne]! Before that happens, before Progress has completed its destructive work, before this present—which is still the past—has disappeared forever, we have tried, so to speak, to fix and immobilize it in a series of photographic views.[16]

Fig. 4.
Henri Béchard
(French, act. late 1800s).
Thèbes, Temple de Ramaseum, intérieur de la salle hyp,
ca. 1870s–80s, albumen print, image: 37.5 × 26.6 cm (14¾ × 10½ in.).
Los Angeles, Getty Research Institute.

Bonfils's alarmist claim about the disappearance of the Orient is hardly new, for late-nineteenth-century Orientalism, as I have shown elsewhere, is marked by a profound sense of belatedness.[17] As early as 1850, Flaubert made a similar plea to Gautier that "it is time to hurry. Before very long the Orient will no longer exist. We are perhaps the last of its contemplators."[18] Nor is Bonfils's idea of

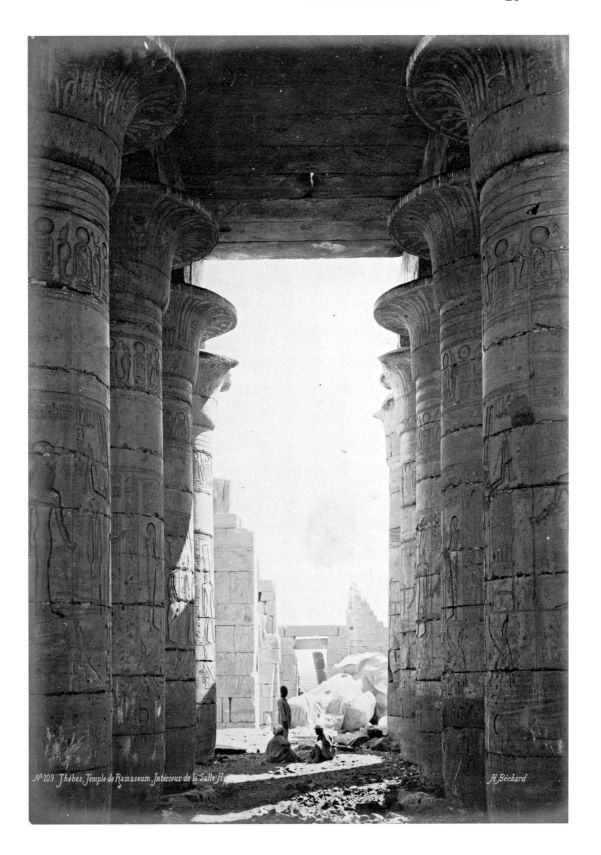

No 109 Thèbes, Temple de Ramaseum, Intérieur de la Salle Hy. H. Béchard

photography as a means of cultural preservation and rescue a novel claim. More than forty years earlier, in his introduction to *Egypt and Palestine,* Frith wrote,

> I may be allowed to state, as giving additional value to good Photographs of eastern antiquities that a change is rapidly passing over many of the most interesting: in addition to the corroding tooth of Time, and the ceaseless drifting of the remorseless sand, Temples and Tombs are exposed to continued plundering—Governors of districts take the huge blocks of stone, and the villagers walk off with the available bricks, while travellers of all nations break up and carry off, without scruple, the most interesting of the sculptured friezes and the most beautiful of the architectural ornaments.[19]

From the very beginning of its invention, the camera provided Orientalists with a tool to visually "rescue" the remnants of the Orient's antiquities just as they were pillaging the remnants of historical monuments in the Middle East (fig. 4). But what is remarkable about Bonfils's belated remark is the mobilization of nostalgia to obscure the contradictory functions of Orientalist photography as both a means of cultural rescue and an agent of change. While Bonfils, like belated travelers, invokes a melancholic discourse of nostalgia in response to the expansion of tourist infrastructure and European colonialism, he resolves his contradiction as the agent and beneficiary of European tourism by engaging in a practice of photographic preservation. The Orientalist image is, therefore, an expression of belatedness expressed so commonly by nineteenth-century Orientalists as well as an attempt to preserve the exotic by fixing it into a photographic icon. Bonfils's invocation of nostalgia masks the fact that his photographs, like those of other resident photographers in the region, were produced almost exclusively for European tourists; that is, for the very agents of progress that threatened the demise of Oriental reality. As such, the Orientalist photograph is a contradictory image, claiming to visually preserve the Orient's glorious past as a means of historical documentation while contributing to its disappearance as a tourist souvenir.

Depopulating the Orient

In a reading for a magic-lantern show of the Great Pyramid of Egypt in 1897, Professor Charles Piazzi Smyth expressed the following common perspective in the nineteenth century about the Orientalist photograph: "[T]he ghost-like figures of the Arabs might as well have been omitted, for with their black, unphotograhicable [*sic*] faces they make very bad ghosts; and besides the modern Arabs of Egypt are such ephemeral occupiers of the soil, that they have no right

to any place amongst the more ancient monuments of Egypt."[20] The Orientalist photograph depopulates the Orient of its inhabitants, for their presences rob the image of its quest for visual monumentalism and circumvent the possibility of visual appropriation. Unlike Orientalist genre paintings where natural scenes and ancient monuments are always peopled with "colorful natives"—think of David Roberts's paintings of the ruins of Baalbek in Egypt or Prosper Marilhat's ruins of El Hakem Mosque in Cairo—Orientalist photographs of Egyptian antiquity and the Holy Land often depict an empty space unobstructed by the presence of indigenous people. Viewed as "bad ghosts" without any photogenic quality, the indigenous people either are utterly erased from the scene or appear occasionally as anonymous physical blotches to provide a sense of scale. In contrast to the superabundance of decontextualized, studio-based images of people produced by resident photographers in the Middle East, the absence of humanity in the Orientalist view photography of Egyptian antiquity and the Holy Land at once participates in a form of static monumentalism that underpins Orientalist historiography and enables the possibility of colonial nostalgia.

Wilhelm Hammerschmidt's photograph of the Médinet-Gábon provides an example of photographic dispeopling (fig. 5). Like most early images of the Middle East taken by expeditionary photographers, it presents a close-up of an archaeological site in decay. In this typical photograph of Oriental antiquity, there are symbolically neither people nor traces of life, only the remains of a glorious past. The sole references to humanity are the archaeologized figures on the standing walls, whose presence, juxtaposed with the fallen stones and crumbling remains, convey static monumentalism; that is, dead magnificence, the remnants of a bygone civilization for nostalgic contemplation as much as for scientific observation. The absence of indigenous people in the Orientalist photograph foregrounds the presence of the viewer as both a yearning subject and a discerning savant. Such depopulating iconography is thus productive of a colonizing gaze that positions the European viewer as the potentially legitimate occupier through a visual erasure of the indigenous population.

Staging the Orient

Nothing belies the myth of photographic "naturalness" in the Orientalist image more than the staging of what is being represented (fig. 6). The photographer's intervention here goes well beyond mere framing, lighting, or focus, for everything in the image denotes a staged scene: the artificial backdrop, the ever-present props, the unnatural gaze of the sitter. The Orientalist photograph in this way is an exception to the art of photographic representation, for it is never "related to a pure spectatorial consciousness," as Roland Barthes claimed; rather,

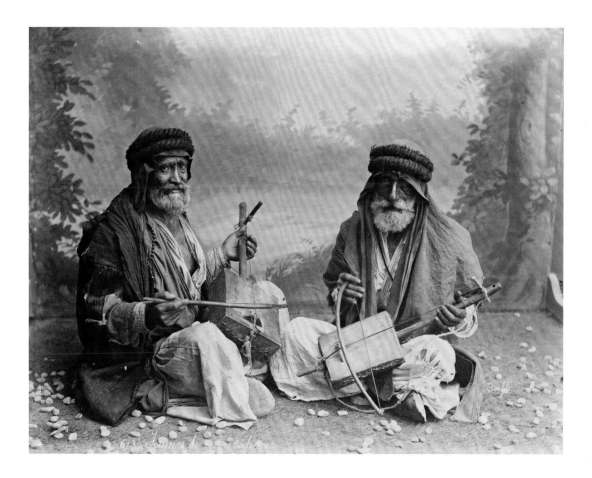

it is related "to the more projective, more 'magical' consciousness on which film by and large depends."[21] Although the Orientalist photograph is born of an archaeological urge for documentary evidence and an anthropological desire for empirical knowledge, its content ultimately reveals a projected fantasy of the Middle East and its people. The image mobilizes a fictional lexicon that undermines its documentary aims while the photograph's reproducible nature diminishes its significance as an authentic souvenir of a voyage.

Fig. 6.
Bonfils family (French, active 1800s–1900s).
Joueurs de violon bédouin, ca. 1880s, albumen print, image: 22.2 × 28.5 cm (8¾ × 11¼ in.).
Los Angeles, Getty Research Institute.

Excessive Anchorage

The Orientalist image is marked by excessive textual anchorage. In principle, the Orientalist photograph has the potential to be polysemous like any other image, but its potential for the "floating chain" of signifieds it carries is undermined by the almost ever-presence of the title in the frame and the repetition or translation of the title in the album (fig. 7). In this sense, the Orientalist photograph is excessively labeled, demonstrating a profound anxiety about the potential for the plurality of signifieds in it. Put otherwise, the Orientalist photograph aims

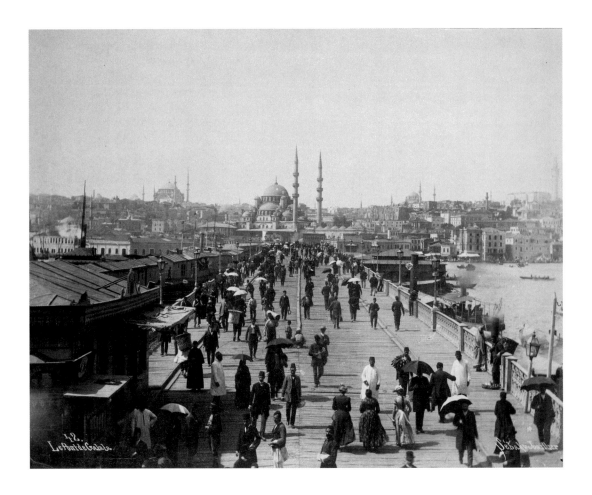

Fig. 7.
Sébah & Joaillier
(Ottoman photography studio,
1888–ca. 1950).
Le Pont de Galata, ca. 1890s,
albumen print, page: 25.7 ×
34 cm (10⅛ × 13⅜ in.);
image: 21.4 × 26.8 cm
(8½ × 10⅝ in.).
Los Angeles, Getty Research
Institute.

Fig. 8.
J. Pascal Sébah
(Ottoman, act. late 1800s).
Dames turques, ca. 1870s,
albumen prints, page: 34.1 ×
40.1 cm (13½ × 15⅞ in.).
From "Constantinople,"
album, 1885.
Los Angeles, Getty Research
Institute.

to name its meaning or content in a monolithic fashion by excessively naming what it depicts. The title in the image is not simply a denoted description of what is portrayed but an expression of a profound desire to fix the meaning of the image, to deprive it of any symbolic message or alternative meaning. The denotative title empties the image of all connotative signs. The title in the Orientalist photograph is therefore never a means of elucidation but rather a means of selective interpolation to limit the totality and plurality of the iconic message. It has thus a pedantically ideological function: to direct the reader to exclude his or her own interpretation. The title chooses the meaning of the photograph in advance; it fixes the signified of its iconography in a repressive fashion that precludes any other viewing but a guided identification. The title counters the terror of uncertainty, the possibility of any intrusion by the Oriental other into the life of the European viewer. In this way, the Orientalist photograph freezes the Oriental other twice: once through an exotic staging of his or her reality, and a second time through an ideological labeling of his appearance in the image.

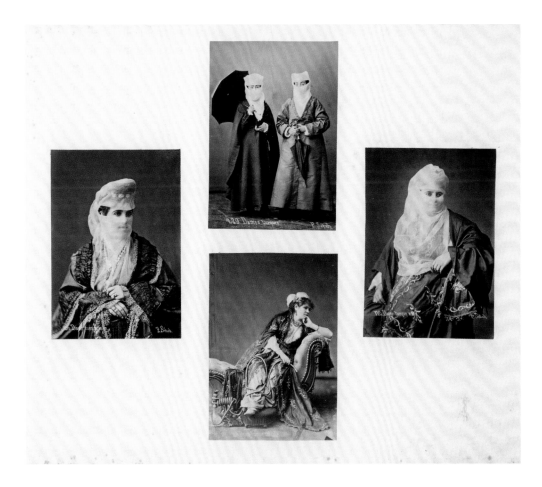

Harem

"The first question invariably addressed to every traveler on his return from the East," wrote Théophile Gautier, "is: 'Well, and the women?' to which each responds by a smile, more or less mysterious and significant, according to this degree of fatuity, and the character of its inquirer; but always implying, with more or less distinctness, that he has encountered more of romantic adventures than he thinks fit to recount to everybody."[22] The Orientalist photograph at once perpetuated the eroticization of the Oriental woman and excised the mystery and curiosity surrounding the topos of the harem.

No other figure was as frequent a topic in Orientalist photography as the Oriental woman. Women of all ethnic and religious types were photographed in every possible pose by residential studios throughout the Middle East. European tourist albums of Constantinople almost always devoted a large section to representations of the *dame turque* (fig. 8), while the most widely collected images by tourists to Algeria and Egypt were those of the

femme arabe. Although these images had their genealogical beginnings in Orientalist paintings of the odalisque, photography—especially in the form of the *carte-de-visite*—"democratized" the possibility of possessing the eroticized other, making the iconography of the Oriental woman a cultural cliché. The increasing availability of such images neither made the pictorial tradition of the odalisque obsolete nor did it dampen the desire for the eroticized other. Just as photographs of Oriental women provided European painters like William Holman Hunt, Jean-Léon Gérôme, John Frederick Lewis, and Pierre-Auguste Renoir with infinite samples to choose from as their models, the excess of representation protracted the longevity of Oriental eroticism by introducing it to the middle class through inexpensive and accessible *cartes-de-visite*. Photographs of Oriental women may have turned the iconography of the harem and its female occupants into kitsch, but in doing so, the photographs also naturalized the mythology of Oriental eroticism.

Studium Matters

A historian of photography ends his essay on the erotic photographs of Rudolf Lehnert and Ernst Landrock (fig. 9), proprietors of one of the most prolific studios in North Africa during the first two decades of the twentieth century, with the following question: "Is the correct paradigm for interpreting this kind of work one of politics and power, or one of imagination and inspiration?"[23] The question is disingenuously suggestive, at once gesturing toward an acknowledgment of how the large archive of erotic images of the Orient can be viewed as a record of exploitation, while calling for an appreciative reading of such representations. Such commonly expressed ambivalence among historians of photography studying European images of the Orient reduces the politics of photographic iconography to mere exploitation and valorizes their formal concerns to pure aestheticism. And yet, the aesthetics of the Orientalist photograph is paramount to an understanding of what Barthes called the *studium;* that is, what endows a photograph with such functions as "to inform, to represent, to surprise, to cause to signify, to provoke desire."[24] What made the photographs of Lehnert and Landrock so compelling and desirable as a souvenir among Europeans, especially French soldiers and colonial settlers, was precisely their emphasis on form, their deployment of classical composition techniques, their self-conscious dramatization of Oriental spaces, their attention to lighting, sartorial detail, and composed background. The politics of the Orientalist photograph is located neither in the message it conveys about the people of the Middle East nor in its depiction of its sociocultural state, but in the very distance it assumes with regard to

Fig. 9.
Rudolf Lehnert (Austrian, 1878–1948) and Ernst Landrock (German, 1878–1966).
Boy with flowers, 1920s, colored gelatin print, 30 × 24.5 cm (11⅞ × 9¾ in.). Los Angeles, Getty Research Institute.

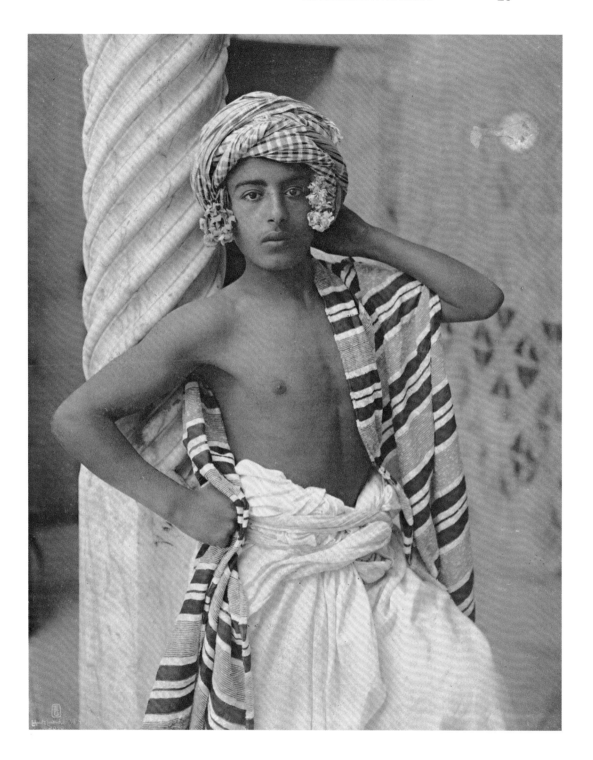

these functions through aesthetics. The Orientalist photograph reconfigures the relation between subjects and objects, spatiality and temporality in such a way that renders the very division of politics and aesthetics impossible.

Notes

I wish to express my gratitude to Luke Gartlan for his extremely thoughtful comments and editorial suggestions on various versions of this paper. As well, I wish to thank Mary Roberts, Nancy Micklewright, and other participants at the symposium on Orientalist photography where I initially presented this essay. Finally, I am grateful to Rebecca Peabody, Gail Feigenbaum, Roy Messineo, Thomas Gaehtgens, Melanie Lazar, and Michele Ciaccio for their generous support of this project.

1. I coin the term *visual regularities* following Michel Foucault's notion of "discursive regularities," which he posits by way of describing the relations between disparate and diverse statements made by practitioners of a particular discourse such as medicine, grammar, and political economy, relations that are marked by particular rules of formation, enunciative modalities, concepts, and strategies that govern and unite them. See Michel Foucault, *The Archaeology of Knowledge,* trans. A. M. Sheridan Smith (New York: Pantheon, 1972), 21–79.

2. See Ajaz Ahmad, *In Theory: Classes, Nations, Literatures* (London: Verso, 1992); and James Clifford, "On Orientalism," in idem, *The Predicament of Culture: Twentieth-Century Ethnography, Literature, and Art* (Cambridge, Mass.: Harvard Univ. Press, 1988), 225–76.

3. Michelle L. Woodward, "Between Orientalist Clichés and Images of Modernization: Photographic Practice in the Late Ottoman Era," *History of Photography* 27, no. 4 (2003): 363.

4. Woodward, "Between Orientalist Clichés and Images of Modernization," 363.

5. Jill Beaulieu and Mary Roberts, "Orientalism's Interlocutors," in idem, eds., *Orientalism's Interlocutors: Painting, Architecture, Photography* (Durham, N.C.: Duke Univ. Press, 2002), 3.

6. John MacKenzie, *Orientalism: History, Theory, and the Arts* (Manchester, N.Y.: Manchester Univ. Press, 1995), 51.

7. Ken Jacobson, *Odalisques and Arabesques: Orientalist Photography, 1839–1925* (London: Quaritch, 2007), 88.

8. I have demonstrated elsewhere, for example, that the indigenous practices of photography in the Middle East were more indebted to Orientalism's aesthetic values and ideological assumptions than to local and Islamic traditions of pictorial representation. See Ali Behdad, "The Power-ful Art of Qajar Photography: Orientalism and (Self)-Orientalizing in Nineteenth-Century Iran," in Layla S. Diba, ed., "Re-presenting the Qajars: New Research in the Study of 19th-Century Iran," special issue, *Journal of Iranian Studies* 34, nos. 1–4 (2001): 141–52.

9. Dominique François Arago, "Report of the Commission of the Chamber of Deputies," in Alan Trachtenberg, ed., *Classic Essays on Photography* (New Haven, Conn.: Leete's Island, 1980), 17.

10. Nissan N. Perez, *Focus East: Early Photography in the Near East (1839–1885)* (New York: Harry N. Abrams, 1988), 15.

11. For an example of the first approach, see Joanna Talbot, *Francis Frith* (London: Macdonald, 1985), which was published as part of the Masters of Photography series, edited by Rosemary Eakins. For an example of the second approach, see Claire L. Lyons et al., *Antiquity and Photography: Early Views of Ancient Mediterranean Sites* (Los Angeles: J. Paul Getty Museum, 2005).

12. Théophile Gautier, *Les Beaux-arts en Europe* (Paris: Michel Lévy, 1856).

13. Francis Frith, "Introduction," in idem, *Egypt and Palestine Photographed and Described*, vol. 1 (London: J. S. Virtue, 1858–59), n.p.

14. Evelyn Waugh, *Labels: A Mediterranean Journal* (London: Duckworth, 1930; reprint, London: Duckworth, 1974).

15. Unless otherwise indicated, all translations are mine.

 C'est donc une bonne fortune au double point de vue de l'art éternel et du voyage cursif, qu'une excursion daguerrienne, surtout quand cette excursion est entreprise dans des pays peu connus, singuliers, curieux, sur lesquels la science ne possède que d'insuffisantes données. Aussi n'est-il pas téméraire de dire que la publication de M. Maxime Du Camp complète, sous une forme brève et compréhensible, l'ourvrage des Denon et des Champollion-Figeac, et ouvre une voie nouvelle à l'investigation des orientalistes, comme un horizon particulier aux études des artistes. L'art, à l'égal de la science, y pourra puiser de précieux, renseignements. Le movement intellectual dirigé vers l'Orient peut désormais le prendre comme le vade-mecum de ses recherches et le manuel le plus certain et le plus intelligent.

 Louis de Cormenin, "Egypte, Nubie, Palestine et Syrie, dessins photographiques par Maxime Du Camp," *La lumière: Revue de la photographie,* no. 27 (26 June 1852).

16. Adrien Bonfils, introduction to "Nouveau testament" (unpublished manuscript, Beirut, ca. 1898), quoted in Carney E. S. Gavin, *The Image of the East: Nineteenth-Century Near Eastern Photographs by Bonfils* (Chicago: Univ. of Chicago Press, 1982), 1.

17. Ali Behdad, *Belated Travelers: Orientalism in the Age of Colonial Dissolution* (Durham, N.C.: Duke Univ. Press, 1994).

18. "Il est temps de se dépêcher. D'ici à peu l'Orient n'existera plus. Nous sommes peut-être des derniers contemplateurs." Gustave Flaubert, *Correspondance* (Paris: Gallimard, 1973), 1:663.

19. Frith, "Introduction," n.p.

20. Charles Piazzi Smyth, *The Great Pyramid: Forty-Eight Slides from Direct Negatives by Professor Piazzi Smyth* (London: W. Isbister & Co., 1897), 2:12; cited in Julia Ballerini, "Orientalist Photography and Its 'Mistaken' Pictures," in Henry Krawitz, ed., *Picturing the Middle East: A Hundred Years of European Orientalism; A Symposium* (New York: Dahesh Museum, 1995), 22–23.

21. Roland Barthes, "Rhetoric of the Image," in Alan Trachtenberg, ed., *Classic Essays on Photography* (New Haven, Conn.: Leete's Island, 1980), 278–79.

22. Théophile Gautier, *Constantinople of To-Day,* trans. Robert Howe Gould (London: David Bogue, 1854), 195. "La première question que l'on adresse à tout

voyageur qui revient d'Orient est celle-ci: —'Et les femmes?'—Chacun y répond avec un sourire plus ou moins mystérieux selon son degree de fatuité, de manière à faire sous-entendre un respectable nombre de bonnes fortunes." Théophile Gautier, *Constantinople* (Paris: Michel Lévy Frères, 1853), 195.

23. Joseph Geraci, "Lehnert and Landrock of North Africa," *History of Photography* 27, no. 4 (2003): 297.

24. Roland Barthes, *Camera Lucida: Reflections on Photography,* trans. Richard Howard (New York: Hill & Wang, 1981), 28.

CHRISTOPHER PINNEY

WHAT'S PHOTOGRAPHY GOT TO DO WITH IT?

It matters little if Orientalistic [*sic*] painting begins to run out of wind…
[p]hotography steps in to take up the slack and reactivates the phantasm at
its lowest level.

—Malek Alloula[1]

[Photography] departs from the disciplinarian gaze or the pattern of com-
municating prerecognized messages. It approximates at least the central
distinguishing features of action: it includes the aspect of a new beginning
and its ends are unpredictable.

—Ariella Azoulay[2]

"Orientalist photography," through the conjunction of these two simple terms,
seems to propose an argument. The sequence points to its trajectory: first there
is Orientalism and then there is photography, and if (like Malek Alloula) you
privilege the phantasm of Orientalism as a set of discursive practices, photog-
raphy is simply a secondary medium-specific manifestation of that force previ-
ously expressed in painting and now reactivated in a base form through a new
technics. Alternatively, we might choose to find in this conjunction a tension
between an ideology (Orientalism) and a technical practice (photography),
which, in turn, might point to the possibility of what Ariella Azoulay describes
as a "new beginning" whose "ends are unpredictable." These two adjacent words
thus stage a contest between paradigms in which theories of power and the
image must be staked.

Orientalism in its Saidian manifestation (that is, Edward Said's *Orientalism*
[1978]), in keeping with its Foucauldian inheritance, always subordinated the
image to power, although Said's later *Culture and Imperialism* (1993) did much
to complicate this relationship. *Orientalism,* however, stressed the connectiv-
ity between colonial interest and cultural practice. Pitched in a battle against
other historiographies deemed to be complicit with colonialism by virtue of
the alibi they grant colonial knowledge, there is little room here for "disinter-
est" and disconnection. Although Said gestures to the complex desires that
underlay Orientalist knowledge production ("a battery of desires, repressions,

investments, and projections"), the bulk of his analysis advances a confident systematicity—a world of "racial, ideological and imperialist stereotypes"—apparently devoid of self-doubt and contradiction.[3]

We should see Said's *Orientalism* as a challenge to engagement and supersession rather than simply, as so often, affirmation or negation. The binary choice that usually characterizes the debate around *Orientalism* can be sidestepped by a different analytic strategy that invokes the notions of transculturation, purification, and autonomy. These terms are chosen as potentials of specific moments and spaces and reflect a desire to avoid having to be *tout court* for or against a particular paradigmatic approach.

Transculturation, Purification, and Autonomy

The term *transculturation* is derived from its usage by Mary Louise Pratt and James Clifford to signify a contact zone characterized by copresence and interaction.[4] This exchange can flow in both directions (from colonizer to colonized and vice versa), as is the case, for instance, with Indians' enthusiasm for the technology of photography.

Purification takes its character from Bruno Latour's use of the term. This is purification in the sense of titration: the creation of two putatively "entirely distinct ontological zones."[5] This purification is also characterized by a bidirectionality: at times it involves a purification toward European idioms (as with the prevalence of Palladian or Gothic civic architecture in colonial India); at others, purification serves to essentialize Indianness as with certain aesthetic styles associated with chromolithography, which derived part of their cachet from their rejection of European conventions, or, equally, the pan-Asian aesthetic associated with Abanindranath Tagore that "purified" an anti-European "Asianness." However, aspects of visual and material culture frequently embody aspects of both the transcultural and the purificatory (as with, for instance, the bungalow, which became a central element in exclusionary enclave settlement patterns; or Gandhian anti-industrialism, which, while indebted to John Ruskin and Lockwood Kipling, was mobilized for the cause of an essentialized India).

Autonomy is a provisional and unsatisfactory term intended to mark the limits of the above terms by recognizing that vast swaths of the visual and material culture in colonial contexts stemmed from enduring traditions and developed in ways that were not significantly impacted by colonialism. The recognition of this domain as largely independent of empire is intended to acknowledge that local cultural production was frequently capable of creating its own history free from the shadow of colonialism.

Photographic exemplars of these three nodes—transculturation, purification, and autonomy—are easy to identify. We might start with purification, for this is the space in which we can identify images and practices that are closest to the phenomenon Said labeled *Orientalism*. Under this rubric we might point to images that cement the union between power and knowledge: anthropometric images of naked Indian bodies, usually underwritten by theories of Aryan invasion; ethnographic catalogs such as *The People of India* (1868–75);[6] and a variety of largely commercially produced images of snake charmers and other exotic topoi that located India as a space of religion from which the polity and economy had been removed.[7]

Maurice Vidal Portman, the eccentric and cantankerous "Officer in Charge of the Andamanese," would exemplify—in both his photographic practice and programmatic writing—the ontological alterity and power/knowledge elision that Orientalism names. In 1896, almost two decades after taking his first appointment in the Andamans, Portman published a paper, "Photography for Anthropologists," notable for its archaic coloniality. Portman's language is littered with demands for clarity: native bodies must be *stark* naked, and all "aesthetics" are to be avoided: "For ethnology, accuracy is what is required. Delicate lighting and picturesque photography are not wanted; all you have to see to is, that the general lighting is correct, and that no awkward placing of weapons or limbs hide important objects."[8] Similarly, "Do not retouch or add clouds &c., to scientific photographs."[9] This powerful sense of the anxious discipline at work in the construction of anthropology's disciplinarity is further reinforced by Portman's insistence on an austere colonial sensibility. There was a logistical and a psychic dimension to this. Logistically, "native servants and savages" could be entrusted with the "mere manual work of cleaning,"[10] but expensive equipment had to be protected: "Lock up all apparatus from savages and others."[11] Finally, one is struck by Portman's desire to abstract and extract: bodies require dislocation from a context infected with the aesthetic corruption of the picturesque. If subjects are not to be photographed against his checkered-flag version of the Lamprey grid, "[a] dull grey or drab background, being unobtrusive, is the best." If foliage is the only option, "it should be as much out of focus as possible." If a fire can be arranged, then the "smoke of a damp leaf fire makes a good background, and is of use in blotting out foliage, &c., which are not required in the photograph."[12]

Photographic exemplifications of transculturation might be approached through a consideration of the nature of the profilmic (that is, the nature of what is placed in front of the camera)[13] and what Walter Benjamin termed that "tiny spark of contingency" residing in every photographic image by virtue of the fact that it has been "seared with reality."[14] Consider this in relation

to a large albumen print in which five Sudanese males face the camera (fig. 1). Made by the commercial photographer Hippolyte Arnoux, it is titled *Tirailleurs soudanienes* (Sudanese sharpshooters or light infantry). The photographer has given expression to his "Orientalist" fantasies through the creation of a redoubt made from various cork logs and the placement of his sharpshooters in front of various studio backdrops. He appears then to have instructed them to perform the sort of ferocity that would appeal to the colonial expectations of the day. Two of the figures perform enthusiastically but three appear diffident, quizzical, and perhaps straightforwardly resistant. The moment of exposure captures these "sparks of contingency": the right-hand figure's uncertainty, the central standing figure's inquisitiveness at the actions of the photographer, and the left-hand figure's disengagement. The technics of photography (which require that live—and possibly noncooperative—bodies are brought before the camera) ensures that every "portrait event" will be uncertain. This is an uncertainty with which painting does not have to contend.

The third domain, of autonomy or indifference, gestures toward a space of practice that may manifest signs of what Arthur C. Danto calls "surface or perceptual contiguity" with "Orientalist" practices but that, on further inspection, can be shown to reflect quite distinct local traditions and concerns.[15] Many local Indian courts, for instance, produced images of courtesans and *nautch* (dancing) girls. The photographer Abbas Ali assembled *The Beauties of Lucknow* (1874), a nostalgic eulogy for Wajid Ali Shah's Lucknow court, illustrated with twenty-four photographic portraits of courtesans. This was an attempt to address an Indian male audience eager for the scent of a "Lucknow immemorable [*sic*] for the Oriental magnificence of the entertainments."[16] Dancing girls and "Oriental magnificence" were certainly also mobilized by Europeans in their own Orientalist photographic projects, but this does not disqualify such tropes from autonomous use in a very different local (in this case, Avadhi) romanticism. Figure 2, for instance, is a subtly tinted photograph of a North Indian courtesan, probably from Jodhpur in Rajasthan. If this image were incarnated as a postcard directed at a European audience (as many comparable images were), we might be justified in categorizing it as "purified" and "Orientalist," but there is no evidence to suggest that this photograph was ever intended to circulate beyond a small court circle for whom the courtesan was a key cultural figure.

We can see a further manifestation of autonomy in the full-body poses that rural customers in central India continue to demand of studio proprietors. Some of these photographers, as I documented in *Camera Indica* (1997), present themselves as bearers of artistic aspirations that are continually frustrated by their clients' insistence on the depiction of a whole body, frontally and lit in such a manner as to facilitate total clarity.[17] A joke that circulates among studio

Fig. 1.
Hippolyte Arnoux (French, act. 1860s–90s).
Tirailleurs soudanienes,
ca. 1870s, albumen print,
27 × 21.6 cm (10⅝ ×
8½ in.).
Cambridge, University
of Cambridge, P.57068.

Fig. 2.
Courtesan, ca. 1890s.
Albumen print with watercolor,
15 × 11.5 cm (6 × 4⅝ in.).
Private collection.

Fig. 3.
**Suresh Punjabi (Indian,
b. ca. 1960).**
Bandmaster in Nagda,
Madhya Pradesh, ca. 1978.

proprietors narrates how outraged peasants insist on paying only a quarter or half of the photographer's fee because only a quarter or half of the sitter's body has been provided. These present-day images of peasants facing the camera bear an optical and perceptual similarity to images produced by colonial practitioners such as Maurice Vidal Portman in the Andamans, which might provoke us to explore the possibility of a historical connection whereby colonial practices of typological portraiture leave a trace in popular local practices. This, however, would be a quite mistaken conclusion, for there is no evidence of such historical continuity, and the full-body pose reflects a distinct local conception of the ideal symmetrical, and whole, body.

In the 1970s and 1980s, when many small-town photographers in central India used medium-format cameras (usually Japanese Yashicas), this frequent insistence by customers on full-length portraiture led to the generation of excessive noise in the margins of the negative. Figure 3 is printed from one of thousands of similar negatives exposed by Suhag Studio in Madhya Pradesh in the late 1970s. A bandmaster desired a full-length image of himself conducting, and to accomplish this, the photographer (Suresh Punjabi) retreated from his subject, finding a place, accidentally, for the studio lights and props, which appear on either side of the square negative. This dimension of photographic contingency (a contingency without parallel in painting) will be returned to at the end of this paper.

In and Out of the Camera

The section above has explored an alternative to the choice of a simple affirmation or negation of Said's hypothesis concerning Orientalism. It proposes three different ways of engaging his problematic and attempts to provide photographic examples that fit the three categories. The second half of this paper addresses the question of whether photography is to be understood as simply one stage in a succession of media, which would make it as susceptible to the ideological demands of Orientalism as the earlier practices of painting and lithography, as Alloula has suggested. Conversely, we might also ask a different question: does photography, by virtue of the specificity of its nature as a technical practice, demonstrate a resistance to being mobilized on behalf of Orientalist interests? What, in other words, has *photography* got to do with this?

An alternative approach focuses on what Roland Barthes terms the "disturbance" introduced by photography. What are the consequences of its individuating *screen,* the prophetic nature of the profilmic moment, and the egalitarian nature of its aesthetics of the same? The rest of this paper examines these questions through a study of photography in India during the nineteenth and early

Fig. 4.
Group portrait, ca. 1880s.
Albumen print, 14.3 ×
19.5 cm (5⅝ × 7¾ in.).
Private collection.

Fig. 5.
Group portrait (detail),
ca. 1880s.
Albumen print, 14.3 ×
19.5 cm (5⅝ × 7¾ in.).
Private collection.

twentieth centuries in order to arrive at conclusions about the propensities of different media. A key element of my argument concerns the manner in which photography's *disturbing* propensity makes it resistant to certain aspects of Orientalization. Note here that resistance does not imply the binary of an either/or but instead is a question of intensity or tension. Tension implies affordance and a limit to tensility, a propensity that is not undermined by *exceptions*: exceptions are not of interest, but the *intensity* of exceptions certainly is.

Photography as technical practice continually confronts a set of spatiotemporal constraints. Elsewhere I have engaged the dualistic nature of photography's networking and individuating propensities.[18] Here I will focus briefly only on the latter. Photography produced better results with individuals (or, at a pinch, couples) than with large collectivities of the sort by which—so one kind of historiography would claim—India in the nineteenth century was still largely constituted. One does not have to agree with the extremity of anthropologist Louis Dumont's claim that the individual as such did not exist in India to recognize that the obvious subject for the photographer in India might have been *jatis* (castes), *biradaris* (brotherhoods), work groups, or other collective expressions of social solidarities.[19]

Individuation—the differentiation of the person from wider social solidarities—was the result of two related dimensions of early photographic practice. One reflected the aesthetic force that single bodies (as opposed to multiple bodies) were able to deposit in the image. The other reflected slow exposure times and the difficulty in marshaling collective bodies in front of the camera. This

second dimension is explicitly commented on by John Blees in his *Photography in Hindostan; or, Reminiscences of a Travelling Photographer* (1877). He stressed the complex preparation that must be made to photograph groups successfully: "Make it a rule to inquire the day before of how many the group will be composed. Trace an outline in your mind, and try to realize your plan the next day on the negative." Very large groups pose further problems: "When there are as many as 30 or 40 to be portrayed on a 10 × 8 or 12 × 10 plate, a fancy design must be abandoned. Here the difficulty encounters you of getting the lens to see them all at the same time." And then, of course, there is the problem of movement in large groups: "Some people will move notwithstanding their best endeavor to the contrary.... Always seat as many as you conveniently can."[20]

That the photography of large groups continued to be a problem in Indian studios throughout the nineteenth century is perhaps suggested by an albumen print from the 1880s depicting fifteen adults as well as eight infants and young children from western India (figs. 4, 5). Visual clues suggest that this was a

single joint household comprising a father (seated at second left), his sons, their wives, and his grandchildren. The twenty-three figures are arranged three deep with women standing at the back, men seated in the middle, and children either held by these men or seated on low stools at the front. In the background a standard studio backdrop is evident with elaborate drapes framing leaded windows. There is much here to indicate that the photographer has confronted the issues highlighted by Blees. The composition of the group (structured as it is by gender and age) suggests careful forethought, and the photographer has clearly seated all those he conveniently could. But notwithstanding these endeavors, some people have "moved." Many faces are clearly fixed but others are caught in motion, their blurred visages pushing at the limits of readability.

Blees's text went on to demonstrate that what he terms "the picture of a gentleman" is what we might term the default setting of nineteenth-century photographic apparatus. Suppose "that a bust of a gentleman is to be taken," he suggests. In such a case, all that is needed is a posing chair and a headrest in which the sitter is positioned. The photographer then focuses and the sitter is told that "he may . . . do whatever he pleases, whilst you are preparing the sensitized plate—he may even get up and walk about."[21]

Here is the photographic apparatus in what we might think of as its pure and normative form: all that is needed is the presence of a sitter, whom we should assume is solitary, and male. In some images we can literally see how backdrops demarcated this solitary space and how larger ensembles exceed and disrupt it. One consequence of this individuating propensity was its prophetic advancement of persons abstracted from the social solidarities in which they were previously absorbed (a theme to which we shall shortly return). But it also directs our attention to another consequence of the nature of the profilmic: the logistics of marshaling real bodies in a lived time and space produced a resistance to allegory. Allegorical impulses may well have motivated photographers but they were always subordinated by the exigencies of other demands ("a fancy design must be abandoned").[22] Each photograph is, as Samuel Bourne would say of his famous image of the Manirung Pass (the highest-altitude photograph of its day), "a memento of the circumstances under which it was taken."[23] In "Ten Weeks with a Camera in the Himalayas," published in February 1864, Bourne cited approvingly Harriet Martineau's discussion of the difference between the idealist and empiricist painter: "it is one thing to lie in bed till noon in a 'simmering' state of thought, or gazing at visionary scenes, and another to be abroad at daybreak, studying the earth and sky. . . . It is one thing to represent historical tragedy in painting . . . and quite another to go to the actual scene . . . in suffering and privation, with labour and anxiety under an eastern sun."[24] Of course, some photographers (perhaps here Henry Peach Robinson is exemplary) strove to turn

photography into a kind of allegorical painting, but they are an exception, the low intensity of which supports a view that photography's propensity pointed in a different direction.

Prophecy is also an effect of the profilmic. Photography ratcheted up the general positivity of the visual, because every photograph was indisputably a document of an event, an event that could not be denied—recall, for example, Rudolf Wittkower's argument about the visual's tendency to solidify presences and claims that in their linguistic form are always more uncertain.[25] In photography, as Roland Barthes observed, "I can never deny that *the thing has been there*."[26] The event—which Barthes also refers to as photography's "sovereign Contingency"—is marked by the particularity and specificity of what Barthes called the "body" (*corps*), whose singularity he contrasted with the generality of the "*corpus*."[27] The camera records what is placed in front of it and on its own is incapable of making distinctions between the relationship of its visual trace to psychic, social, or historical normativity. It never knows and can never judge whether what it records is "typical," "normal," or "true."

The city of Amritsar became a central site of political struggle after the Jallianwalla Bagh massacre in 1919. Photography's "civil contract" was mobilized a few days later when the Bombay-based photographer Narayan Vinayak Virkar traveled to the site of the massacre and photographed the aftermath. In a series of haunting images, survivors point to bullet holes in a wall against which many protesters had died. Two images similar to these were subsequently published in the Indian National Congress's Punjab Inquiry report in 1920, one with the caption "Western walls in Jalleanwala [*sic*] Bagh showing holes caused by bullets even six inches deep."[28] Other photographs showing survivors' injuries were a prominent feature of the report. An image of a seated young boy whose left arm has been amputated near the shoulder is captioned "Sardari Lala of Gujrunwala wounded in arm by bomb from aeroplane."[29] The 1920 report also reproduced a series of images of public flogging at Gujrunwala that had preceded the massacre and that had been featured in *Amritsar and Our Duty to India*, published in London by the recently deported newspaper editor B. G. Horniman in the same year. Horniman opened his account with a reference to the "Congo atrocities" with which the Amritsar images may well have resonated in British public conscience, not least as a result of Arthur Conan Doyle's championing of E. D. Morel's and Roger Casement's campaign in *The Crime of the Congo* (1909).[30] Horniman then notes that "floggings took place in public, and photographic records of these disgusting incidents are in existence, showing that the victims were stripped naked to the knees, and tied to telegraph poles or triangles."[31]

In 1922 an American cinematographer named A. L. Varges documented a clash between Sikh Akalis and the Indian police.[32] An official report described

how Varges had photographed an Akali protest procession en route for the Guru-ka-Bagh. Four waves of protesters attempted to access a disputed piece of land and were beaten back by *lathi*-wielding police, all of this being filmed and photographed by Varges. "Eventually 23 of the Akalis were taken off on stretchers, the remaining two, who were more obstinate, were treated more roughly by the Police...meanwhile the cinematograph operator and other photographers and Press representatives were all busy," an official report noted.[33] The governor in council proclaimed that he did "not feel happy about the activities of the cinema operator and the possible ill-effect of these films in fostering anti-British feeling in the United States" and then instructed the Home Department to ascertain whether there was any way to stop Varges from shooting more film, to identify his whereabouts, and to make clear to him the necessity of "exercis[ing] caution that none are exhibited which are likely to cause misunderstanding."[34]

In Varges's images—these scratched, panicked slices of reality—we see evidence of photography's indiscriminate capture that (as Friedrich Kittler noted) "shifted the boundaries that distinguished...random visual data from meaningful picture sequences, unconscious and unintentional inscriptions from their conscious and intentional counterparts."[35] It is clear here that a profound anxiety is at large, an anxiety marking the deep and destabilizing realization that the control of photography as a technical practice had now slipped from the hand of the state. Photography's "penetrating certainty," which earlier colonial figures had extolled, had been desirable to the extent that it was a certainty the state could own.

Having failed to prevent the Guru-ka-Bagh images being taken, and then having failed to prevent the images from leaving the country, various anxious middle-ranking officials looked to the caption as a final redemptive strategy. Writing a desperate prefiguration of Walter Benjamin's declaration in the 1930s that in the future, "inscription [will become] the most important part of the photograph" (as Benjamin put it),[36] Rushbrook Williams noted that "it is [crucial] that the captions employed, *which are so important from the propaganda point of view,* are deployed in the most moderate terms."[37]

The evidential potential of photography is even more explicitly foregrounded in the Indian National Congress report of the Peshawar Enquiry Committee of 1930. The report focused on events of 22 and 23 April 1930, when, following the arrest of nine activists (associated with Khan Abdul Ghaffar Khan, the so-called Frontier Gandhi), a crowd attacked three armored vehicles, resulting in a police firing in which about twenty protesters were killed.[38] Photographs were used in the Congress investigation to determine whether the crowd had been peaceful and unarmed, and whether "in the situation that had arisen...firing by armoured cars and troops was justified."

The report reproduced several photographs as "exhibits," and concluded that "a very strong proof of the crowd being unarmed" was to be found in the fact of two platoons initially refusing to fire on the crowd and the "equally striking proof" provided by the photographs "showing the unarmed crowd facing the armoured cars."[39] Some witness testimony also mobilized the photographs as support of their own eyewitnessing. Witness no. 62 testified that "the state of things at the place of occurrence was the same as appearing in the photographs. People who appear as standing in the photographs had nothing with them; sticks, axes, or any weapons in their hands."[40] Similarly, Hakim Abdul Jalil, witness no. 55, recorded that "the state of affairs presented in the two photographs is exactly as I saw on the spot.... This is a correct and precisely accurate photograph of the spot.... In the photos none of the crowd appears to possess a stick, a lathi or an axe and in fact they did not have any such weapons."[41]

The exhibits, compiled over fifty pages at the end of the report, mix proclamations with Congress bulletins, and lists of the dead and wounded with photographs that document and preserve protest and suffering as shared public and contractual dimensions of what Azoulay terms "photographic citizenry." Exhibit T reproduces a photograph showing the "unarmed crowd face to face with the military" before the second firing (fig. 6). Exhibit W is a "List of the Martyrs and wounded of Peshawar who on 23rd of April 1930, became the victims of the bullets, the machine-guns and atrocities of the tyrannical Bolton

Fig. 6.
"Exhibit T: Scene showing unarmed crowd face to face with the military at Dhaki Nalbundi in Kissa Khani Bazar (now known as Shahidi Bazar) before the second firing."
From V. J. Patel et al., *Report (with Evidence) of the Peshawar Enquiry Committee Appointed by the Working Committee of the Indian National Congress* (Allahabad: Allahabad Law Journal, 1930), n.p.

Exhibit T

Scene showing unarmed crowd face to face with the military at Dhaki Nalbundi in Kissa Khani Bazar (now known as Shahidi Bazar) before the second firing. (Vide witnesses Nos. 55 and 62)

regime." Exhibit X shows a group of mourners crowding around the body of "Chamanlal shot dead while following the funeral procession of S. Gunga Singh's children" (fig. 7). At the edges of the frame, faces squeeze into the collaborative space of photography. If the frame declares the limits of the camera's "room," the desire to be "in camera" becomes—under the terms of this new technics—an explicit declaration of photography's shared and public space, its *ex camera*. The *in camera* of legal exclusion and occlusion *within* photography becomes the guarantee of visibility. The bodies that strain to be photographed *inside* the camera understand that this is the precondition for visibility *outside*.

This last image recalls Pierre-Louis Pierson's *Napoleon III and the Prince Imperial* from about 1859 that serves, for Ariella Azoulay, as something akin to the "primal scene" of photography's collaborative and ethically incorporative idiom (fig. 8). The photograph felicitously prefigures the portrait of the bandmaster by Suresh Punjabi (see fig. 3) in its bringing to visibility the "noise"[42] of the studio environment, in this case the borders of the background against which the horse-mounted imperial prince is posed and the figures of Napoleon III seen on the right (together with a dog) and an assistant on the left. For Azoulay this image, which so remarkably foregrounds the "ritual of photography…itself,"[43] illustrates the manner in which "photography's form of political relations are not organized around a sovereign power."[44] Azoulay's argument foregrounds the nature of photography as the trace of an event, as an index, but also a performance: Napoleon wanted a photograph of his son and "in order to obtain it, his son had to go to the photographer's studio"—so his father accompanied him and put in place the contingencies of this particular "photographic situation" with its attendant "dynamic field of power relations."[45] This dynamic field involves a complex and paradoxical set of relationships between the sitter, the photographer, the sovereign, and the assistant. The child is perhaps the most obviously subordinate and "yet he is the center of the event." Inversely, the sovereign's image is "pilfered" by a camera, which is unable to simply reflect the intentionality of the photographer because "the photograph escapes the authority of anyone who might claim to be its author, refuting anyone's claim to sovereignty."[46] Something is happening here *photographically,* which would not, and does not, occur in other media that lack the index and the event. The painter who lies "simmering" in bed, to recall Samuel Bourne, never has to engage this contractual space.

I started this paper with a critique of the assumption (evident in Alloula) that photography is merely a "screen" onto which more powerful primary ideologies (such as Orientalism) are projected. The materials presented in the second half of this paper provide, I hope, the basis for a critique of the Foucauldian version of this thesis. Most influentially advanced by John Tagg, this proposed that "photography

Fig. 7.
"Exhibit X: Chamanlal shot dead while following the funeral procession of S. Gunga Singh's children on 31st May 1930."
From V. J. Patel et al., *Report (with Evidence) of the Peshawar Enquiry Committee Appointed by the Working Committee of the Indian National Congress* (Allahabad: Allahabad Law Journal, 1930), n.p.

Exhibit X

Chamanlal shot dead while following the funeral procession of S. Gunga Singh's children on 31st May 1930. (Vide Nikkaram, Chaman Lal's father, witness No. 66)

as such has no identity…its history has no unity. It is a flickering across a field of institutional spaces. It is this field we must study, not photography as such."[47] This vision of photography as an epiphenomenal reflection of discourse and power could hardly be less appropriate to the history I have telegraphed here. The logic (or, perhaps better, propensity) that I have been describing is not the logic of the state. Tagg focused on photographic practices that demonstrated "not the power of the camera, but the power of apparatuses of the local state which deploy it and guarantee the authority of the images it constructs to stand as evidence or register a truth."[48] The examples from Amritsar and Peshawar are difficult to reconcile with such a stance, pointing instead to the camera's role in constructing a photographic citizenry. Indian anticolonial nationalists became *citizens of photography* just as Azoulay argues that Palestinians became part of the "citizenry of photography long before there was any possibility of their becoming citizens in the ordinary meaning of the word."[49]

The Amritsar and Peshawar images illuminate another aspect of photography's "disturbance": the extent to which, in certain circumstances, it is "feared by power."[50] These photographs support, with considerable force, Stephen Eisenman's Bhabhaesque conclusion that "rather than buttressing repressive regimes," visual representations "may actually undermine their ideological legitimacy, or at least offer potential paths for future cultural and political resistance."[51] I have tried to argue that to view photography as a mere "reactivator" of the Orientalist phantasm is too simplistic. Indeed, of all visual techniques it is perhaps the *most* resistant to the ontological and epistemological distinctions upon which, as Said argued, Orientalism rests.

Notes

1. Malek Alloula, *The Colonial Harem,* trans. Myrna Godzich and Wlad Godzich (Minneapolis: Univ. of Minnesota Press, 1986), 4.

2. Ariella Azoulay, *The Civil Contract of Photography,* trans. Rela Mazali and Ruvik Danieli (New York: Zone, 2008), 96.

3. Edward W. Said, *Orientalism* (New York: Pantheon, 1978; reprint, Harmondsworth, U.K.: Penguin, 1985), 8, 328. Said's later *Culture and Imperialism* (London: Chatto & Windus, 1993) complicates the reductions of his earlier position. Important critiques and elaborations include Ali Behdad, *Belated Travelers: Orientalism in the Age of Colonial Dissolution* (Durham, N.C.: Duke Univ. Press, 1994); and Jill Beaulieu and Mary Roberts, eds., *Orientalism's Interlocutors: Painting, Architecture, Photography* (Durham, N.C.: Duke Univ. Press, 2002).

4. Mary Louise Pratt, *Imperial Eyes: Travel Writing and Transculturation* (London: Routledge, 1992), 6. See also James Clifford, *Routes: Travel and Translation in the Late Twentieth Century* (Cambridge, Mass.: Harvard Univ. Press, 1997), 192.

Fig. 8.
Pierre-Louis Pierson
(French, 1822–1913).
Napoleon III and the Prince Imperial, ca. 1859,
albumen print, 21 × 16 cm
(8¼ × 6⅜ in.).
Los Angeles, J. Paul Getty Museum.

5. Bruno Latour, *We Have Never Been Modern,* trans. Catherine Porter (London: Prentice Hall, 1993), 10.

6. J. Forbes Watson and John William Kaye, eds., *The People of India: A Series of Photographic Illustrations, with Descriptive Letterpress, of the Races and Tribes of Hindustan,* 8 vols. (London: India Museum, 1868–75).

7. Ronald Inden, "Orientalist Constructions of India," *Modern Asian Studies* 20, no. 3 (1986): 401–46.

8. Maurice Vidal Portman, "Photography for Anthropologists," *Journal of the Anthropological Institute* 25 (1896): 77.

9. Portman, "Photography for Anthropologists," 86.

10. Portman, "Photography for Anthropologists," 85.

11. Portman, "Photography for Anthropologists," 86.

12. Portman, "Photography for Anthropologists," 85.

13. See Eileen McGarry, "Documentary Realism and Women's Cinema," *Women and Film* 7 (1975): 50.

14. "No matter how artful the photographer, no matter how carefully posed his subject, the beholder feels an irresistible urge to search such a picture for the tiny spark of contingency, of the here and now, with which reality has (so to speak) seared the subject, to find the inconspicuous spot where in the immediacy of that long-forgotten moment the future nests so eloquently that we, looking back, may rediscover it." Walter Benjamin, "A Little History of Photography," in Michael W. Jennings et al., eds., *Walter Benjamin: Selected Writings, 1931–1934,* vol. 2, pt. 2, trans. Rodney Livingstone (Cambridge, Mass.: Harvard Univ. Press, 1999), 510.

15. Arthur C. Danto, "Art and Artifact," in Susan Vogel, ed., *Art/Artifact: African Art in Anthropology Collections* (New York: Center for African Art, 1988), 23.

16. Abbas Ali, *The Beauties of Lucknow Consisting of Twenty-Four Selected Photographed Portraits, Cabinet Size, of the Most Celebrated and Popular Living Histrionic Singers, Dancing Girls, and Actresses of the Oudh Court and of Lucknow* (Calcutta: Calcutta Central, 1874), n.p., cited by Sophie Gordon, "A City of Mourning: The Representation of Lucknow, India, in Nineteenth-Century Photography," *History of Photography* 30, no. 1 (2006): 90.

17. Christopher Pinney, *Camera Indica: The Social Life of Indian Photographs* (Chicago: Univ. of Chicago Press, 1997).

18. Christopher Pinney, *The Coming of Photography in India* (London: British Library, 2008).

19. Louis Dumont, "The Functional Equivalents of the Individual in Caste Society," *Contributions to Indian Sociology,* no. 8 (1965): 85–99.

20. John Blees, *Photography in Hindostan; or, Reminiscences of a Travelling Photographer* (Byculla, India: Education Society's Press, 1877), 100–101.

21. Blees, *Photography in Hindostan,* 101.

22. Blees, *Photography in Hindostan,* 100.

23. Samuel Bourne, *Photographic Journeys in the Himalayas, Comprising the Complete Texts of Four Series of Letters to the "British Journal of Photography" Published between July 1st 1863 and April 1st 1870,* ed. Hugh Ashley Rayner, 2nd ed. (Bath: Pagoda Tree, 2004), 21.

24. Bourne, *Photographic Journeys in the Himalayas,* 18. Bourne's article was originally published in the *British Journal of Photography* (1864).

25. Rudolf Wittkower, *Allegory and the Migration of Symbols* (London: Thames and Hudson, 1987), 20.

26. Roland Barthes, *Camera Lucida: Reflections on Photography,* trans. Richard Howard (New York: Hill & Wang, 1981), 76.

27. Barthes, *Camera Lucida,* 4.

28. Indian National Congress, *The Congress Punjab Inquiry* (n.p.: Indian National Congress, 1920); reprint, Indian National Congress, *The Congress Punjab Inquiry, 1919–1920: Report of the Commissioners Appointed by the Punjab Sub-Committee of the Indian National Congress* (New Delhi: National Book Trust, 1994), caption to pl. 1.

29. Indian National Congress, *The Congress Punjab Inquiry,* caption to pl. 1.

30. B. G. Horniman, *Amritsar and Our Duty to India* (London: T. Fisher Unwin, 1920), 7.

31. Horniman, *Amritsar,* 155.

32. Varges worked for International News, a Hearst organization, and specialized in filming colonial wars and political struggle: he had previously made films in Macedonia and Mesopotamia, and would subsequently film the Italian incursion in Abyssinia (1935) and the Spanish Civil War. Home Political, 1922, 949:25, National Archives of India, New Delhi.

33. Home Political, 1922, 949:2, National Archives of India, New Delhi.

34. Home Political, 18 September 1922, National Archives of India, New Delhi.

35. I draw here on Kittler's translators' words. Geoffrey Winthrop-Young and Michael Wutz, "Preface," in Friedrich Kittler, *Gramophone, Film, Typewriter,* trans. Geoffrey Winthrop-Young and Michael Wutz (Stanford, Calif.: Stanford Univ. Press, 1999), xxvi.

36. Benjamin, "Little History," 527.

37. Home Political, 1922, 949:21, National Archives of India, New Delhi (emphasis mine).

38. V. J. Patel et al., *Report (with Evidence) of the Peshawar Enquiry Committee Appointed by the Working Committee of the Indian National Congress* (Allahabad: Allahabad Law Journal, 1930), 2–3.

39. Patel, *Report,* 11.

40. Patel, *Report,* 11.

41. Patel, *Report,* 24–25.

42. "Noise" signifies what Barthes called the "exorbitance" of photographic deposition, or what Friedrich Kittler conceptualized as meaningful "random visual data." See Pinney, *The Coming of Photography in India,* 4–5, 92.

43. Azoulay, *Civil Contract,* 110.

44. Azoulay, *Civil Contract,* 110.

45. Azoulay, *Civil Contract,* 112.

46. Azoulay, *Civil Contract,* 112.

47. John Tagg, *The Burden of Representation: Essays on Photographies and Histories* (Basingstoke, U.K.: Macmillan, 1988), 63.

48. Tagg, *Burden of Representation,* 64.

49. Azoulay, *Civil Contract,* 131.

50. Tagg suggests that on the contrary, "realism," within which we might locate certain photographic practices, is more likely "a channel through which power drains into the social body." Tagg, *Burden of Representation,* 174.

51. Stephen Eisenman, *Gauguin's Skirt* (London: Thames & Hudson, 2000), 19.

MARY ROBERTS

THE LIMITS OF CIRCUMSCRIPTION

> Most of the photographs taken [by European photographers] for sale in
> Europe vilify and mock Our Well-Protected Domains. It is imperative that
> the photographs to be taken in this instance do not insult Islamic peoples
> by showing them in a vulgar and demeaning light.[1]

This directive, issued in 1892 by Sultan Abdülhamid II, eschews the demean-
ing stereotypes of European Orientalist photography, circumscribing a distinct
Ottoman engagement with the medium. The result of the sultan's directive
was the immense, multivolumed representation of the modernizing Ottoman
Islamic state that was gifted to the Library of Congress in 1893. As Selim Deringil
has noted, this and other interventions by the sultan and his diplomatic repre-
sentatives in Chicago at the 1893 World's Columbian Exposition constituted
an Ottoman critique of Orientalist representation.[2] In recent years, the analy-
sis of photography by practitioners and patrons from the Middle East region
has challenged how Orientalist photography is defined, with the emergence of
the terms *Ottoman, Persian,* and *Ottoman-Egyptian*—among other alternative
nomenclature—for these regional subcategories of nineteenth-century photog-
raphy. In this context, the Abdülhamid II albums, dubbed an "imperial self-
portrait," have been central to creating a definition of Ottoman photography.[3]

Despite this proliferation of subcategories, the distinctions between them and
Orientalist photography remain disputed and unstable.[4] There is, for example, no
securely identifiable canon of works or practitioners, even though the work of
some photographers more clearly inhabits the category of Ottoman rather than
Orientalist photography. The Istanbul-based Ottoman-Armenian firm Abdullah
Frères was appointed as the official Ottoman court photographer in 1863 and
produced many photographs of the sultan and Ottoman elites while also creat-
ing exotic images that catered to the sensibilities of the European tourist trade.
Some photographs within their oeuvre more securely inhabit one category over
another—a generalized photograph of an "odalisque" by Abdullah Frères rep-
resents European Orientalist exoticism, whereas the honorific portraits of the
Ottoman royal princesses and other members of the royal household, produced
by the same studio, are designated as Ottoman photography. Moreover, there

are subsets of photographs that dwell in both categories. One has only to glance through books published under these two labels to see that as bodies of works, Ottoman and Orientalist photographs are by no means mutually exclusive. These had, and have, morphing boundaries, creating a compelling reason for locating such photographs within their precise historical contexts in order to map their movement between categories and trace the processes of boundary formation.

In this essay, I approach this issue through a case study of Sultan Abdülaziz's use of photographic portraiture as a tool of Ottoman statecraft in the 1860s. Abdülaziz was the first of the Ottoman sultans to embrace the medium for this purpose. His successor, Sultan Abdülhamid II, was notoriously reluctant to sit for his own portrait, but during Abdülaziz's reign (1861–76) the sultan's portraits were germane to the creation and dissemination of the empire's image both at home and abroad. Focusing on these portraits situates us clearly within the category of Ottoman photography, perhaps in its heartland. The construction of a modern identity of the Ottoman ruler and the state was at stake in the production and reception of the portraits, as was a historiography of the empire. Their formation and reception was, however, also imbricated within the field of Orientalist photography. Here, I investigate the ways in which the invention of the Ottoman regal photographic portrait, its aesthetics and politics, was formed and re-formed throughout the 1860s by alternating processes of circumscription and negotiation. Doing so reveals processes by which particular definitions of Ottoman photography (whether implicitly or explicitly) were fashioned both in the nineteenth century and more recently.

Affiliation

Two international exhibitions in the 1860s, the Ottoman General Exposition of 1863 and the Exposition Universelle of 1867, were key occasions for the promotion of the sultan and his empire through photography. The Abdullah Frères studio was commissioned for both events. Scant records remain of the photographs at the first exhibit, held in Istanbul in 1863, but there is sufficient documentation related to the Ottoman photographic display at the Paris exposition of 1867 to give us a sense of how this image of empire was staged.[5] The contemporary account by Salahéddin Bey attests to the centrality of Sultan Abdülaziz's photographic and painted portraits in the Ottoman displays. For Abdülaziz, royal portraiture formed a hinge between the long-standing tradition of representing the Ottoman sultans in painting and his embrace of the modern medium of photography.[6]

The photograph of Abdülaziz (fig. 1) was hung among a carefully chosen grouping of eminent Ottoman and French political and religious figures, as

Fig. 1.
Abdullah Frères (Ottoman photography and painting studio, 1858–99).
Sultan Abdülaziz, 1863, albumen print, 20.3 × 16 cm (8 × 6⅜ in.).
Istanbul, Ömer M. Koç collection.

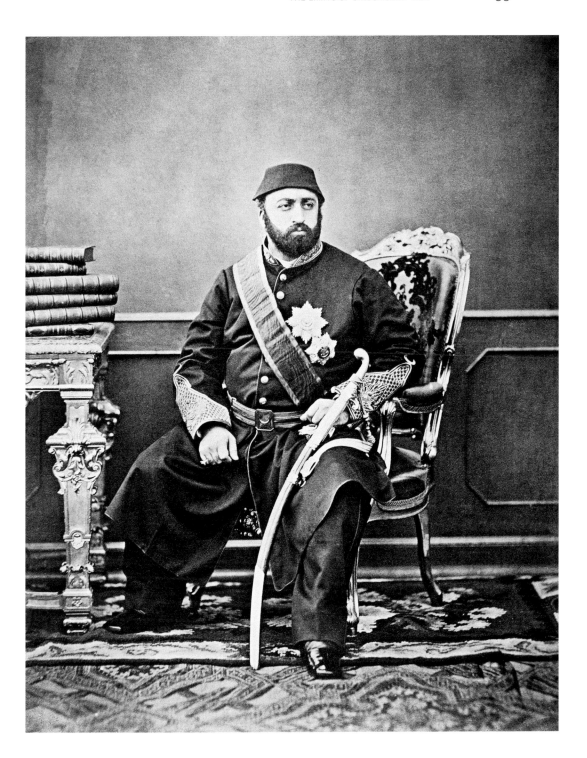

well as key players in the sphere of Ottoman economy and finance. Members of the European diplomatic community were represented, including the Belgian consul and the Marquis de Moustier, the French foreign minister and former ambassador to the Sublime Porte. The photographic installation coincided with the sultan's state visit to the Paris exposition as the invited guest of Napoleon III—the first-ever visit of an Ottoman sovereign to Europe. These photographs, together, were a visual assertion of the ideals of affiliation and alliance that the sultan was seeking to bolster as part of this important trip. The sultan himself articulated the diplomatic objectives for his journey in a speech he delivered in London, where he asserted that the aim was "to establish, not only among my own subjects, but between my people and the other nations of Europe, that feeling of brotherhood which is the foundation of human progress and the glory of our age."[7] Despite the mismatch between this diplomatic rhetoric and the realities of the political tensions and economic inequalities between the Ottoman Empire and the most powerful European states during this period, both the oratory and the visual statements delivered a clear message about the Ottoman Empire's claim to an equal standing among the community of European nations.[8]

Portraiture was not the only genre brought into service in the Ottoman photographic display in Paris in 1867. A range of photographs of costumed figures demonstrated the empire's diversity, while cityscapes showcased the architectural splendors of its capital. Two of the four panoramas were taken from the Serasker (Beyazıt) Tower. Radiating out from the Ottoman military headquarters, these panoramas encompass the famous monuments of the old city in the midground, including the Hagia Sophia and the great royal mosques, and look in the distance toward Galata and across to the Asian shore. This was a symbolic vantage point of Ottoman power. Indeed, deliberate and careful choices were made in the photographic staging of the Ottoman Empire in Paris in 1867: everything pivoted around the image of the sultan. Here was photography, Ottoman photography, used to delineate an image of empire.

I am struck by the parallel between the logic of this 1867 installation and the structure of Bahattin Öztuncay's landmark Ottoman photography survey book published in 2003.[9] In a surprising echo of the Ottoman approach to photography in 1867, the sultan's portrait is the first and framing image in Öztuncay's second volume of illustrations, titled *The Album,* and the panorama section in this same volume commences with one taken from the Serasker Tower. Additionally, some of the many familiar Orientalist "types" are included in the section titled "Costumes, Professions and Street-Sellers" and are framed in Öztuncay's introductory paragraph in terms that assert the authenticity of the costumes and their importance as contemporary "documentary evidence."[10] Such a gesture

Fig. 2.
Joseph-Philibert Girault de Prangey (French, 1804–92).
Alay Köşkü (kiosk of processions), Constantinople, 1843, daguerreotype, with frame: 9.5 × 8.1 cm (3¾ × 3¼ in.). Los Angeles, Getty Research Institute.

self-consciously repositions what have elsewhere been designated as Orientalist photographs within an Ottoman history of photography. In Öztuncay's text, the import of photography into the Ottoman capital is noted as historically coterminous with the sultan's patronage of portrait painting and the court's ongoing role as "an important driving force of the visual arts in the empire."[11]

Öztuncay's approach to Ottoman photography forms a historiographic counterpoint to recent surveys of Orientalist photography. Portraits of the sultans authorize Ottoman photographic history but have no such role within the corpus of Orientalist imagery created by histories of the subject. This latter approach is exemplified by Ken Jacobson's book *Odalisques and Arabesques* (2007): palace architecture rather than modern regal portraiture signifies the Ottoman sultanate, as seen in the inclusion of rare photographs of the Topkapı Palace interior and an early daguerreotype of the palace's Alay Köşkü (kiosk of processions), all of which inscribe an exotic and traditional image of the sultans (fig. 2).[12] The ruler's vantage point onto public ceremonies through the exterior wall of the Topkapı Palace that we see in this daguerreotype continued to fascinate European travelers (despite the fact that this was no longer the main royal residence by the mid-nineteenth century) because it appealed to the imagination by invoking the sultan's intriguing and powerful position of seeing without being seen.[13] In Jacobson's book, architecture as panoptic screen operates as a provocation to desire in a contemporary legacy of the Orientalist impulse.

Proliferation

The pathway to the production of the first Ottoman royal photographic portrait was fraught. Initial sittings for photographs produced by local French photographer Jules Derain produced unsatisfactory results that were interdicted by Sultan Abdülaziz. After this, the Abdullah Frères studio was engaged.[14] From his first portrait sitting onward, Sultan Abdülaziz circumscribed what constituted an Ottoman royal photographic portrait and in doing so drew on iconographic and symbolic precedents. The dignified informality of the pose in the Abdullah Frères photograph, I would argue, has a precedent in David Wilkie's portrait of the sultan's immediate predecessor, Sultan Abdülmecid, who had also been actively involved in negotiating the precise details of his representation (fig. 3).[15] The similarities between this painting and the photographic portrait are evident in the European furnishings, full dress uniform, indirect gaze, and, particularly, the relatively informal seated pose each sultan has adopted.

The choice to wear two orders embeds Sultan Abdülaziz's portrait photograph within a nuanced codification of Ottoman imperial ideology. The lower breast badge was created at the behest of Sultan Abdülmecid. This eponymous

Fig. 3.
David Wilkie (Scottish, 1785–1841).
Abd-ul-Mejíd, Sultan of Turkey, 1840, oil on panel, 80.7 × 58.4 cm (31 7/8 × 23 in.). United Kingdom, The Royal Collection.

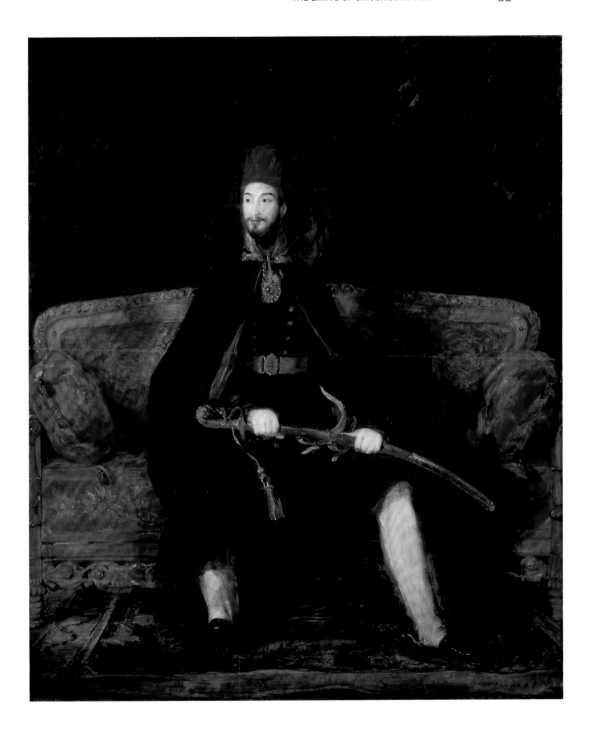

order, the Mecîdî, has in its center the sultan's *tuğra* (calligraphic monogram) surrounded by the Ottoman inscription "Patriotism, zeal, loyalty."[16] The breast badge above it, recently introduced by Sultan Abdülaziz himself, was named the Osmânî, in a dual reference to the Ottoman state and its founder, Osman I. With this order, Abdülaziz emphasizes his role as caliph, or religious leader, through the color green and the inscription in Arabic that reads "Abdülaziz Khan, Sovereign of the Ottoman state, who relies on Divine Guidance."[17] This was, as Edhem Eldem argues, "a statement of 'Imperial Ottomanism,' with a heavily pronounced Islamic dimension, as if to counter the more liberal and secularizing tendencies of the preceding reign."[18] Abdülaziz's profile portrait was also an integral part of this internationally focused numismatic state symbolism. His profile shot, initially created as a template for the medal that celebrated the sultan's visit to London in 1867, was also released as a *carte-de-visite* (fig. 4) and subsequently used for a cameo that is now in the Topkapı Palace collection.[19] The profile format is a historicizing gesture that recalls the coins and cameo portraits of the ancient Greeks and Romans as well as earlier Ottoman precedents. All of this attests to the enmeshing of the sultan's photographic portraits within a complex cross-media visual field and an elaborate system of Ottoman statecraft that operates in a historicizing mode.

Although I am arguing for a connection between the long-standing tradition of the sultan's painted portraits and those photographs that he approved as royal portraits, the photographs are profoundly unlike paintings because of the particular contingencies of the photographic process. The time that it took to sit for a photographic portrait was unlike a sitting for a painter. The painted portrait is accrued in parts, often over multiple sittings, and can be subject to protracted choices and modifications by both sitter and painter as the process is unfolding. This is particularly true when that sitter is a royal patron with a canny sense of the visual arts and a willingness to intervene in the painter's work, as Abdülaziz was. Himself a painter, Abdülaziz directly intervened in the sketches for the battle scenes he commissioned from his palace painter Stanisław Chlebowski. The sultan's assured markings in red ink over the Polish artist's preliminary pencil sketches (evident, for example, in fig. 5) indicate that he was instructing the painter to create a more energetic, dramatic representation of armed combat by accelerating the forward thrust of the central Ottoman figures on horseback and through an increased massing of combatants on the ground to the right. Given this level of minute intervention, it seems reasonable to presume that Abdülaziz was similarly interventionist in his photographic portrait sittings. However, the moment in front of the camera was one of uncertainty; it was impossible to predict whether the result would constitute an imperial portrait. Therefore, numerous shots were taken—always more photographs than were selected and

Fig. 4.
Abdullah Frères (Ottoman photography and painting studio, 1858–99).
Sultan Abdülaziz, ca. 1869, carte-de-visite, 10.6 × 6.2 cm (4¼ × 2½ in.).
Los Angeles, Getty Research Institute.

designated as the official portraits. In producing the imperial image photographically, there was an excess. The sultan's photographic portraits were often augmented through processes of circumscription, supplementation, and framing. Even when the designated official photographic portraits were used as models for some of the sultan's painted portraits, there are numerous small corrections to the indexical contingencies registered in the photographs. The photographic medium offered an unparalleled opportunity for the dissemination of the sultan's image, yet this proliferation brought with it challenges for containment.

Riposte

When Sultan Abdülaziz commissioned and circulated his photograph in 1863, portraits of the dynasty's earlier rulers had already been photographed and widely disseminated (fig. 6). On 18 December 1862, in the local Ottoman newspaper *Tercüman-ı Ahval,* Abdullah Frères advertised the sale of cartes-de-visite of the Ottoman dynasty, which were available for purchase for five piastres each.[20] Here was a new form of dissemination of an earlier representation of the sultanate; furthermore, it was a contested historiography of the empire that had already been subject to a series of cross-cultural appropriations and reappropriations.

These are photographs of mezzotints made from gouache portraits that were derived in part from eighteenth-century miniature portraits of the sultans.[21] Abdülaziz's photographic portrait was included alongside this dynastic lineage within the Abdullah Frères catalog, disrupting any secure distinction between painted, printed, and photographic portraits of the sultans while simultaneously situating Abdülaziz's photographic portrait within a visual history of the Ottoman Empire. The history of the print album from which these photographs were taken is needed in order to understand the cartes-de-visite in terms of Ottoman historiographic reappropriation.

The photographs come from an album of mezzotint portraits published in 1815 that is known today as the Young album.[22] In 1862, when the photographs were released, multiple versions of this album were held in the Topkapı Palace archive, but they had been for sale in London in a modified form since 1815. Their release as cartes-de-visite ensured their broader dissemination to local and foreign audiences. The prints made in London by John Young under commission from the reigning Sultan Selim III were based on the gouache portraits of the Ottoman-Greek artist Konstantin Kapıdağlı sent from the Topkapı Palace in 1807. Young's work on this project was highly circumscribed by the sultan, with the requirement that all prints and engraved plates be given to his agent and that "the pictures were, on no account, to be exhibited publicly or privately."[23] The album was intended for presentation to Ottoman statesmen and European ambassadors and monarchs. As such, it was part of Selim III's broader initiative to open up the channels of communication with Europe and end the long-standing policy of isolationism that until the late eighteenth century had characterized the Ottoman approach to foreign policy.[24]

This was a diplomatic gift with a message. A historical narrative of the Ottoman Empire is presented through the vignettes under each portrait, which signal the prestige of the respective sultans via symbolic reference to their achievements, either great military victories or contributions to public life. In the first, and largest, segment of this portrait series, the vignettes represent the consolidation of the Ottoman Empire due to military triumphs during the empire's expansionary stage; the major territorial gains are represented in the vignettes of their respective sultans (the vignette accompanying Sultan Mehmed II's portrait, for example, represents the conquest of Istanbul in 1453). The last three portraits shift away from this emphasis on territorial acquisition, presenting instead the military reform agendas of these three sultans. The reforms are symbolized in reigning Sultan Selim III's vignette, which shows a row of the sultan's New Order troops in their new European-style uniforms and a parallel row of naval vessels docked near the recently renovated naval arsenal in Istanbul—the linchpins of Selim III's controversial military reform strategy (fig. 7). The three

Fig. 7.
John Young (British, 1755–1825).
Sultan Selim Khan IIIme Vingt Huitieme Empereur Othoman, 1815, hand-colored mezzotint. From John Young, *A Series of Portraits of the Emperors of Turkey, from the Foundation of the Monarchy to the Year 1808: Engraved from Pictures Painted at Constantinople by Command of Sultan Selim the Third, with a Biographical Account of Each of the Emperors* (London: printed by W. Bulmer, 1815), pl. 29. New Haven, Yale Center for British Art, Paul Mellon collection.

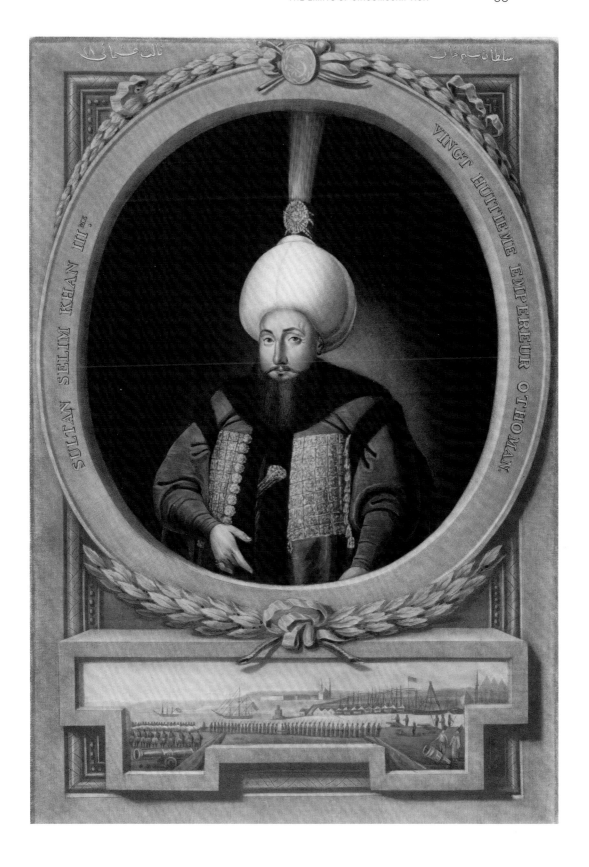

portraits of the reigning sultan and his immediate predecessors signify a sustained period of innovation and the sultans' responsiveness to the challenges facing the Ottoman Empire in this later period. The portraits that precede them locate this challenge in relation to a glorious Ottoman past.[25]

Ottoman alliances, primarily those with Britain and France, shifted dramatically over the course of the nineteenth century as the balance of power was renegotiated. Key to such alliances was a shared interest in maintaining the Ottoman Empire, albeit prompted by very different motivations. With its emphasis on negotiation, diplomacy is also an important model for the role of Ottoman visual culture in this context. Operating within the gift culture of diplomatic relations, the sultans' portraits became tools in what Richard Sennett refers to as the "soft power" of international diplomacy.[26]

The regular shuttling of portrait gifts between the Ottoman Empire and Europe in this era of diplomacy, I would argue, was part of the aforementioned process of response and counterresponse, achievement and setback. The assumed mutual ground was the language of honorific portraiture with its rhetorical aggrandizement of the respective rulers. The Young album and the sultans' portraits displayed in the Ottoman pavilion at the Paris exposition in 1867 were both part of this process. Thinking about these portraits in terms of the dynamics of diplomacy not only focuses attention on the individual gesture of a particular portrait's iconography but emphasizes instead the ways in which meaning is generated and renegotiated through the life of these images, highlighting the ritual function of the portraits.[27] The initial purpose of the Young album lent a historical dimension to this aggrandizement, enshrining the legitimacy of the reigning sultan by asserting the longevity of this powerful dynasty. So too, the reform agenda represented in the vignettes accompanying the portraits of the most recent Ottoman sultans clearly articulates the state's embrace of a modernizing imperative and asserts a common purpose with the European states.

The history of the Young album, however, speaks as much about the failures of that process of Ottoman diplomatic negotiation as it does about the efforts toward its success. As it turned out, the British printmaker was by no means simply a hired hand for the articulation of the Ottoman sultans' identity and history. The album production became caught up in both Ottoman internal and external political machinations. The album was unfinished at the time of Selim III's deposition in 1807; thus, the printmaker sought to recoup his costs by commercially releasing the album in Britain. Young made it salable to this new audience by adding a dedication to his British patron, the Prince Regent, and appending short written histories of each sultan to their portraits. These changes to the version of the album sold in London appropriated the project for

the self-aggrandizement of the British artist and his monarch. The individual histories of the last three sultans in particular are revealing in terms of a British historiography of the Ottoman Empire, confirming a trajectory of decline premised on inept, corrupt, or thwarted leadership. This was Ottoman history for a British audience.

Yet the continuing legacy of the album within Ottoman culture ensured it was further redeployed for the purposes of celebrating Ottoman history. At the same time that the album was commercially released in London, a batch without the accompanying text was delivered to Sultan Mahmud II; eighty albums from that batch still remain in the Topkapı Palace archives. (One of those albums was later augmented with printed and photographic portraits of subsequent sultans and used as a model for many later paintings of the dynasty.)[28] This is the backstory to their reproduction as cartes-de-visite in 1862 and why I would argue that these cartes were a gesture of Ottoman historiographic reappropriation. In this context, the Young album entered yet another image economy.[29] Unlike the London version of the album, these cartes are divested of their text. But they also differ from the albums held in the Topkapı archives. Miniaturized and reproduced without the clarity of the large mezzotint format, the symbolism conveyed through the vignettes is barely legible. Given their affordability, the cartes were within the reach of a much wider local and foreign audience than either the deluxe mezzotint albums that Young sold in Britain or those secluded in the sultan's collection.

The provenance of the Young album cartes-de-visite in the Getty Research Institute's Pierre de Gigord collection is unknown. However, the signs of handling, the wear and tear on their surfaces, the fading black stain marks, and especially the pinholes are enigmatic indications of their history of display and robust use before they entered the archives. For an Ottoman audience, these portable, scaled-down photographic reproductions offered their owners an intimate access to Ottoman imperial history. They provided a historiographic context for Sultan Abdülaziz's photographic portraits. Yet this narrative was just one on offer to the consumer in the Abdullah Frères shop. Once the portraits were no longer bound in a predetermined order within a print album, the consumer was at liberty to weave all sorts of alternate narratives. The imprecision in our ability to account for the circulation of these cartes-de-visite prior to their entry into the Gigord collection is a testament to the openness and mutability of these framing processes.

Sold separately, the photographs were subject to the combinatory preferences of individual consumers as they assembled their own albums. Such choices dislodged the royal image from any aggrandizing history of the empire or carefully forged associations with contemporary statecraft. In an anonymous

The Ariadne at Frankfort.

Sultan Aziz.

album in the Gigord collection, for example, Sultan Abdülaziz takes his place alongside cultural artifacts from European museums, such as the nude sculpture of Ariadne in Frankfurt (fig. 8). This page, which also includes an image of an unidentified member of the legal fraternity, seems to be a rather randomly arranged traveler's assemblage of foreign curiosities that evacuates associations of the grandeur of empire from the Ottoman sultan's photograph. In a more obviously Orientalist vein, a photograph of the Egyptian khedive Ismail Paşa was placed alongside a studio "odalisque" in a different album in the Gigord collection (fig. 9). Like Sultan Abdülaziz, the khedive was adept at the manipulation of his own visual image in the service of statecraft. Here, however, he is associated not with contemporary politics but with the more familiar Orientalist stereotype of the despot and his harem, and yet its photographic evocation is disjunctive given the khedive's sartorial choices. In these two examples we see the image of the Ottoman sultan and the Egyptian khedive in the semantic slide from an Ottoman or Ottoman-Egyptian to an Orientalist narrative.

I have addressed three impulses in relation to the production and circulation of Sultan Abdülaziz's photographic portraits: affiliation, proliferation, and riposte. The public display of Sultan Abdülaziz's photograph within the Ottoman pavilion at the Paris exposition of 1867 positioned his portrait as the linchpin within a network of Ottoman-French political relations. In this context, Ottoman photography was a tool for asserting the Ottoman Empire's place

Fig. 8.
The Ariadne at Frankfort (top left) and *Sultan Aziz* (lower right), n.d.
Page from untitled album, page: 30 × 22.4 cm (11⅞ × 8⅞ in.).
Los Angeles, Getty Research Institute.

Fig. 9.
Photographs of odalisque (left) and *Khedive Ismail d'Egypt* (right), n.d.
Loose page formerly bound in an album, each photograph: approx. 13.4 × 9.6 cm (5⅜ × 3⅞ in.); page: 19.4 × 31.2 cm (7⅝ × 12⅜ in.).
Los Angeles, Getty Research Institute.

among the community of European nations. The central role of the sultan's portrait within this network of affiliations was also a formative proposition about Ottoman photography. The sultan's authorizing role within this arrangement has parallels with the function of his portrait in recent accounts of Ottoman photography and is one of the ways this category of representation has been differentiated from Orientalist photography.[30] Sultan Abdülaziz's photographic portraits were embedded in a cross-media visual field, drawing on and modifying precedents for the Ottoman regal image in paint and print. Yet as a distinct process of production of the royal portrait, the proliferative tendency of the medium necessitated procedures of containment for the Ottoman state wishing to present a carefully orchestrated, respectful image of the sultan. When the sultan posed for his photograph, it was as yet undecided if the product would be a royal portrait. In a sense, this was a blind moment in the studio. Abdülaziz's first unsuccessful sitting for the hapless local French photographer in particular discloses the risks associated with the process. And even when the sitting was judged a success, the process resulted in an excess of nonregal images, necessitating procedures of circumscription. The photographic precursors to Abdülaziz's portrait—the Young album cartes-de-visite released in 1862—anchor Abdülaziz's photographic portrait within the empire's dynastic genealogy. The cartes incorporate symbolism that positioned the state's recent efforts at renewal (of which the embrace of photography for imperial representation was itself a sign) in relation to a glorious Ottoman past. Yet the vicissitudes of the Young album reveal processes of Orientalist appropriation and Ottoman reappropriation. When the initial intention for the album to become a tool within rituals of Ottoman-European diplomatic gift exchange was thwarted, it was reconfigured by Young for commercial sale to a British audience. The album was again repurposed when released as cartes-de-visite. This was, I would argue, both a reappropriation and a new proposition, offering a local Ottoman audience a new form of intimate access to Ottoman imperial history—thus consolidating Ottoman dynastic power. But the technology brought with it a risk, subjecting the sultan's portrait to the logic of individual consumer choices. Through this case study, Orientalist photography emerges not as an immutable category but rather as a risk or a provocation to riposte.

Abdülaziz's successor, Abdülhamid II, chose not to disseminate his portrait despite using photography extensively as part of statecraft, most famously in the Abdülhamid II albums. As Wendy Shaw notes, landscape—not portraiture—was the preeminent genre in this context.[31] Yet the impulse toward photographic representation of the sultan did not stop. In the absence of up-to-date official portraits, early photographs of Abdülhamid taken when he was a *şehzade* (prince) were customized by those among the foreign press who sought

to represent him. In some instances, a beard was added to age the sultan.[32] This, too, is a testament to the proliferative impulse of photography.[33] Such processes need to be contended with in conceptualizing the aesthetics and politics of Ottoman and Orientalist photography. In this brief analysis of the production and reception of images of the Ottoman sultanate in the age of mechanical reproduction, I have drawn attention to processes of circumscription and negotiation. Focusing on such processes underscores the ways the Ottoman imperial photographic portrait was created and disseminated within broader networks in which notions of Ottoman and Orientalist photography were and are constituted and reconstituted in relation to one another.

Notes

My sincere thanks to Ali Behdad, Luke Gartlan, Rob Linrothe, Robert Wellington, and my colleagues in the Orientalist photography research group in 2008–9. The research for this essay was supported by the Australian Research Council and fellowships at the Getty Research Institute and the Sterling and Francine Clark Art Institute.

1. Başbakanlık Osmanlı Arşivleri, Irade Hususi 878/123, 17 Muharrem 1310/12 August 1892, Yıldız Palace Imperial Secretariat no. 678, quoted in Selim Deringil, *The Well-Protected Domains: Ideology and the Legitimation of Power in the Ottoman Empire, 1876–1909* (London: I. B. Tauris, 1998), 156.

2. Deringil, *The Well-Protected Domains,* 156. See also Zeynep Çelik, "Speaking Back to Orientalist Discourse at the World's Columbian Exposition," in Holly Edwards, ed., *Noble Dreams, Wicked Pleasures: Orientalism in America, 1870–1930* (Princeton, N.J.: Princeton Univ. Press, 2000), 77–97.

3. Şinasi Tekin and Gönül Alpay Tekin, eds., "Imperial Self-Portrait: The Ottoman Empire as Revealed in the Sultan Abdul Hamid II's Photographic Albums: Presented as Gifts to the Library of Congress (1893) and the British Museum (1894)," *Journal of Turkish Studies* 12 (1988).

4. The complex and ambivalent relationship of Antoin Sevruguin's photographic oeuvre to Orientalism, for example, has been much debated over the last decade by Frederick Bohrer, Ali Behdad, and Aphrodite Désirée Navab, among others. Behdad invokes Edward Said's term *Orienteur* rather than *Orientalist* to characterize the complexity of his subject position; see Ali Behdad, "Sevruguin: Orientalist or *Orienteur?*," in Frederick N. Bohrer, ed., *Sevruguin and the Persian Image: Photographs of Iran, 1870–1930* (Seattle: Univ. of Washington Press, 1999), 79–98.

5. For an analysis of the Ottoman architectural pavilions at these events, see Zeynep Çelik, *Displaying the Orient: Architecture of Islam at Nineteenth-Century World's Fairs* (Berkeley: Univ. of California Press, 1992).

6. Salahéddin Bey, *La Turquie à L'Exposition Universelle de 1867* (Paris: Hachette & Cie, 1867), 144. The Ottoman fine arts section included portraits of Sultan Abdülaziz by Mary Walker and Ahmet Ali Efendi (during the period when this

Ottoman artist was a young student training in Gustave Boulanger's studio in Paris). The same photograph by Abdullah Frères was used as the basis for Maria Chenu's portrait of the sultan published on the front page of issue twenty of the exposition's illustrated catalog; see M. E. Dentu and M. Pierre Petit, eds., *L'Exposition Universelle de 1867 illustrée: Publication internationale autorisée par la commission impériale,* issue 20 (Paris: Imprimerie générale de Ch. Lahure, 1867), 305.

7. *The Times,* 20 July 1867, 8.

8. Taner Timur provides a thorough account of the gap between these ideals expressed through such diplomatic rhetoric and the political and economic realities of this visit in his articles; see Taner Timur, "Sultan Abdülâziz'in Avrupa Seyahati—I," *Tarih ve Toplum* (November 1984): 42–48; and Taner Timur, "Sultan Abdülâziz'in Avrupa Seyahati—II," *Tarih ve Toplum* (December 1984): 16–25.

9. Bahattin Öztuncay, *The Photographers of Constantinople: Pioneers, Studios and Artists from 19th-Century Istanbul,* 2 vols. (Istanbul: Aygaz, 2003).

10. Öztuncay, *The Photographers of Constantinople,* 2:351.

11. Öztuncay, *The Photographers of Constantinople,* 1:37.

12. Ken Jacobson, *Odalisques and Arabesques: Orientalist Photography, 1839–1925* (London: Quaritch, 2007), 189. Jacobson does, however, acknowledge the distinctive image of the Ottoman Empire created by the Abdülhamid II albums; see Jacobson, *Odalisques and Arabesques,* 55–56.

13. For a history of this dodecagonal tower pavilion, the Alay Köşkü, see Gülru Necipoğlu, *Architecture, Ceremonial, and Power: The Topkapı Palace in the Fifteenth and Sixteenth Centuries* (Cambridge, Mass.: MIT Press, 1991), 33–34.

14. This account by Abdullah Frères of the process by which they were chosen as the court photographers, written in the Armenian yearbook of 1912, is transcribed in Engin Özendes, *Osmanlı İmparatorluğu'nda Fotoğrafçılık, 1839–1919,* 2nd ed. (Istanbul: İletişim Yayınları, 1995), 225.

15. There are two versions of this painting: one in the Queen's collection, the other in the Topkapı Palace collection. David Wilkie wrote about Sultan Abdülmecid's active role during his portrait sitting as follows: "His Highness was most particular about the likeness, which, in the course of sitting, I had to alter variously, the Sultan taking sometimes the brush with colours, and indicating the alteration he wished made. The sitting was, however, continued very long—three hours, at least: worked greatly on the head, to try to make it young and lively." Allan Cunningham, *The Life of Sir David Wilkie: With His Journals, Tours, and Critical Remarks on Works of Art and a Selection from His Correspondence* (London: John Murray, 1843), 3:351.

16. Edhem Eldem, *Pride and Privilege: A History of Ottoman Orders, Medals and Decorations* (Istanbul: Ottoman Bank Archives and Research Centre, 2004), 192.

17. Eldem, *Pride and Privilege,* 217.

18. Eldem, *Pride and Privilege,* 222.

19. This cameo is illustrated in Günsel Renda, *The Sultan's Portrait: Picturing the House of Osman* (Istanbul: Türkiye İş Bankası, 2000), 526. On the production of the profile portrait in 1869, see Öztuncay, *The Photographers of Constantinople,* 1:199.

20. *Tercüman-ı Ahval,* 18 December 1862. See Öztuncay, *The Photographers of Constantinople,* 1:183–85.

21. On the precedents for these portraits, see Renda, *The Sultan's Portrait,* 474. See also her other important essays on the Young album: Günsel Renda, "Art and Diplomatic Relations: The Story of an Ottoman-British Project in London," in *Cultural Encounter and Cultural Differences: First International Hacettepe Conference* (Ankara: Hacettepe University Research Center for British Literature & Culture, 1999), 227–38; and Günsel Renda, "Selim III's Portraits and the European Connection," in *Art turc: 10e congrès international d'art turc* (Geneva: Fondation Max Van Berchem, 1999), 567–77.

22. John Young, *A Series of Portraits of the Emperors of Turkey, from the Foundation of the Monarchy to the Year 1808: Engraved from Pictures Painted at Constantinople by Command of Sultan Selim the Third, with a Biographical Account of Each of the Emperors* (London: William Bulmer, 1815).

23. Young, *A Series of Portraits,* 2.

24. M. Şükrü Hanioğlu, *A Brief History of the Late Ottoman Empire* (Princeton, N.J.: Princeton Univ. Press, 2008), 47.

25. As historians of the Ottoman Empire have demonstrated, by the nineteenth century Ottoman historiography had a long and complex history, and it is within this context that the vignette's celebratory narrative is to be situated. The literature is extensive; see, for example, Cemal Kafadar, "The Myth of the Golden Age: Ottoman Historical Consciousness in the Post-Süleymânic Era," in Halil İnalcık and Cemal Kafadar, eds., *Süleymân the Second and His Time* (Istanbul: Isis, 1993); Cemal Kafadar, *Between Two Worlds: The Construction of the Ottoman State* (Berkeley: Univ. of California Press, 1995); Colin Heywood, "Between Historical Myth and 'Mythohistory': The Limits of Ottoman History," *Byzantine and Modern Greek Studies* 12 (1988): 315–45; Michael Ursinus, "Byzantine History in Late Ottoman Turkish Historiography," *Byzantine and Modern Greek Studies* 10 (1986): 211–22; Michael Ursinus, "'Der schlechteste Staat': Ahmed Midhat Efendi (1844–1913) on Byzantine Institutions," *Byzantine and Modern Greek Studies* 11 (1987): 237–43; Michael Ursinus, "From Süleymân Pasha to Mehmet Fuat Köprülü: Roman and Byzantine History in Late Ottoman Historiography," *Byzantine and Modern Greek Studies* 12 (1988): 305–14; and Ercüment Kuran, "Ottoman Historiography of the Tanzimat Period," in Bernard Lewis and P. M. Holt, eds., *Historians of the Middle East* (London: Oxford Univ. Press, 1962), 422–29.

26. Richard Sennett, *The Craftsman* (New Haven: Yale Univ. Press, 2008), 171.

27. For an extended analysis of the Young album and its transcultural history, see Mary Roberts, "Divided Objects of Empires: Ottoman Imperial Portraiture and Transcultural Aesthetics," in Julie F. Codell, ed., *Transculturation in British Art, 1770–1930* (Aldershot, U.K.: Ashgate, 2012), 159–75.

28. I am grateful to the staff at the Topkapı Palace archives for facilitating my access to their copies of the Young album in 2005.

29. Audiences' ongoing interest in the cartes is suggested by the studio trademark on the back of many of them, indicating that the cartes continued to be released during the period when the photography studio was appointed as the official

photographer for the Ottoman Palace. Whether or not the sultan directly approved the first production run of these cartes is unknown. However, it is unlikely that the studio would have proceeded without an understanding that they would have received the tacit support of the palace, because any offense in those quarters was a highly risky undertaking for their business interests in the Ottoman capital (as the studio was to find out in later years during the reign of Sultan Abdülhamid II). See Öztuncay, *The Photographers of Constantinople,* 1:219–22.

30. In this essay, I am investigating the complexities of elite and royal patronage within the history of Ottoman photography and the way this official Ottoman embrace of the medium in the nineteenth century has inflected the historiographic priorities of some histories of Ottoman photography. In recent years, scholars have also investigated the interstices of Orientalist and Ottoman photography to consider nonelite Ottoman audiences and specific community engagements. See, for example, Michelle Woodward's concept of the Ottoman community portrait in her article "Between Orientalist Clichés and Images of Modernization: Photographic Practice in the Late Ottoman Era," *History of Photography* 27, no. 4 (2003): 363–74, and Nancy Micklewright's analysis of the engagement with photography by some of the Sufi communities in Istanbul; Nancy Micklewright, "Dervish Images in Photographs and Paintings," in Raymond Lifchez, ed., *The Dervish Lodge: Architecture, Art, and Sufism in Ottoman Turkey* (Berkeley: Univ. of California Press, 1992), 269–83.

31. Wendy Shaw, "Ottoman Photography of the Late Nineteenth Century: An 'Innocent' Modernism?," *History of Photography* 33, no. 1 (2009): 84.

32. Bahattin Öztuncay, *Hâtıra-i Uhuvvet: Portre fotoğrafların Cazibesi, 1846–1950* (Istanbul: Aygaz, 2005), 92.

33. My thinking about this issue has been influenced by Geoffrey Batchen's reflections on photography's processes of reproduction in relation to the Derridean concept of dissemination. See Geoffrey Batchen, "Repetition and Difference: The Dissemination of Photography" (Visible Presence Symposium, Oakley Center for the Humanities, May 2010).

NANCY MICKLEWRIGHT

ALTERNATIVE HISTORIES OF PHOTOGRAPHY IN THE OTTOMAN MIDDLE EAST

This paper is part of an ongoing conversation about the histories of photography in the Middle East that began as a research project on Orientalist photography at the Getty Research Institute. A research group was convened shortly after the Research Institute's acquisition of the Ken and Jenny Jacobson Orientalist photography collection. While that collection was in many ways the focus, the issues at the core of the project demanded the consideration of the full photographic record, not just those held in a single collection—no matter how large or spectacular. Thus, members of the group discussed many photographs and collections over the course of their time together. One of those was a second assemblage of photographs from the Middle East also in the Research Institute, the Pierre de Gigord collection of photographs of the Ottoman Empire and the Republic of Turkey, which had been acquired in 1996. My paper is an examination of works from that second collection, but before going further, I would like to begin by saying a few words about how I see the Gigord and Jacobson collections.

The two collections share some important similarities, including a certain overlap in images, image types, and photographers, but they also embody striking differences. In terms of similarities, they were assembled at about the same time by private individuals, European men in each case, who worked primarily through the art market. Pierre de Gigord began collecting earlier and bought quite a lot of his collection in antique markets in Turkey, while Ken Jacobson seems to have focused mostly on the European market. Apparently, the two men often encountered each other in the course of their collecting activities. The collections are very extensive, although the Gigord collection is the larger of the two (it contains approximately six thousand photographs while the Jacobson has about forty-five hundred), and each has a book published that illustrates its contents.[1] The time period and general focus of the collections are similar, but the specific collecting interests were different, as were details of Gigord's and Jacobson's respective collecting practices. In each case those differences had a significant impact on the shape of the collection and the histories of photography most obviously revealed by them.

In the preface to the book about his collection, Ken Jacobson points out that he wanted to claim a place for this photography (meaning Orientalist

photography) on the basis of its aesthetic and emotional merits within the larger history of photography. He is captivated by the exotic qualities of this material (using the word *exotic* frequently and uncritically) and states that as a collector, he privileges the aesthetic qualities of the photograph over balanced coverage of the region. As a result, his collection contains many more images of people than of places, and more of North African and Egyptian subjects than of Anatolian.[2]

Pierre de Gigord and his collection of photographs were the subject of two articles in the popular French press in 1993, and while these do not address Gigord's motivations for assembling his collection in as much detail as Jacobson does in the preface to his book, they are nonetheless illuminating.[3] Gigord describes himself as captivated by Istanbul ("Come evening, from the heights of Galata or the café Pierre Loti, I contemplate the expiring rays of the sun gilding minarets and cupolas")[4] and fascinated by the work of Orientalist writers and painters. He seems to regard historical photographs as a means of preserving a record of an Ottoman past that was fast disappearing. However, while Gigord may have begun his collecting due to a fascination with picturesque or exotic subject matter, as Jacobson did, Gigord's collecting pursuits took him in different directions. First of all, his focus is very much on the Ottoman Empire, particularly Istanbul and some of the other Anatolian cities of the empire. Although his collection contains many beautiful photographs, it also includes a great number whose primary importance lies in the information they convey or in the rarity of their subject. Gigord cast a wider net in terms of subject matter and format, and thus his collection is much more diverse than Jacobson's.

Together, these two collections contain well over ten thousand photographs, and while there is no doubt something to be gleaned from the study of each individual photograph, it is also true that the photographs gain meaning and context from their place in a specific collection. The two collections suggest different histories of photography and they privilege a certain kind of looking and engagement with the images they contain. I will return to this idea at the essay's conclusion, but now I would like to examine a few photographs.

This essay is structured around five photographs from the Gigord collection, images that I have returned to many times over the years. Individually, each image reveals particular aspects of Ottoman photography; taken as a group, they lead us into a much broader consideration of the history of photography in the Ottoman context, of how the Ottomans themselves interacted with photography, and of the Ottoman world more generally. I chose them for discussion because they each demonstrate an engagement with photography on the part

of Ottoman photographers and/or consumers that is at once self-conscious and deliberate. It is impossible to claim that these five photographs are a representative sample of the entire Gigord collection, but their particularity in style and subject matter, as well as the engagement with photographic practice that they demonstrate, nonetheless allows us to draw conclusions about Ottoman photography more generally.

I would like to begin with an exceedingly formal and official-looking portrait, an image not particularly engaging on an aesthetic level but one that does take us in very important directions in terms of understanding how photography was used in an Ottoman context (fig. 1). It is the opening image in an album commemorating the visit of Shah Muzaffar al-Dīn of Persia to the Ottoman court in 1900, and for the purposes of understanding the context and significance of the photograph, it is worth giving some attention to the album as a whole.[5] This page and the other ten pages in the album have handwritten labels in Ottoman Turkish identifying the subjects of the photographs. Additionally, this first page has notes written in German that name some of the figures and discuss the diamond in the shah's headgear. On the ten pages that follow, the Ottoman labels are transliterated into modern Turkish, all in the same messy penciled-in manner.

The portrait itself is a relatively straightforward presentation of a group of high-ranking Ottoman and Persian political figures in full military regalia, grouped around the central seated figure, the Persian shah. The photographs in this small album are arranged to present a brief narrative of the shah's visit, beginning with this official portrait and continuing through his short sailing trip along the Bosporus. Other subjects in the album include views of the shah's boat at different places during his visit, official greeting parties, and the Yalta palace where the shah stayed. The presentation of the images, one photograph to a page, on carefully lined and ornamented album boards, enhances the impact of the album, transforming the eleven photographs into something much more monumental.

The album shares significant similarities in format—album size, cover design, number of photographs—with several others in the Gigord collection.[6] Each of these albums has a red or brown cloth cover, an imperial insignia (a kind of Ottoman coat of arms that was adopted in the early 1880s), and other imperial signage on both the front and back covers.[7] The albums contain a focused presentation of images showing a certain event, usually in ten or twelve faded gelatin prints. The transliterations into modern Turkish and the other notations that were added after the albums were produced indicate the continued circulation of the albums beyond what was originally intended.

Several of this group of albums, including the one under examination, display the business card of the photographer responsible for producing them. Ali Sami Bey was chief photographer of the Ministry of the Navy and served as an official photographer for Sultan Abdülhamid II from about 1892 until the sultan's deposition in 1909. The albums' similarities in format suggest that they were a regular production, not unique objects—an idea confirmed by Bahattin Öztuncay in his 2003 work *The Photographers of Constantinople*.[8] According to the newspaper *Sabah,* Ali Sami Bey was present for the Persian shah's visit and produced commemorative albums almost immediately for presentation to the sultan and the shah, among others. The Persian ruler then commissioned Ali Sami Bey to produce twelve more copies of the album he had been given, and it seems likely that one of these ended up in the Gigord collection. As a result of this and similar projects at around the same time, Ali Sami, in his Ministry of the Navy office, was put in charge of supervising the production of other commemorative albums, using photographs that had been taken by photographers working on specific assignments across the empire.

The official photographic record of the Ottoman Empire—by which I mean compilations of photographs that document the activities of the government or of entities supported by the government, the sultan, and other official bodies— is extensive. The Gigord collection has quite a few albums and many loose photographs that fall into this category of official photography. They are a hugely important scholarly resource, demonstrating the extent to which the production and circulation of photographs had permeated the Ottoman bureaucracy, especially in the last decades of the nineteenth century, and confirming the existence of a complex communications strategy with an organizational structure and technical capability to support it.[9]

The second image we will examine also comes from an official context (fig. 2). The photograph is a collage, part of a compilation of images documenting training procedures for Ottoman firefighters. The album to which this page belongs has the same insignia on its cover as the previous album, indicating that the album was a government project of some kind and, in this case, designed for an Ottoman audience. The album is extremely worn, perhaps because it was well used in its day, or perhaps merely as the result of poor storage conditions.[10]

The twenty-six pages of the album contain photographs of marching formations of the fire brigade as well as of training diagrams, equipment, and practice drills. Although the images are rather faded, it is obvious that a great deal of care went into their creation. The training exercises they depict, such as the rescue of people from upper stories of burning buildings, would have had to be staged in order to produce the photograph; the numerous images of firefighters'

**Fig. 1.
Ali Sami Bey (Ottoman, dates unknown).**
Untitled (Muzaffar al-Dīn with his court and Ottoman dignitaries), ca. 1900, page from untitled album (Visit of Shah Muzaffar al-Dīn), image: 22.9 × 16.7 cm (9 × 6⅝ in.); page: 33.7 × 28.6 cm (13¼ × 11¼ in.). Los Angeles, Getty Research Institute.

قيه‌فيه‌ تخميم

assembly formations also required a close degree of cooperation between pho-
tographer and subjects. In a few examples, hand-drawn diagrams have been
photographed so that they could be included in the album. Page captions are
neatly written in ink and only in Ottoman Turkish, providing a further indica-
tion of the audience for whom this book was intended. The album ends with
two collages like the one shown in figure 2, all using photography in a sophisti-
cated way and with the most current technology to bring the images (and pre-
sumably the training that accompanied them) to a visual conclusion by showing
the firefighters in action.

The photograph being discussed here is the album's concluding image and
contains elements drawn from photographs that appear earlier in the album.
Beginning with a relatively straightforward view of a street in the Galata neigh-
borhood of Pera, the photograph is modified so that it illustrates a range of fire-
fighting techniques in a dramatic, action-packed scene. Firefighters marching
in formation are added at the bottom of the image, walls are cut away to show
activity within the burning building, the negative is manipulated to create a
large hose snaking through the image, and pictorial elements from staged train-
ing exercises are pasted in to simulate actual rescue action.

This photograph is compelling for at least two reasons: first, the image and
the album in which it appears provide a glimpse of the use of photography
beyond the strictly official. Apart from documenting the activities of the ruler
or the government (as seen in fig. 1), an enormous variety of other topics were
addressed in what I have been calling official photography, of which this is only
one example.[11] Second, with its use of images to demonstrate firefighting tech-
niques, equipment, and routine activities, the album in general and this image
in particular demonstrate an impressive understanding of the illustrative and
didactic potential of the medium of photography. The album includes a range
of photographic techniques, including collage, in a context that was functional
but not extravagant, so one can assume that the photo techniques incorporated
here reflected those in common usage.

Our next example comes from a much more elaborate album than the previous
two (fig. 3).[12] The photograph depicts surgery being performed on a patient
and a large group of more than forty people, carefully organized in a manner
similar to the tableaux vivants that were popular in this period. The composi-
tion has a shallow picture plane, with the wall of the military hospital serving
as a backdrop for the people arranged in front of it. The group is structured to
demonstrate a series of actions that may or may not have happened simultane-
ously during the operation but that would have taken place at some point in the
procedure. Moving from left to right across the picture plane, we see a group

Fig. 2.
Untitled (Photocollage showing
firemen evacuating apartment
buildings, Galata Tower in
background), ca. 1890.
Page from untitled album
(Fire department), image:
23 × 16.8 cm (9 1/8 × 6 5/8 in.);
page: 27.4 × 20.7 cm
(10 7/8 × 8 1/4 in.).
Los Angeles, Getty Research
Institute.

Une opération à l'hôpital d'Aghalar · Daïressi (Beyler-Bey)

of people washing their hands in a basin held by attendants; nurses and others holding instruments; men recording details of the operation; the patient himself lying on a bed or stretcher attended by a group of people; a table with a display of instruments; and, somewhat inexplicably, two small children. The back row is made up of various onlookers and officials, people who were no doubt connected with the operation of this military hospital in different capacities.[13] The photograph is a complex composition, requiring careful orchestration of a large group of people; Ottoman photographers were obviously able to create such compositions, and their subjects knew what was required of them as the photograph was made.

The photograph is part of a large album in poor condition that presents the work of the Comité central du Croissant rouge (Red Crescent Society) from 1877 to 1878, during the Russo-Turkish War.[14] The album was clearly an expensive object, carefully and beautifully designed. The leather cover, with extensive gold tooling, is much more elaborate than many albums from this period, and some of the inside pages are also decorated. The page shown in figure 4, a portrait assemblage of the members of the central committee, is designed to

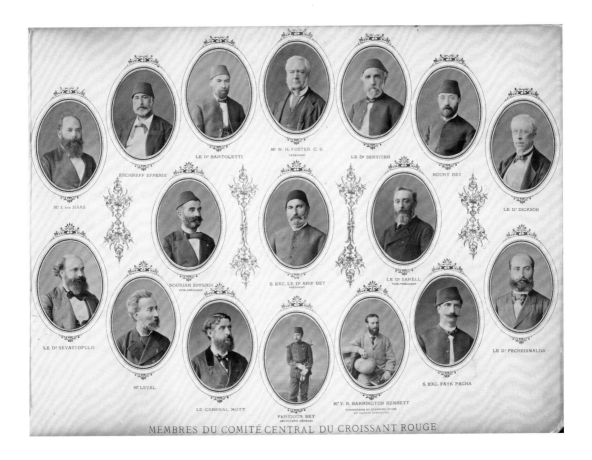

LE D? BARTOLETTI

M? W. H. FOSTER C. B.
TRÉSORIER

LE D? SERVICEN

ESCHREFF EFFENDI

NOURY BEY

M? J. von HAAS

LE D? DICKSON

NOURIAN EFFENDI
VICE-PRÉSIDENT

S. EXC. LE D? ARIF BEY
PRÉSIDENT

LE D? SARÊLL
VICE-PRÉSIDENT

LE D? SEVASTOPULO

LE D? PECHEDIMALDJI

M? LEVAL

S. EXC. FAYK PACHA

LE GENERAL MOTT

FERIDOUN BEY
SECRÉTAIRE GÉNÉRAL

M? V. B. BARRINGTON KENNETT
COMMISSAIRE DU STAFFORD HOUSE
ET MEMBRE HONORAIRE

MEMBRES DU COMITÉ CENTRAL DU CROISSANT ROUGE

accommodate seventeen oval portraits, with each person's name printed below his portrait. The next page, honoring doctors and one nurse who died in the course of their service, is similarly designed specifically to accommodate the images, with each small portrait ornamented with wreaths and garlands. From here the album goes through a tightly ordered presentation of society members' work, showing their meeting room in Dolmabahçe Palace; several of their hospitals, both in Istanbul and farther afield in Thessaloníki; the ambulance corps, including a team in Erzurum; and views of their patients.

Although there is much that we will never know about this album, we can deduce quite a lot based on the information within it. The album has a dedicatory inscription in French on the first page noting that it was given to the Comte of (an illegible word) by Doctor Pechedimaldji (whose portrait appears in the album and who was very active in the formation of the Comité central du Croissant rouge) on behalf of the Croissant rouge on 14 September 1878. Given the effort involved in the album's production (especially the design and manufacture of the portrait pages) and the inclusion of photographs taken in locations far removed from Istanbul, it seems likely that other presentation

albums were made at the same time, perhaps as part of an international fund-raising effort or to publicize the work of the society. The value of photographs in telling a story was obviously recognized by the album's compilers, and as with the firefighters' manual, the photographs themselves demonstrate an expert grasp of the medium.

With the next image in our series (fig. 5), we examine a very different kind of photograph—a single image, not part of an album, and a portrait of an individual. The subject of this photograph is positioned directly in front of the viewer with the implements of the modern bureaucrat arrayed in front of him on the desk: ink jars, blotter, basket for papers requiring attention, and other items whose exact purpose is not clear. He is working, posed as if a telephone call had just interrupted him, pen in hand, while he was recording an important piece of information in the ledger open in front of him. His attention is focused on his telephone conversation, which in turn directs our attention to his conversation, making it impossible to overlook the presence of the telephone on his desk. The central figure is immaculately dressed in a fez and a suit jacket with vest, wing collar, and tie. His glasses and neatly trimmed beard and mustache contribute to his overall appearance of calm responsibility.

This is a striking portrait for several reasons. For one, at nearly 13 × 16 inches, it is at least four times larger than most portraits of this period and lacks the ornamental cardboard frame into which portraits were commonly placed—instead, it is pasted directly onto a cardboard support. With its size, sharpness of focus, and crisp tonal range, the photograph demonstrates a remarkable technical competence. In addition, although there is a long tradition of documenting men at work or places of business in the photography of the late Ottoman Empire, these images tend to privilege traditional kinds of work (for example, itinerant merchants or craftsmen) and sites of commerce such as outdoor markets, the covered bazaar, or the shops of Pera in Istanbul—images that are plentiful in both the Gigord and Jacobson collections, by the way. Finally, with its setting, the objects chosen to be included on the desk, and the pose of the central figure, the portrait insists upon the modernity of the subject as its primary message, raising questions about the intended audience and about the image's purpose.

The candlestick telephone and the man's clothing allow us to date the image very generally between 1881 and 1910. Given the unusual subject matter, perhaps this portrait was commissioned by the man himself on the occasion of a promotion or a new job, to mark the arrival of the telephone in his office, or just to represent himself as a modern, progressive figure. But that does not explain the format of the photograph, exceeding by far the typical size for most

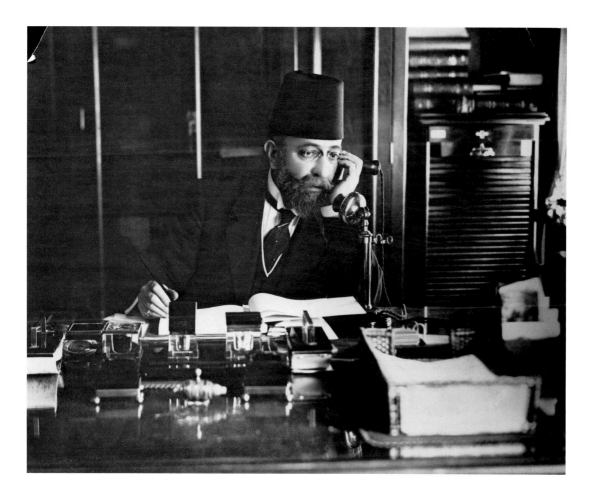

portraits, which in this period (as today) were usually meant to be included in an album or framed for display on a table or the wall. In the end, we do not know if the man or the telephone was intended to be at the center of this portrait of Ottoman modernity.[15]

Fig. 5.
Untitled (Ottoman official on telephone), ca. 1881–1910.
Gelatin silver print, 30.6 × 38.7 cm (12⅛ × 15¼ in.).
Los Angeles, Getty Research Institute.

The final image in this series of indicative photographs is a snapshot, only about 4 × 6 inches, showing us seven people in front of the camera wearing very odd clothes, neither their typical everyday dress nor the vintage clothing that might have belonged to their grandparents (fig. 6). Instead the men have on turbans, robes, and some kind of loose cloth garment under the robes, with regular belts holding their outfits together. The women are draped in what might be lightweight bedcovers or tablecloths. The three older women have scarf-type arrangements on their hair, but not regular yaşmaks. The two younger women bracketing the central group play the part of servants, one holding two coffee cups, one with a small plate of pastries. The set—because this is very obviously a staged piece—is dressed with the typical signifiers of a harem scene: a glass

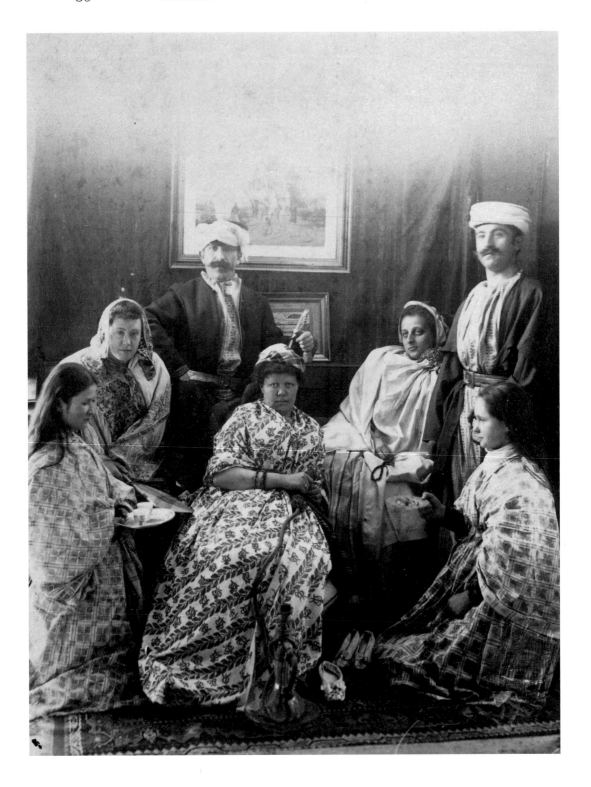

water pipe on the carpet, a long pipe, and slippers. The figures are posed in a shallow space, grouped on and around a couch against a wall. Behind the couch, the wall is draped with fabric on which is hung a large framed image, difficult to make out. Below that, leaning against the couch, is a framed page of calligraphy, most likely an *icazet,* a type of calligraphy diploma.[16]

We see some of the figures from the dress-up scene again in a different arrangement, in what seems to be a family grouping, with a house as a backdrop (fig. 7). The group of nine is tightly organized around the man seated in the middle, who wears some kind of military uniform with a sword across one knee. He is flanked on his left by two small boys. The group is arranged in a manner that suggests close relationships between the group's members: the two little boys leaning against the man in the center; the two women sitting to the man's right; and the three women immediately behind him. (A ninth figure, who is female, is only partially visible.)

These are two of a series of fifty-nine snapshot-type images, dated between about 1890 and 1910 on the basis of the women's clothing.[17] The photographs were probably made using a simple box camera, the kind that began to be generally available beginning in the 1880s. Based on the ages of the people in the images and the clothing they are wearing, it is clear that the photographs were all taken in close succession. This little group of snapshots includes a range of

Fig. 6.
Untitled (Ottoman family), ca. 1890–1910.
Snapshot, 13.7 × 10.6 cm (5⅜ × 4¼ in.).
Los Angeles, Getty Research Institute.

Fig. 7.
Untitled (Ottoman family), ca. 1890–1910.
Snapshot, 11.1 × 16.5 cm (4⅜ × 6½ in.).
Los Angeles, Getty Research Institute.

subject matter very similar to what one might find today in such an assemblage: parties, portraits, special events, the family's house, and so on. I believe that the gentleman wearing a military uniform in the center of this grouping is the photographer, because it was at the Imperial School of Engineers, a military academy, that photographic training was first widely available to Ottoman Muslims, and because he does not appear in many of the snapshots.

In another photograph from the series, we can see three people in the group scene from the house exterior as well as three others, again carefully posed as they drink tea and other beverages. The six figures are wearing reasonably fashionable European clothes and are sitting in the same space where the harem scene in figure 6 was staged, an indication that the harem scene was perhaps a family amusement created at the direction of the photographer or another member of the group.

Returning to that first snapshot with information gleaned from an examination of other photographs in the series, we recognize the same interior setting that appears in the tea-drinking scene mentioned above as well as in other snapshots. The faces in this scene are familiar from other images. The snapshot series includes five or six other versions of this harem scene, with the participants in varied groupings and slightly different poses. The harem scenes sold in the commercial studios of Istanbul had become a familiar trope by the late nineteenth century, signaled by the inclusion of key elements (water pipe, musical instruments, and coffeepot or teapot being among the most common) and only loosely related to the characteristics of the domestic space that Ottoman subjects inhabited. The intriguing set of images being discussed here presents a defective version of this stereotypical harem scene, staged by a family group that was apparently engaged with photography and comfortable in front of the camera. The family's parody reminds us of the ways in which different visions, different constructions of the same subjects coexisted and collided in the studios of commercial photographers in Istanbul (and elsewhere for that matter). It provides a response to those commercial tourist photographs, produced by people who were completely familiar with the standard harem scene and its individual components.

Here too in this snapshot is a collision of the different histories of Middle Eastern photography that we may encounter today. On the one hand, without understanding the Orientalist pretext—the "harem" scene—we would miss what to me is the most significant component of this photograph: the information it provides about how the people producing the image reacted to European views of them. On the other hand, the snapshots' existence also tells us about the adoption of new photo technology and reveals how Ottomans were

interacting with the medium itself. Then again, the content of several images in the series (not necessarily the ones we have examined) provides rare and crucial information about domesticity in the Ottoman context at a moment when many aspects of Ottoman life were changing. Thus, if we were to try to untangle the complex threads of information this photograph embodies, we could easily identify three separate strands—and probably more than that.

Scholars have generally come to understand that photographs are complex documents demanding careful readings and often yielding multiple interpretations and evidence in a variety of contexts. The images at the center of this essay, with their range of contexts and purposes (official court record, didactic tool, historical document, and family history, to name only a few), function as objects of study on several different levels, in some cases raising more questions than they answer, and occasionally, as in the case of the snapshots, providing unexpected insights into Ottoman society.

The alternative histories of photography referenced in the title of this essay are numerous. These could include commercial history (how photography businesses were established and spread, who the important photographers in the city were, and so on), technical history (when certain processes were adopted, why one kind of printing was more popular than another), and social history (how photography was used by the Ottomans, what class differences are seen in how it was adopted), as well as specific information about Ottoman political and social history gleaned through the study of old photographs.

Calling these histories "alternative" implies the existence of a dominant history, which, in the context of the project that generated this volume of essays, was the history of Orientalist photography in the Middle East. Certainly, that is the photography that captures the popular imagination, sells books, and fills museum galleries, so in some ways it can be considered a dominant history. I set up this alternative/dominant dichotomy—knowing full well that it oversimplifies a complex discourse and messy universe of surviving photographs—because I think we often tend to assume that such clearly delineated categories of interpretation exist. To return to one of the questions with which we began, is it possible to see beyond the Orientalist boundaries of Jacobson's collection to untangle the different histories in those photographs? Can we look at the diverse, puzzling, and sometimes worn images in the Gigord collection, together with its better-known and more beautiful subjects, to see the broadest possible range of histories in the collection? This would seem to be the responsibility of those who wish to be the interlocutors of this complex and compelling body of material, and there is much to learn from their work.

Notes

I am deeply grateful to my former Getty Research Institute colleagues Charles Salas, Thomas Gaehtgens, and Gail Feigenbaum for including me in the Orientalist photography research project, which began with the 2008–9 scholar year. The opportunity to spend time in front of the photographs in the Research Institute's Special Collections with other members of the research group was a great luxury. I would also like to thank group members Esra Akcan, Sussan Babaie, Ali Behdad, Hannah Feldman, Anne Lacoste, Rob Linrothe, and Mary Roberts, as well as Luke Gartlan, Darcy Grigsby, and Kathleen Howe for the conversations that took place over the course of our work together, from which I learned so much. The staff of the Special Collections reading room has provided the best possible support over the many years that I worked on the Gigord collection, and I am hugely grateful to them for all of their help in so many ways.

1. Ken Jacobson, *Odalisques and Arabesques: Orientalist Photography, 1839–1925* (London: Quaritch, 2007); and Gilbert Beauge and Engin Çizgen, *Images d'empire: Aux origines de la photographie en Turquie* (Istanbul: Institut d'Études Françaises d'Istanbul, 1993).

2. Jacobson, *Odalisques and Arabesques,* 11–14.

3. I thank Ali Behdad for kindly sharing this information with me.

4. "Le soir venu, du haut de Galata ou du café de Pierre Loti, je contemple les derniers rayons du soleil qui dorent les minarets et les coupoles." Unless otherwise indicated, all translations are mine. Please see "Comte Pierre de Gigord: Sur les traces de Loti," *Point de vue: Images du monde* (1993); and Marie Plaisance, "Aux portes de l'Orient," *Beaux arts,* no. 112 (1993): 38–40. Quotation from Plaisance, "Aux portes de l'Orient," 38.

5. Untitled album (Visit of Shah Muzaffar al-Dīn), ca. 1900, Pierre de Gigord collection of photographs of the Ottoman Empire and the Republic of Turkey, 96.R.14, box 38, Getty Research Institute. (Please note that many of the dates assigned to the material in the Gigord collection have not yet been confirmed by scholars.) The album measures 32.5 × 24 × 1.8 cm (12¾ × 9½ × ¾ in.). It is bound with red percaline boards decorated with embossed insignia and contains eleven gelatin silver prints mounted on decorated cardboard pages.

6. For example, there is a second nearly identical album, also the work of Ali Sami Bey, produced in 1901 to commemorate the dedication of the fountain of Kaiser Wilhelm in Istanbul. See the album titled "Inauguration of Kaiser Wilhelm Fountain and Views of SMS Moltke," 1901, Pierre de Gigord collection of photographs of the Ottoman Empire and the Republic of Turkey, 96.R.14, box 37, Getty Research Institute.

7. For a thorough account of the development and use of Ottoman insignia, see Edhem Eldem, *Pride and Privilege: A History of Ottoman Orders, Medals and Decorations* (Istanbul: Ottoman Bank Archives & Research Center, 2004).

8. Bahattin Öztuncay, *The Photographers of Constantinople: Pioneers, Studios and Artists from 19th-Century Istanbul* (Istanbul: Aygaz, 2003), 2:360.

9. The subject of Ottoman official photography has not received a great deal of attention to date. The existence of official photography is widely recognized, and photographs from various archives, contemporary publications such as the

journal *Servat-I Funun,* and material in private collections are frequently incorporated into ongoing research. So far, there has been no work focused specifically on the structures, production, and circulation of official photography within government circles and beyond.

10. Untitled album (Fire department), ca. 1890, Pierre de Gigord collection of photographs of the Ottoman Empire and the Republic of Turkey, 96.R.14, box 29, Getty Research Institute. Measuring 28.5 × 23.5 × 5 cm (11¼ × 9¼ × 2 in.), the album contains twenty-nine albumen prints mounted one per page. The volume opens from right to left, with ink captions in Ottoman Turkish. It is bound in red leather with a gold embossed insignia and other ornamentation on the cover.

11. Other photographic projects that fall into this category would include the Abdülhamid albums in the Library of Congress and the British Museum, as well as the so-called Yıldız albums, also compiled during the reign of Abdülhamid II. The Library of Congress and British Museum collections were presented to their respective governments in 1893 and 1894, and each contains about eighteen hundred photographs in fifty-one albums. In addition, the Gigord collection includes several albums documenting the construction of railroad lines across the Ottoman Empire, the operation of factories, and the art and architecture of specific regions of the empire.

12. The album measures 37.5 × 52.5 × 6 cm (14¾ × 20⅝ × 2⅜ in.) and contains fifty-one albumen prints mounted on board pages. See "Album de la société ottomane de secours blèssés militaires, guerre 1877–1878," 1878, Pierre de Gigord collection of photographs of the Ottoman Empire and the Republic of Turkey, 96.R.14, box 20, Getty Research Institute. It is dated 1878 per an inscription on the front flyleaf. In poor condition, the album is bound in brown leather with elaborate gold stamped designs on the front and back covers, including the title on the front, written as "ALBUM DE LA SOCIÉTÉ OTTOMAN DE SECOURS AUX BLÈSSÉS MILITAIRES Guerre 1877/78."

13. This photograph (and others in the album depicting patients who underwent successful surgical procedures) is very much part of a trend, also documented elsewhere, regarding the use of photography to depict medical subjects. A similar interest in the portrayal of the latest developments in medicine can be seen in paintings of the period; *The Gross Clinic* (1875) and *The Agnew Clinic* (1889), by the American artist Thomas Eakins, are among the best known of this genre. Eakins was able to depict an actual operation in progress, a feat not possible in the medium of photography. Yet the identification of photography as a science rather than an art medium lent photographs of medical patients a certain scientific authority absent in painting or drawing.

14. Although a society for the care of wounded soldiers had already been in existence for a few years, the red crescent symbol was first used in this context during the Russo-Turkish War. However, it was not officially approved for use by the International Committee of the Red Cross until 1929.

15. An earlier discussion of this photograph appeared in Nancy Micklewright, "An Ottoman Portrait," *International Journal of Middle East Studies* 40, no. 3 (2008): 372–73.

16. I have written about this group of snapshots at greater length elsewhere. Please

see Nancy Micklewright, "Harem/House/Set: Domestic Interiors in Photography from the Late Ottoman World," in Marilyn Booth, ed., *Harem in History and Imagination* (Durham, N.C.: Duke Univ. Press, 2010), 336–57.

17. The fifty-nine snapshots, dated 1890–1910, are from the Pierre de Gigord collection of photographs of the Ottoman Empire and the Republic of Turkey, 96.R.14, box 136a, Getty Research Institute.

ESRA AKCAN

OFF THE FRAME
The Panoramic City Albums of Istanbul

Photography as a new medium developed simultaneously in Europe and the Ottoman Empire. The news of a technological device that could reproduce an exact image of reality appeared in the Ottoman paper *Takvim-i Vakai* as early as October 1839, the same year Dominique François Arago presented the device to the French Académie des sciences. A certain student of Louis-Jacques-Mandé Daguerre's named Kompa (Compan?) was reported to be taking commercial photographs of passersby in Istanbul's streets.[1] The new medium immediately attracted the attention of Western travelers, architects, and engineers, who were invited to Istanbul for modernization projects, as well as local Armenian and Orthodox Greek habitants.[2] A map prepared by Engin Çizgen, which indicates the addresses of thirty photography studios on and around the Grand Rue de Pera, testifies that Istanbul had indeed become a center of photography during this period.[3]

Ottoman photography, I argue, needs to be understood as being in tension with Western Orientalism on the one hand and the disciplinary gaze of the Ottoman state on the other. I would like to examine in this article a specific visualization paradigm that emerged, despite these tensions, in the panoramic city albums of nineteenth-century Istanbul. Scholarly accounts on photographic panoramas are limited, even though a few excellent books do exist about the painted panorama—namely, the type of painting that Robert Barker received a patent for on 17 June 1787: a painting on a 360-degree circular canvas displayed on the interior walls of a large rotunda usually built for this purpose, a painting that was meant to be a realist representation of a place viewed from all angles and from the farthest possible point.[4] However, the photographic panorama, usually composed of a series of prints attached together, needs to be conceptualized and historicized for its own sake, as its commonalities with the painted panorama in the technical sense are limited. There were only a few semisuccessful attempts to make round photographic panoramas that resembled painted ones, and there were some extended painted panoramas and portable rolled panoramas that may be cited as precursors of a photographic panorama.[5] Yet it seems that today it is the photographic version, not the painted one, that evokes the "metaphorical" senses of the word *panorama,* which has been used

worldwide more popularly than its technical usage in Europe during the late eighteenth and early nineteenth centuries. The modern meaning of panorama implies a view that pans a landscape or cityscape, a view from an elevated point, or an overview of a field of knowledge (a survey).

Istanbul/Constantinople captured the imagination of panorama painters quite frequently. The first painted panorama in Spring Gardens in England, which remained on view during the summer of 1800, was titled *Constantinople* and executed by Joshua Cristall and assistant J. S. Hayward. Henry Aston Barker exhibited a panorama from the Galata Tower in the rotunda of Leicester Square in 1803. The prominent French panorama painter Pierre Prévost exhibited his panorama of Constantinople in a building on the Boulevard des Capucines, Paris, in 1825. This panorama was based on Prévost's sketches during his three-year trip (1816–19) and completed by his pupil Frédéric Ronmy and brother Jean Prévost. Daguerre, who later invented the diorama and photography, was also an assistant of Prévost's, which hints at a further link between panorama, photography, and Istanbul. Another panorama of Constantinople, by Jules-Arsène Garnier, was exhibited in Copenhagen, with C. V. Nielsen capturing the artwork's viewing platform and partial image in a wood engraving (ca. 1882). These examples withstanding, I will illustrate that Istanbul had an even stronger influence on the development of the photographic panorama, as well as a genre that might be called a panoramic city photograph, due not only to the works of Western travelers who exhibited in Europe but also to the works of local photographers who practiced the medium in Istanbul. This essay is thus meant to help revise theories of photography by foregrounding the medium's simultaneous developments in different parts of the world during the nineteenth century, thereby eschewing its mainstream conception as a medium established entirely in Europe and disseminated to the world afterward. Hence, I invest in the retheorization of photography by suggesting a conversation between the Western accounts of the medium and its parallel history elsewhere.

Western photographers who depicted the Near East rendered the staged studio tropes of exotic, seductive women and naked Oriental dancers, thus maintaining the most common Orientalist visual stereotypes already promoted in painting.[6] Such photographs as Tancrède Dumas's *Life in Harem* (1889) rebuilt the clichés of harem life through photomontage. Local photography studios in Istanbul did not refrain from staging "harem scenes" for the commercial Orientalist market, either.[7] Sébah & Joaillier's studio photograph of a veiled fellah woman with naked arms is perhaps less violent than those French colonial postcards exposing the model's naked breasts.[8] However, in both cases the veil is meant to stage her as an Oriental and, in the Ottoman case, as an

Arab laborer, and her unveiling is meant to suggest the photographer's and the audience's power over her. A portrait of a Nubian woman with naked breasts, attributed to the studio Abdullah Frères, most likely took advantage of her blindness in order to convince her to pose in front of the camera.[9] Nonetheless, these photographers had an array of subjects and formats to offer their customers, including *cartes-de-visite* and portraits of the royal family, which makes their relationship to Orientalism ambivalent because it is the exhibited subject that has some power over meaning in these cases. Architecture and cityscape views practiced through the indexical medium also complicate Orientalism in many ways.

During the reign of Sultan Abdülhamid II (r. 1876–1909), photography reached new sections of Ottoman society. A studio and lab, for instance, was set up in the Yıldız Palace for Abdülhamid himself. His daughter Ayşe later recalled choosing her prospective husband from the photographs her father sent her, testifying to the new medium's diffusion into the lives of the royal elite.[10] The sultan self-consciously employed the medium against Orientalism. In an important statement, Abdülhamid said, "Most of the photographs taken for sale in Europe vilify and mock Our Well-Protected Domains. It is imperative that the photographs to be taken in this instance do not insult Islamic peoples by showing them in a vulgar and demeaning light."[11] To this end, Abdülhamid ordered fifty-one album sets (seventeen of which were cityscape albums) to be sent as gifts to the Library of Congress and the British Museum Library in 1893.[12] These albums disseminated a self-prepared image of the sultan's empire to foreign audiences and purposefully sought to reverse the portrayal of Ottoman women and buildings in Orientalist visual culture.[13] Photographs of schoolgirls with books in their hands replaced stereotypical "harem scenes"; monuments of Istanbul's historical peninsula were given due attention, but they were complemented by schools, factories, bridges, train stations, hospitals, and especially military facilities—namely, Ottoman modernization projects—that usually attracted little attention in the European markets. Altogether, the albums were meant to portray a much more modernized and empowered image of the empire than was perceived in Europe.

Abdülhamid invested in photography not only to unmake his empire's Orientalist image but also to control the lands and populations under his reign. As Nancy Micklewright has suggested, his use of the medium exemplifies John Tagg's conceptualization of the disciplinary gaze of photography in the hands of the state.[14] Abdülhamid built the colossal Yıldız collection—consisting of eight hundred albums of thirty-five thousand photographs (probably compiled by the Turkish courtly and military photographers Ali Sami Aközer, Bahriyeli Ali Sami, and Kenan Paşa[15]—in order to document the empire in great detail for

his own ruling purposes.[16] At the time, photographers' practices were closely supervised: Western travel photographers were obliged to seek courtly permission, and some were escorted by official forces (*zabıt*) who secretly reported their "suspicious behavior";[17] numerous photographs, probably those favored in Orientalist markets, were collected and banned because of their perceived suggestive/erotic (*müstehcen*) content;[18] photographers who "shot the destroyed houses during the upheaval in the Armenian streets" were reported to the state;[19] and minority photographers in Sivas and Adana were closely watched.[20]

Such practices and forms of supervision placed nineteenth-century photography at the center of numerous debates related not only to Western Orientalism and ethnography but also to minority politics, state control, and the inner social tensions of the Ottoman Empire. The photographs portraying various subjects by these photographers have been received by different audiences both at the time of their production and thereafter. Tracing the circulation of the photographs and comparing the content of numerous collections highlights that different selections by the same artist appealed to different audiences. Despite this diversity of subject and audience, one genre seems to have made its way into each of these collections: the panoramic photographs of the Bosporus.

Architecture and cityscape were favorite topics for almost all of the prominent nineteenth-century photographers, who embarked on a project that was no less than a full inventory of the city. Regardless of ideological incentives, one can discern a notable emphasis on the Bosporus in various collections including commercial albums distributed in Europe, Abdülhamid's own collection and gifts to the West, civil collections in Turkey, and the like. When the French forces occupied the Ottoman Empire during the First World War, a French colonial album (currently in the Getty Research Institute) celebrated this victory with nothing but photographs of the Bosporus and panoramic views adjacent to the occupying military forces.[21] The myth of the Bosporus continued to inspire leading photographers of the twentieth century, including Ali Enis, Othmar Pferschy, and Ara Güler. As of June 2011, a web-based group on Facebook named Old Nostalgic Istanbul Photos had 30,096 members who had so far uploaded and discussed, in Turkish, 27,953 cityscapes. These photographs, which members must have inherited from their grandparents or collected from local books and postcards, constitute one of the largest digital and noncopyrighted collections of Istanbul photographs in the world. I will therefore treat this archive as a collection that represents local habitants' voices.

Architectural and cityscape photographs attracted audiences as diverse as Western tourists and occupying military forces, members of the Ottoman court, and contemporary and future inhabitants of Istanbul. At the time of

their production, the photographs might have appealed to both foreign and official audiences because they complied with the expectations of both, combining what the West wanted to see with what the Ottoman elite wanted the world to see. On the one hand, many of the depictions of the Golden Horn maintained the Orientalist myth of Istanbul as a beautiful, exotic, unchanging, and nonmodernizing city without the transformative power of history—very common features of latent Orientalism, as Edward Said has characterized it.[22] On the other hand, the official forces that fought against Orientalism also invested in this genre. The Ottoman Palace commissioned photographers to represent buildings and landscapes, and distributed courtly orders to help local photographers work on the shores of the Bosporus and Kağıthane.[23] These photographs constructed a peaceful, beautiful, contemplative image of Istanbul and, predictably, seldom portrayed the frequent fires, minority revolts, or other evident signs of tensions within the Ottoman Empire. Only a few such scenes fell between the cracks, such as the executions on the streets in Istanbul or the unmarked graves of victims of the Armenian massacre in the Anatolian town of Karahisar that appeared in an album prepared by a German soldier in 1917, which is currently in the Getty's collection.[24]

That said, these cityscapes, with their wide circulation and their appeal to diverse contemporary and future audiences, deserve a closer look, not least because of their unyielding power, both for local audiences later in the twentieth century and within the canon of visual history today. I would like to argue that Bosporus photographs, like those taken by Abdullah Frères, introduce a specific genre that constructs a distinct way of looking at the city perhaps not readily apparent from the viewpoint of photography's art historical canon.[25] This specific perception of the city is especially evident when the photographs are viewed together in an album that I characterize as panoramic. I use the term *panoramic city album,* or *panoramic city photographs,* not necessarily because the albums contained panoramas in the technical sense (usually images composed of two or more prints attached to each other, although some albums did include single prints taken for the purpose of a larger panorama) nor because the photographs reproduce an aerial gaze from a high point overlooking the city (although such photographs certainly made up part of the group). Rather, I use the term because these albums constructed a specific perception that marked the city as panoramic—namely, a city that viewers commonly enjoy by looking at it with a moving eye, a city where watching the view is one of the most cherished (and increasingly expansive) experiences of daily life.

Let me begin with the photographic panorama in the technical sense. James Robertson and Felice Beato's first panorama of Istanbul, photographed in the mid-1850s, was taken from the Serasker (Beyazıt) Tower rather than the more

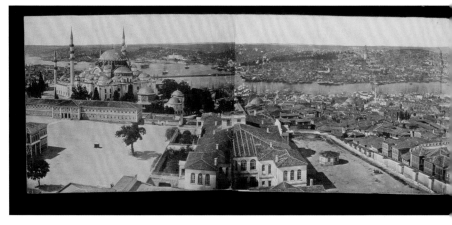

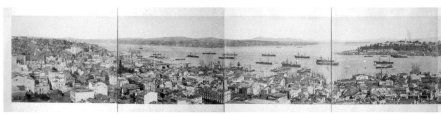

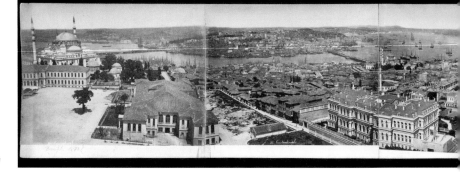

Fig. 1.
James Robertson (British, 1813–88) and Felice Beato (British, ca. 1825–ca. 1908).
Panorama of Constantinople from the Seraskier Tower, 1857, panorama formed of five salted paper prints, 24.3 × 148.2 cm (9⅝ × 58⅜ in.). Montreal, Canadian Centre for Architecture.

Fig. 2.
Guillaume Berggren (Swedish, 1835–1920).
Istanbul panorama (from the Galata Tower), ca. 1880, photograph, each panel: approx. 21.6 × 27 cm (8½ × 10⅝ in.). Los Angeles, Getty Research Institute.

Fig 3.
Bonfils family (French, act. 1800s–1900s).
Vue prise de Seraskierat, ca. 1870, photograph, each panel: approx. 21.3 × 27.3 cm (8⅜ × 10¾ in.). Los Angeles, Getty Research Institute.

favored Galata Tower. This unusual vantage point has the Bosporus at its center and emphasizes the city surrounded by three waters: the Golden Horn, the Bosporus, and the Marmara Sea (fig. 1). In contrast, almost all future panoramas of Istanbul depict the historical peninsula and the Golden Horn. Numerous panoramas from the Galata Tower by J. Pascal Sébah, Guillaume Berggren, and others adopt the same vantage point and reproduce the same composition—the same center, frame, and narrative—even though they were taken years apart (fig. 2). At first sight, the panoramas look nearly identical, maintaining the nineteenth-century myth of Istanbul as a beautiful but nonmodernizing city. It is perhaps difficult to record signs of change in the major highlights, such as the Topkapı Palace, Hagia Sophia, and Sultan Ahmed Mosque, especially when one judges from the distant and totalizing aerial view of a panorama. Nonetheless,

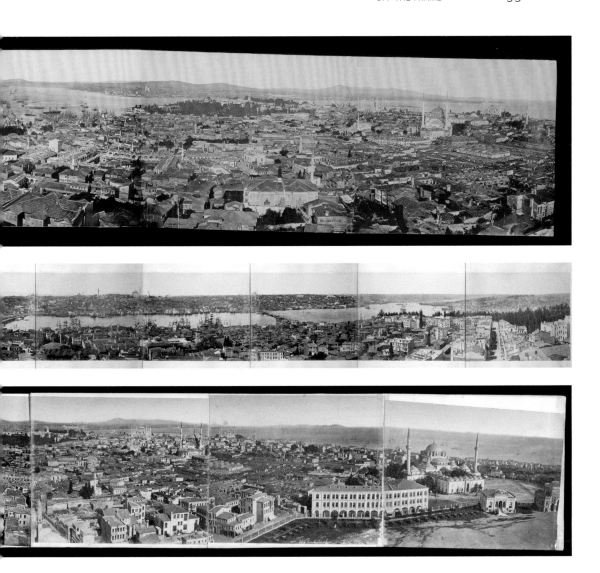

if one compares these panoramas, many features—the slowly changing urban tissue, the new modern buildings and multistory apartments, the disappearance of wooden houses and their replacement with wide roads, the debris on the ground, the renovation of some houses, the decreasing number of small boats, the growing or cutting down of trees, the transformation of the Galata Bridge and its increasing number of promenaders—do not escape a careful eye. When viewed together, the panoramas testify to the modernization of Istanbul, despite their intent to show a familiar view of an allegedly unchanging city. Another panorama, probably taken from the Serasker Tower circa 1870, also displays the transformation of the city, with modern buildings now texturing the cityscape in contrast to Robertson and Beato's earlier panorama from the same viewpoint (fig. 3; cf. fig. 1). I argue that this panoramic view of the Golden Horn was

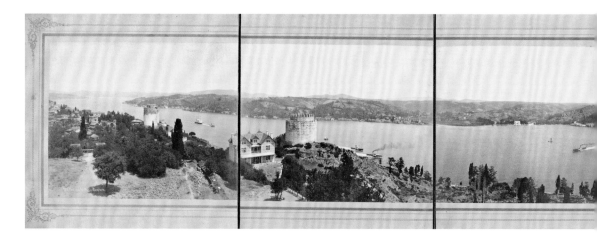

transposed to the Bosporus as well, not only in the form of actual panoramas—as in the exceptional panorama by Gülmez Frères that pans Bebek Bay and its environs (fig. 4)—but also, and more commonly, in the form of the panoramic city album.

Before considering Abdullah Frères' panoramic city photographs, a brief overview of their studio history may be useful, especially given the limited scholarship available on their influential enterprise. The eldest brother, Viçen, entered the photography studio of the German chemist Rabach in 1856, after impressing Rabach with his skills in miniature manuscript illumination. Two years later, Rabach left his studio to Viçen and Viçen's two brothers, Hovsep and Kevork. In 1863, the Abdullah brothers earned the status of court photographers to the Ottoman Empire and, during the very first decade of their commercial work, represented the empire at international expositions.[26] From 1886 to 1895, they also managed a branch studio in Egypt. As with many other minority photographers, the Abdullah brothers' relationships with the Ottoman Palace were complicated. Kevork Abdullah was politically and intellectually active on behalf of the Armenian cause, bringing together intellectuals, writers, and artists at his studio in Istanbul.[27] When Abdülhamid ascended to power in 1876, the brothers initially remained court photographers, but this status came to a close when the sultan penalized them for allegedly taking his unauthorized portrait. Abdülhamid collected these prints by force with an order on 26 December 1880.[28] The brothers' courtly status was restored in 1890, only for their studio to be seized once again two years later, charged with the claim that "Armenians photographed women dressed in various clothes offending the Muslims" (literal translation: raise suspicion in Muslims' minds).[29] These photographs were destroyed and the brothers were prohibited from such engagement. Nonetheless, Abdülhamid commissioned the brothers to compile

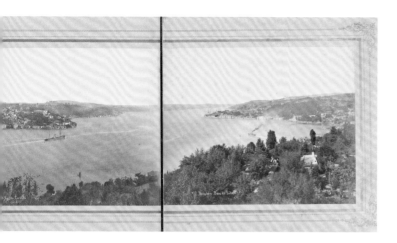

albums of Istanbul, which were presented as gifts to the Library of Congress and the British Museum Library, and for which the brothers must have shot hundreds of frames.[30] In 1900, the studio was finally sold to its competitor, Sébah & Joaillier.[31]

At first sight, Abdullah Frères' panoramic city photographs, taken both for the Abdülhamid albums and for the studio's own commercial reasons, are easy to dismiss as what Wendy Shaw has called "documents without style," or "informative but compositionally unmeaningful" attempts to represent in the absence of a tradition of representation.[32] According to Shaw, the superiority of a Western photographer was a result of his or her place in a long tradition of representation, which had taught the rules of "neat," "balanced," "meaningful" images, employing "golden mean and focal point" as well as "depth and visual balance." Lacking those compositional tools and visual traditions, Abdullah Frères, in contrast, produced random photographs that did not deserve the status of art and hence failed to "fully enter the world of modernity."[33]

However convincing Shaw's formal analysis might be, she inherits two common values of the art historical and humanist canon in her judgment of Abdullah Frères' photographs. The first is the hierarchical division between a self-contained "West" in opposition to a self-contained "Orient," the former materialized as the possessor of a tradition of representation in contrast to the latter's putative lack of such conventions. Yet Ottoman photographers were not isolated from representational traditions: Kevork Abdullah, for example, undertook an art education in Venice. Indeed, Pablo Picasso is said to have collected eight of their photographs and, in 1914, based a sketch on one of them.[34] Many Ottoman photographers inherited the visual traditions of travelers' illustrated guidebooks and travel literature.[35] Engravings of Istanbul (such as the Bosporus views and waterfront houses of Thomas Allom and, most notably, Anton Ignace Melling's *Voyage pittoresque de Constantinople et du rive de Bosphore* of 1819)

and the painted panoramas from the Galata Tower already existed at the time. Photographers transformed and adapted these visual legacies for their own purposes, making use of the new medium's possibilities.

Shaw's second criterion of judgment is based on the familiar opposition between the constructed photograph and the documentary photograph, materialized in a hierarchical manner as the artful, compositional image in contrast to the informative record without style. I do not intend to review here the extensive literature around the indexicality of photography or to examine, using Susan Sontag's germane description, its "unappealing reputation of being the most realistic, therefore facile, of the mimetic arts."[36] However, in the context of Said's critique of Orientalism as "distorted scholarship," and in the context of the seemingly realist Orientalist paintings emanating false information, we have to acknowledge that documentary photography is often invested with an antidotal power against the constructed or staged photograph. It was the relative "truthfulness" of Melling's engravings that won him a respectable place in the minds of local writers and artists including Ahmed Hamdi, Sedad Eldem, and Orhan Pamuk. As weak as the distinction between staged and documentary photograph might be, it was the informative quality of the architectural photograph that motivated, for instance, Vedad Nedim Tör to send the Austrian photographer Othmar Pferschy on an extensive tour of Anatolia to take more than ten thousand photographs in order to counter Orientalist stereotypes with a positive, proactive conception of Turkey's national image.[37] The perceived realism of documentary photography might have been a burden, at least according to some narratives of European modern art, but it was nonetheless considered a powerful tool against Orientalist stereotypes in the context of Ottoman and Turkish photography.

More importantly, I would argue that these photographs did indeed construct the "artful" convention of the panoramic city album. It is, in fact, hard to appreciate Abdullah Frères' panoramic photographs of Istanbul at first sight. Their photographs can easily be dismissed as careless and hasty. In the 1870s, why would a photographer take a carriage to the far end of Istanbul, climb the hills, prepare the camera, and wait for the exposure, just to capture an image with little discernible content other than a barren foreground, the odd randomly placed building, a distant view of the hills, and a strip of water squeezed into the frame (fig. 5)? Yet it is precisely this latter feature, this small piece of the Bosporus, that makes these photographs meaningful parts of an important visualization paradigm.

A comparative mapping of two albums will illustrate my point. I am using the word *mapping* quite literally here, since it is a cognitive mapping that gives

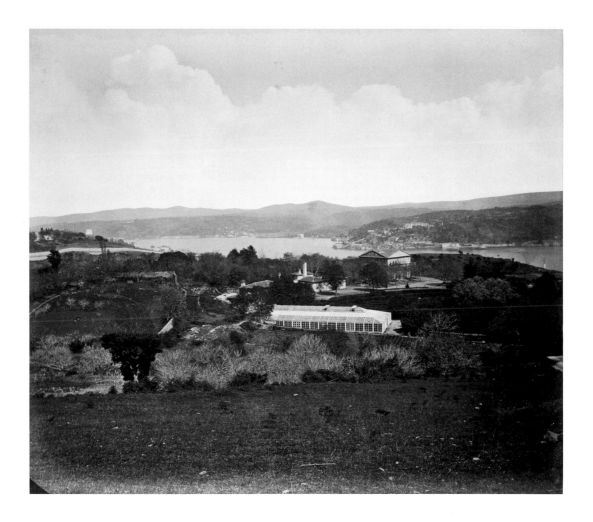

meaning to these photographs. Both albums to be discussed are exclusively composed of architectural and cityscape photographs: the first is restricted to the historical peninsula alone, while the second moves along the Bosporus and the city's new sections.

The first album, titled "Stamboul or Constantinople Proper," brings together framed, carefully sequenced photographs, each correctly captioned in English, of the well-known monuments of the historical peninsula.[38] The album's narrative intentionally moves from the gates of the Topkapı Palace to the interior of the Baghdad Kiosk and the circumcision room; it then visits the fountain of Sultan Ahmet III and, in three consecutive photographs, approaches the exterior of the Hagia Sophia. The album's sequence of photographs moves inside that building to document the entrance porch, panoramic interior, nave, galleries, *mimbar,* and other architectural details. After a few canonical photographs of the obelisk of Emperor Theodosius, the Serasker Tower and its gate, and the Süleymaniye Mosque, the album concludes with five photographs around the

Fig. 5.
Abdullah Frères (Ottoman photography and painting studio, 1858–99).
View across the Bosphorus, Constantinople, 1870s–80s, albumen silver print, 24 × 28 cm (9½ × 11⅛ in.). Montreal, Canadian Centre for Architecture.

Diagram 1.
Route tracking the locations
photographed for the
undated album "Stamboul
or Constantinople Proper" by
multiple photographers.

Fig 6.
Abdullah Frères (Ottoman
photography and painting
studio, 1858–99).
*Vue prise de Rouméli Hissar
(Bosphore), Château des
ambassadeurs, les 7 tours,*
ca. 1885, photograph from
untitled album, page: 34.6 ×
45.1 cm (13⅝ × 17¾ in.);
image: 23.8 × 29.8 cm
(9⅜ × 11¾ in.).
Los Angeles, Getty Research
Institute.

Fig. 7.
Abdullah Frères (Ottoman
photography and painting
studio, 1858–99).
*Stamboul. Vue du quai de
Boyouk Deré,* ca. 1885,
photograph from untitled
album, page: 34.4 × 41 cm
(13⅝ × 16⅛ in.);
image: 24 × 30.2 cm
(9½ × 11⅞ in.).
Los Angeles, Getty Research
Institute.

city walls that encircle the historical peninsula. Diagram 1 charts a rough itinerary of this photographic journey.

The second album, by Abdullah Frères, bears the title "Vues et types de Constantinople: Photographie d'après nature." In contrast to the previous volume, this album does not follow the above compositional rules.[39] It shifts the viewer's attention outward to the developing sections of the city and, more particularly, to the Bosporus, portrayed without captions. The album commences with courtly monuments, both on the historical peninsula and elsewhere, such as the Topkapı Palace gate, the fountain of Sultan Mihrişah in Sweet Waters, and the gate of Dolmabahçe Palace. The monuments of the historical peninsula are given their proper place and photographed with proper compositional means. These include the Azakkapı Fountain, the tomb of Sultan Mahmud, the Hagia Sophia and the Sultan Ahmed Mosque, and the obelisk of Emperor Theodosius, as well as the newer mosques of Nurosmaniye and Tophane. Thereafter, the album moves to a series of Bosporus photographs, depicting anonymous houses or cityscapes in a seemingly random itinerary but nonetheless in conversation with each other. Similar Bosporus photographs are very common in Abdullah Frères' other albums, and many still capture the imagination of modern-day residents, visitors, and Facebook fans (fig. 6). At first sight, many of the images in this album appear arbitrarily chosen and poorly framed, with no obvious focus of attention or sense of composition (see fig. 5). Taken either from a hill or from sea level, these photographs depict the facades

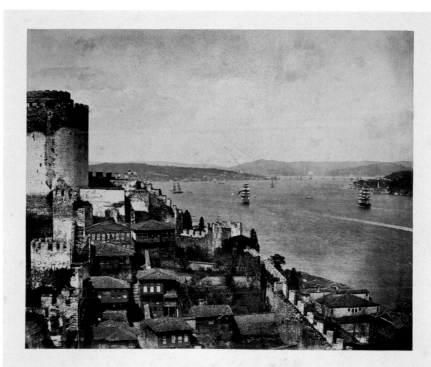

Vue prise de Rouméli Hissar (Bosphore) Château des Ambassadeurs - Les 7 Tours.

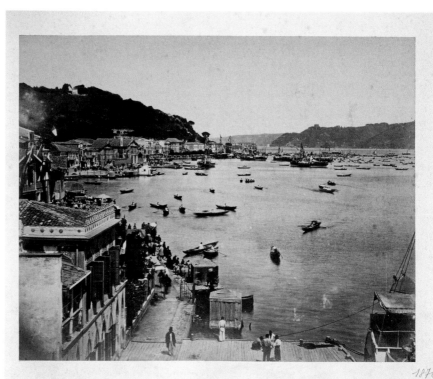

Stamboul . Vue du Quai de Boyouk Deré (H^t Bosphore)

1870

of anonymous waterfront houses and discernible Bosporus towns, such as the view of Büyükdere, a favorite location for many photographers (fig. 7). The order of the photographs in this album is not particularly systematic, but upon closer inspection, one notices that two or three consecutive photographs create a dialogue with one another, a dialogue that is especially evident to those with an intimate knowledge of the city.

As the viewer turns the pages, the album depicts the official buildings along the Bosporus, such as the British Embassy in Tarabya, along with the embassies' rowboats. Thereafter, the album's content crosses the Bosporus to the Asian side to illustrate the Beykoz Mansion; the gate of Beylerbeyi Palace (the photograph looks out to the Bosporus from the gate rather than to the palace itself); the Mansion of Sweet Waters and its view from above. In three consecutive photographs, we look at a steamboat, at first anchored adjacent to the waterfront houses in Büyükdere, then traveling on the open water between destinations, and finally anchored again in a broader context than the first photograph. After traveling along the Bosporus, the album returns to the modern district of Pera (capturing the view of the historical peninsula this time from Pera), including the modern embassy buildings. This album, too, concludes with photographs of the walls encircling the city. Even though some of the photographs do not adhere to the expected sequence, the album makes a rough loop that begins at the historical peninsula, travels along the European side of the Bosporus to its farthest end, and depicts the sites of Tarabya before crossing the Bosporus to the Asian coast and returning to the peninsula via the neighborhood of Pera. Diagram 2 shows a rough itinerary of this journey.

There were numerous albums, or consecutive album pages, in which photographs of the Bosporus were presented in a similar panoramic manner. In some of the albums, panoramic photographs were placed side by side, as if to invite the eye to look beyond the frame (fig. 8). Guillaume Berggren, for instance, prepared an album titled "Vues du Bosphore" composed exclusively of photographs of Büyükdere, a distant small town on the shore of the Bosporus.[40] The panoramic city photographs are best experienced consecutively by turning the pages of an album, as if rolling out or walking along an extended panorama, or circling the rotunda of a painted panorama, or (perhaps more importantly) as if sailing along the Bosporus or observing the shore from a distance with a moving eye. The most obvious sign of making an implied panorama of the Bosporus may be the photographing of the coastline from a boat, thus depicting the city from a sailor's or fisherman's viewpoint. This is apparent in Berggren's panorama of Büyükdere (fig. 9), and in a later city album signed by M. C.[41]

Rather than staging monuments in a carefully constructed frame, as in most travelers' guidebooks of the period, these panoramic city photographs represent

Diagram 2.
Route tracking the locations photographed for the Abdullah Frères album "Vues et types de Constantinople: Photographie d'après nature" (ca. 1885).

buildings as part of a sequence of views of the Bosporus. This visualization invites the viewer to expand the actual frame of the photograph, to imagine the sea and the city beyond the limits of the photograph, to locate the object in the context of the city, and to complement the view by imagining the continuity of the Bosporus. Stephan Oettermann explains the type of vision that led to a pano-rama as "primarily a way of 'getting a grip' on things, a grip that leaves what is observed undamaged, but surrounds and seizes the whole." This is a recognition that images "could appear as a detail or 'segment' of reality...the detail now demanded completion; it exerted pressure to cross the frame."[42] Additionally,

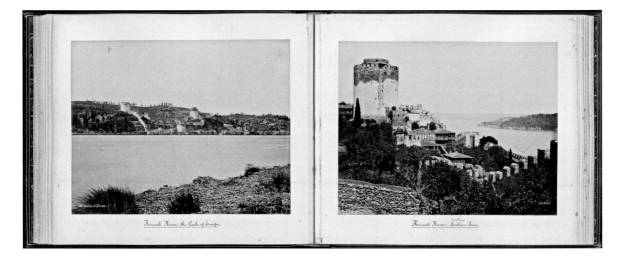

in the case of Istanbul photographs, the segmented view of the Bosporus can be appreciated only in the context of an implied panorama, with a cognitive map, a map in the mind's eye that consciously or subconsciously locates these images on the Bosporus. The panoramic Istanbul photograph becomes a panorama because the viewer completes the frame with his or her cognitive map of the city. One of the major, well-deserved criticisms of Orientalist "armchair" artists was their secondhand portrayal of the lands and peoples of the East. Many Orientalist painters produced scenes of Turkish baths and harems without ever having visited such sites. Conversely, it would be difficult for audiences who have never been to Istanbul to appreciate these panoramic cityscapes, but it is quite likely that the local inhabitants and photographers who regularly traveled along the Golden Horn and the Bosporus mastered the cognitive map that allowed for such an appreciation. With the launch of the Şirket-i Hayriye commuter boats in 1854 along the Bosporus, the view of the city from the sea became accessible to an even wider audience of inhabitants. This may also account for the cityscapes' appeal to current residents of Istanbul. Thus, the panoramic city photographs unmade Orientalism, even though they simultaneously constructed an idealized image of Istanbul devoid of its many tensions. They became meaningful only with the knowledge of the actual city, by actually being there—not by relying on a fantastical vision transmitted through false representation as would have been the case in Orientalist representations.

The indexical and analog photograph—unlike a painting, an architectural drawing, an engraving, and later, a digital photograph that allows for easy modification—bears a closer relationship to actuality, a feature that becomes significant in the historical context of Orientalism. During the time of analog photography, it was common to create staged harem scenes in studios, hire

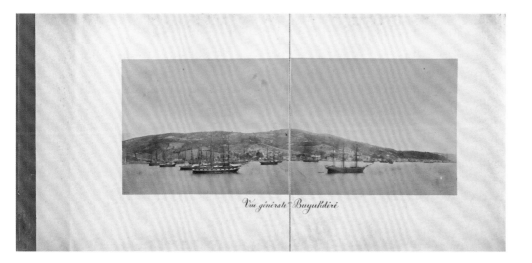

Vue générale Buyukdéré

models to stand lazily in front of monuments, or turn the camera's eye away from the violence on the streets, but it was not easy to manipulate or alter the cityscape or a building. This was not the "post-photographic era," to borrow William Mitchell's term, when the editors of a magazine could effortlessly photoshop pyramids closer to each other in order to create a more exotic effect on the cover or discreetly add a pointed dome, fashion an exaggerated ornament, change the placement and number of minarets on a building.[43] While the relative realism of analog photography constituted, at least for some, an obstacle for its appreciation in the modern art canon, this was its major strength in fighting against the stereotypes of another canon. Photography, when theorized by attending to its practices beyond Europe and North America, thus finds a new meaningful voice in art history. Additionally, Istanbul photographers made a major contribution to the history of this medium, I have suggested, both by perfecting the art and technique of a photographic panorama and by creating a genre based on a panoramic vision that can be appreciated through a cognitive map or decent knowledge of the city.

Coda

I would like to end this essay with another layer in the biography of these photographs, which I was initially attracted to as a scholar of modern architecture. Istanbul's writers in the early twentieth century politicized the visual memory carried in these photographs through a resistant melancholy, precisely because the city's urban fabric was put under threat during their time. Istanbul's wooden houses were left to slowly decay, old neighborhoods had long been rapidly perishing due to extensive and regular fires,[44] and the waterfront houses were

abandoned for use as coal storage. With the collapse of the Ottoman Empire and the birth of the Turkish nation in the twentieth century, the ruling elite transferred the country's resources to the new capital, Ankara, and to Anatolian cities through top-down modernization projects. The devaluation of Istanbul as an old, decaying, and shrinking city during the first half of the twentieth century produced a literature of resistant melancholy among the early Republican writers and architects who portrayed the city as the last remnant of a lost Eastern civilization. In 1944, the prominent author Ahmed Hamdi Tanpınar wrote:

> What you call civilization resembles this old mansion [*İşte medeniyet dediğin bu eski konağa benzer*].... Then, there comes a moment when the mansion burns down. Now, we resemble those bodies that we see in the rubble. Tons of trash, blackened column, rotten iron, smoke burning here and there, smut and mud.... The whole Istanbul...seemed...to share the fate of this orphan whose secret was just disclosed. The Orient was dead [*Şark ölmüştü*].[45]

Abdülhak Şinasi Hisar's book *Boğaziçi Mehtapları* (The full moons of the Bosporus) presented a similar eulogy to the decaying city.[46] This book is a textual metaphor of a Bosporus panorama, which Hisar defined as "a poetry that lasts for kilometers."[47] The book offers no plot, no notable character, no conversational dialogues, no story line or dramatic incident consequential for others, no chronology of occasional events, but rather a pure description of life in the old waterfront houses. Word after word, sentence after sentence, almost nothing "happens" in this book but a long description that continues for a condensed 195 pages. It requires the reader to meditate upon descriptions without expecting a thrilling mystery, pathos, or even an emerging character; to contemplate the writer's extensive but intentional repetitions; and to mourn over, and perhaps protest against, the disappearance of Istanbul's houses: "The Bosporus has an effective and melancholic beauty like a full moon [*mehtap gibi tesirli ve hüzünlü bir güzellik*].... I cannot believe this past has been wasted. ... The Bosporus is the most beautiful part of the unmatched Istanbul, and yet, like all subtle and gracious things, it has a sad beauty [*mahsun bir güzellik*]."[48] The seemingly benign and apolitical visual memory that had been constructed in the nineteenth-century panoramic city photographs was thus implicitly politicized by local audiences through a resistant melancholy against the interventionist forces of their own state.[49] As such, these photographs continued to resist disciplinary gaze and unmake Orientalism—as long as this word means "Western" instrumental representations of the "Orient" that maintain a divide between the two—by increasingly becoming the voice of Istanbul's residents and making their history.

Notes

1. Carney E. S. Gavin, Şinasi Tekin, and Gönül Alpay Tekin, eds., "Imperial Self Portrait: The Ottoman Empire as Revealed in the Sultan Abdülhamid II's Photographic Albums," *Journal of Turkish Studies* 12 (1988). Also see Nazan Ölçer, Engin Çizgen, and Gilbert Beaugé, *Images d'empire: Aux origines de la photographie en Turquie; Türkiye'de fotoğrafın öncüleri,* trans. Yiğit Bener (Istanbul: Istanbul Fransız Kültür Merkezi, n.d.), 38. Unless otherwise indicated, all translations are mine.

2. Take, for example, the urban engineer Ernst Caranza and architect P. A. Bilekzidji. In the 1850s, large photography studios began to operate in Istanbul, the earliest ones being opened by Basil Kargopoulo (ca. 1850); James Robertson (ca. 1855); J. Pascal Sébah (1857); the three Armenian brothers Abdullah Frères (1858); and, later, Guillaume Berggren (1870) and the three brothers Gülmez Frères (1870).

3. Engin Çizgen, *Photography in the Ottoman Empire* (Istanbul: Haset Kitabevi, 1987), 27.

4. Heinz Buddemeier, *Panorama, Diorama, Photographie* (Munich: Wilhelm Fink, 1970); Stephan Oettermann, *The Panorama: History of a Mass Medium,* trans. Deborah Lucas Schneider (New York: Zone, 1997); and Bernard Comment, *The Painted Panorama,* trans. Anne-Marie Glasheen (London: Reaktion, 1999).

5. See Oettermann, *The Panorama,* 83–90; and Comment, *Painted Panorama,* 62–65.

6. For more discussion on Orientalism (in Edward Said's sense) in photography, see Nissan N. Perez, *Focus East: Early Photography in the Near East, 1839–1885* (New York: Harry N. Abrams, 1988); and Ali Behdad, "Photographic Contacts: Reflections on Photography and Orientalism" (paper presented at the annual College Art Association conference, Los Angeles, 2009). The literature on colonial photography is more extensive. See especially Christopher Pinney, *Camera Indica: The Social Life of Indian Photographs* (Chicago: Univ. of Chicago Press, 1997); Anne Maxwell, *Colonial Photography and Exhibitions: Representations of the "Native" and the Making of European Identities* (London: Leicester Univ. Press, 1999); and Eleanor M. Hight and Gary Sampson, eds., *Colonialist Photography: Imag(in)ing Race and Place* (New York: Routledge, 2002).

7. See Engin Özendeş, *From Sebah and Joaillier to Foto Sabah: Orientalism in Photography* (Istanbul: Yapı Kredi Yayınları, 1999).

8. See Malek Alloula, *The Colonial Harem,* trans. Myrna Godzich and Wlad Godzich (Minneapolis: Univ. of Minnesota Press, 1986).

9. Perez, *Focus East,* 106–7.

10. Ayşe Osmanoğlu, *Babam Sultan Abdülhamid* (Istanbul: Selçuk Yayınları, 1984).

11. Selim Deringil, *The Well-Protected Domains: Ideology and the Legitimation of Power in the Ottoman Empire, 1876–1909* (London: I. B. Tauris, 1998), 156.

12. Abdul-Hamid II collection of photographs of the Ottoman Empire, LC control no. 2003652945, Library of Congress, Washington, D.C. For more on these albums, see Gavin, Tekin, and Tekin, "Imperial Self Portrait"; Ölçer, Çizgen, and Beaugé, *Images d'empire;* and Nancy C. Micklewright, "Personal, Public, and Political (Re)Constructions: Photographs and Consumption," in Donald Quataert, ed., *Consumption Studies and the History of the Ottoman Empire, 1550–1922* (Albany: State Univ. of New York, 2000), 261–88.

13. "Padişah tarafından Amerika Kütüphanesi'ne hediye olmak üzere askeri daireler ile İstanbul'un umumi manzarası ve güzel mekanlarının fotoğrafçı Abdullah kardeşler tarafından fotoğraflarının alınması için gerekli olan meblağın tesviyesi," 1311, Dosya No. 230, Gömlek No. 6, Fon: DH.MKT, Date: 20/L/1311 (Hicri), Ottoman Archives, Istanbul, Turkey.

14. John Tagg, *The Burden of Representation: Essays on Photographies and Histories* (Basingstoke, U.K.: Macmillan, 1988); and Micklewright, "Personal, Public," 261–88.

15. These albums are in Istanbul University's Library Collection. For further information, see http://www.kutuphane.istanbul.edu.tr/albumler/a.htm.

16. "İdam ve müebbed kürek cezasıyla mahkum olarak hapishanelerde mevkuf bulunan suçluların fotoğraflarının çekilmesi ve altlarına suçlarının yazılıp adliye dairelerine gönderilerek masraflarının hapishaneler masarif-i müteferrikası tertibine ilave edilerek ödenmesi talebi," 1499, Dosya No. 1499, Gömlek No. 70, Fon: DH.MKT, Date: 26/B/1305 (Hicri), Ottoman Archives, Istanbul, Turkey; and "Darülaceze fahri fotoğrafcılığına Hamidiye Fotoğrafhanesi sahibi Salih Efendi'nin tayini ile fotoğrafı olmayanların fotoğraflarının çekilmesi," 1317, Dosya No. 2205, Gömlek No. 2, Fon: DH.MKT, Date: 9/B/1317 (Hicri), Ottoman Archives, Istanbul, Turkey. Abdülhamid asked for detailed documentation of prisoners sentenced to death and individuals at the fringes of society in Darülaceze (almshouse). See Wendy Shaw, *Possessors and Possessed: Museums, Archaeology, and the Visualization of History in the Late Ottoman Empire* (Berkeley: Univ. of California Press, 2003), 143.

17. "Fransız fotoğrafçı Mösyö Kilme'nin İstanbul'a gelen Rumeli ahalisinin fotoğraflarını çekerken Şehremanetince tayin olunacak bir zabitin yanında bulundurulması," 1295, Dosya No. 53, Gömlek No. 122, Fon Kodu: MF.MKT, Tarih: 22/S/1295 (Hicri), Ottoman Archives, Istanbul, Turkey; and "Edirne, Selanik, Manastır ve Kosova vilayetlerini dolaşıp fotoğraf çekecek olan Alman Fondernahr'ın şüpheli hali görüldüğünde şifre ile bildirilmesi," 1323, Dosya No. 961, Gömlek No. 34, Fon: DH.MKT, Date: 22/Ra/1323 (Hicri), Ottoman Archives, Istanbul, Turkey.

18. "Harput'da fotoğrafçı Ohannes'in hanesinde yakalanan muzır neşriyat ve resimlerin Müddei-i Umumiliğe havale edildiği," 1305, Dosya No. 1495, Gömlek No. 27, Fon: DH.MKT, Date: 06/B/1305 (Hicri), Ottoman Archives, Istanbul, Turkey; "Beyrut'ta ele geçirilen bir fotoğraf mecmuası muzır bulunduğundan, intişarına müsaade edilmemesi," 1310, Dosya No. 155, Gömlek No. 52, Fon: MF.MKT, Date: 09/Ca/1310 (Hicri), Ottoman Archives, Istanbul, Turkey; and "Alenen müstehcen resim ve fotoğraf satan Musevi Avram ile fotoğrafçı Yorgi ve Sofyanos hakkında gerekli tahkikatın yapılarak, bundan böyle ahlaka aykırı yayınların satış ve dağıtımına meydan verilmemesi," 1320, Dosya No. 652, Gömlek No. 24, Fon: DH.MKT, Date: 14/Za/1320 (Hicri), Ottoman Archives, Istanbul, Turkey.

19. "Almanyalı Dr. Leman'ın Ermenilerin bulunduğu sokaklardan geçerken karışıklık esnasında hasar gören evlerin fotoğrafını çektiği," 1316, Dosya No. 10, Gömlek No. 84, Fon: Y.PRK.DH, Date: 19/B/1316 (Hicri), Ottoman Archives, Istanbul, Turkey.

20. "Sivas'da faaliyetlerde bulunan Fotoğrafçı Gabriel Gabriyan, Arzuhalci Batakcıyan Mardiros (diğer adı Mardiros veled-i Mıgırdıç Tandıryan) ve sair kişilerin fesatlarının engellenmesi...," 1308, Dosya No. 1786, Gömlek No. 32, Fon: DH.MKT, Date: 16/R/1308 (Hicri), Ottoman Archives, Istanbul, Turkey; "Adana'da fotoğrafçılık yapmakta olan Kayserili Serkis'in evinde yapılan araştırmada kitap, mühür ve sair bazı maddelerin ele geçirildiği," 1311, Dosya No. 81, Gömlek No. 157, Fon: Y.MTV, Date: 16/S/1311 (Hicri), Ottoman Archives, Istanbul, Turkey; and "Fotoğrafçı Ferahyan Agob ile Dişçi Aharo'nun odalarında bulunup incelenmek üzere gönderilen fotoğrafın sakıncalı olmadığından Adana Vilayeti'ne iade edildiği," 1313, Dosya No. 275, Gömlek No. 56, Fon: MF.MKT, Date: 07/S/1313 (Hicri), Ottoman Archives, Istanbul, Turkey.

21. Pierre de Gigord collection of photographs of the Ottoman Empire and the Republic of Turkey, 96.R.14, box 95, Getty Research Institute.

22. Edward Said, *Orientalism* (New York: Verso, 1978).

23. "Kağıthane ve Boğaziçi'nin resimlerini çekecek olan Beyoğlu'nda mukim fotoğrafhane ressamlarına kolaylık gösterilmesi," 1308, Dosya No. 1783, Gömlek No. 108, Fon: DH.MKT, Date: 10/R/1308 (Hicri), Ottoman Archives, Istanbul, Turkey.

24. "Kleinasien 1917/1918," 1917/18, Pierre de Gigord collection of photographs of the Ottoman Empire and the Republic of Turkey, 96.R.14, box 96, Getty Research Institute. (*Massacre* is the word the photographer uses on the album caption, and I retain the same word here.)

25. Even though I use the word *canon* loosely here, I think it is legitimate to say that there are a few established art historical methods in discussing photographs.

26. Çizgen, *Photography in the Ottoman Empire,* 225.

27. Engin Özendeş, *Abdullah Frères: Osmanlı Sarayının Fotoğrafçıları* (Istanbul: Yapı Kredi Yayınları, 1998).

28. "Abdülhamid'in izinsiz olarak çekilip çoğaltılan fotoğrafının toplatılıp gerekli cezanın fotoğrafçı Abdullah'a derhal verilmesine dair irade tebliği," 1298, Dosya No. 4, Gömlek No. 33, Fon: Y. .PRK.BŞK, Date: 22/M/1298 (Hicri), Ottoman Archives, Istanbul, Turkey.

29. "Abdullah biraderlerin fotoğrafhanesinde Ermenilerin müslümanların fikirlerinde şüphe uyandırmak maksadıyla türlü kıyafetlerde kadınların resimlerini çekmelerinin yasaklanarak çekilen fotoğrafların imhası," 1309, Dosya No. 1914, Gömlek No. 76, Fon: DH.MKT, Date: 21/C/1309 (Hicri), Ottoman Archives, Istanbul, Turkey; and Özendeş, *Abdullah Frères,* 86–87, 161.

30. The Abdülhamid albums are believed to contain 1,269 images by Abdullah Frères, but this may be misleading since they were commissioned to compile the cityscapes and they had just acquired Sébah & Joaillier's collection. "Padişah tarafından Amerika Kütüphanesi'ne hediye olmak üzere askeri daireler ile İstanbul'un umumi manzarası ve güzel mekanlarının fotoğrafçı Abdullah kardeşler tarafından fotoğraflarının alınması için gerekli olan meblağın tesviyesi," 1311, Dosya No. 230, Gömlek No. 6, Fon: DH.MKT, Date: 20/L/1311 (Hicri), Ottoman Archives, Istanbul, Turkey.

31. Circa 1857, J. Pascal Sébah opened a photography studio in Constantinople under

his name. In the mid-1880s, Policarpe Joaillier joined the studio, and in 1888, Sébah's son and Joaillier officially formed Sébah & Joaillier. Later, the studio was renamed Foto Sabah until its closure in 1952.

32. Wendy Shaw, "Ottoman Photography of the Late Nineteenth Century: An 'Innocent' Modernism?," *History of Photography* 33, no. 1 (2009): 88, 93.

33. Shaw, "Ottoman Photography," 93.

34. Özendeş, *Abdullah Frères,* 197.

35. For instance, Sébah & Joaillier's album "Fotoğraf Görüntüleri Koleksiyonları Genel Kataloğu" (1905) literally *illustrated* T. Gautier's chapter on Istanbul. There was not a single photograph that did not coincide with the writer's depictions of Istanbul. See Ölçer, Çizgen, and Beaugé, *Images d'empire,* 81.

36. Susan Sontag, *On Photography* (New York: Anchor, 1973), 51.

37. According to Vedad Nedim Tör, the aim of the portfolio was "to improve our international, non-materialistic prestige and show Turkey's sympathetic, shiny image." Vedad Nedim Tör, *Kemalizmin Dramı* (Istanbul: Çağdaş Yayınları, 1983), 26.

38. "Stamboul or Constantinople Proper," undated, PH1978-0206, Canadian Centre for Architecture, Montreal.

39. Abdullah Frères, "Vues et types de Constantinople: Photographie d'après nature," ca. 1885, PH1981.0348, Canadian Centre for Architecture, Montreal.

40. "Vues du Bosphore par Guillaume Berggren," ca. 1880, Pierre de Gigord collection of photographs of the Ottoman Empire and the Republic of Turkey, 96.R.14, box 3, Getty Research Institute.

41. "Album Photographique, M. C.," ca. 1910, Pierre de Gigord collection of photographs of the Ottoman Empire and the Republic of Turkey, 96.R.14, box 41, Getty Research Institute.

42. Oettermann, *The Panorama,* 22, 30.

43. One of the major differences between analog and digital photography is the ability to easily modify and manipulate the latter. For the best discussion, see William Mitchell, *The Reconfigured Eye: Visual Truth in the Post-Photographic Era* (Cambridge, Mass.: MIT Press, 1992).

44. Zeynep Çelik, *The Remaking of Istanbul: The Portrait of an Ottoman City in the Nineteenth Century* (Berkeley: Univ. of California Press, 1986).

45. Ahmed Hamdi Tanpınar, *Mahur Beste* (1944; reprint, Istanbul: Nurettin Uycan Baskı Evi, 1975), 121–23.

46. Abdülhak Şinasi Hisar, *Boğaziçi Mehtapları* (1943; reprint, Istanbul: Bağlam, 1997).

47. Abdülhak Şinasi [Hisar], "Yıkılan Yalı," *Varlık* (1936): 245–46, quotation 245.

48. Abdülhak Şinasi [Hisar], "Madalyonlar," pt. 1, *Varlık* (May 1934): 825–27; Abdülhak Şinasi [Hisar], "Madalyonlar," pt. 2, *Varlık* (June 1934): 344–45.

49. For more discussion, see Esra Akcan, *Architecture in Translation: Germany, Turkey, and the Modern House* (Durham, N.C.: Duke Univ. Press, 2012).

DARCY GRIMALDO GRIGSBY

TWO OR THREE DIMENSIONS?
Scale, Photography, and Egypt's Pyramids

From the moment of its invention, photography was linked to ancient Egypt. When Dominique François Arago, permanent secretary to the Académie des sciences, publicly introduced photography to the Chambre des députés in 1839, he contrasted the new technology to the efforts of Napoleonic draftsmen in Egypt.

> Everyone will imagine the extraordinary advantages which could have been derived from so exact and rapid a means of reproduction during the expedition to Egypt; everybody will realize that had we had this process in 1798 we would possess today faithful pictorial records of that which the learned world is forever deprived of by the greed of the Arabs and the vandalism of certain travelers.
>
> To copy the millions and millions of hieroglyphs which cover even the exterior of the great monuments of Thebes, Memphis, Karnak and others would require decades of time and legions of draftsmen. By daguerreotype, one person would suffice to accomplish this immense work successfully. . . . Innumerable hieroglyphics as they are in reality will replace those which now are invented or designed by approximation.[1]

For Arago, Louis-Jacques-Mandé Daguerre's invention competed with Napoleon Bonaparte's supreme achievement, *Description de l'Égypte* (1809–22), and because of the former's speed and "fidelity of detail," it won.[2] One man wielding the new camera could replace twenty years of work by "legions of draftsmen."

Of course, photography diminishes all things to human scale. Indeed, this was considered one of its wondrous achievements. In 1849 David Brewster had underscored that the sculptor now "may virtually carry in his portfolio . . . the gigantic sphinxes of Egypt."[3] If Brewster celebrated the portability of colossi made miniature, other photographers noted the diminution with greater frustration. The medium's miniaturization of the world was especially problematic for photographers who trained their lenses not on hieroglyphs but on ancient Egyptian monuments, not on the detail but on the overwhelming whole. In their 1862 publication *La vallée du Nil: Impressions et photographies,* Henry

Cammas and André Lefèvre noted that "our cameras had notably reduced the size of the temples, and at a certain point we felt the need to rectify this by providing an indication of their colossal proportions."[4] Their solution, given very long exposure times, was the fabrication of a dummy that they named Abou-Simbel. Reliance on the human body as a measure was a commonplace then, as now, to suggest size, but as we will see it posed its own problems.

Few man-made structures have enraptured photographers more than Egypt's immense pyramids, yet representing their immensity has always been challenging. The nineteenth-century English photographer Francis Frith complained about the difficulty: "The Pyramids are in full view almost all of the way, and seem ever to remain at the same distance from the eye, even until one stands close under them, when their vastness becomes suddenly oppressive."[5] Let us pause over this remark: the Pyramids seem always to remain the same distance from the eye. That is, they appear always the same size: if they were closer they would seem bigger; if they appeared to be farther away they would seem smaller, but somehow they do not look either closer or more distant according to where one stands. Instead, they appear the same. What this suggests is Frith's apprehension that it was difficult to represent their immensity: to make them appear the extraordinary, colossal, man-made monuments audiences assumed them to be. I think this effect of sameness is corroborated by many nineteenth-century photographs of the Pyramids that imply constancy no matter where the camera was positioned, whether ten miles away or one mile away (fig. 1). Partly because of their geometric simplicity, the Pyramids appear always similar, especially in relation to the emptiness around them: unclouded sky and desert sand. As Frith states, "the Pyramids are in full view almost all of the way." They are seldom overlapped (except by the Sphinx). Surely the eye's difficulty in gauging distances across such unmarked emptiness exacerbates our sense of the Pyramids' relative sizelessness.

This effect was remarked by people other than photographers. In the Napoleonic *Description de l'Égypte,* repetition of the Pyramids across plates and within single images verified the constancy of their pyramidal form; it subjected their variety and complexity to the ruthless simplification of pure Euclidean shape.[6] Although repetition makes possible heterogeneity or variability of effect in these plates, it ultimately underscores these monuments' eternal, a priori geometry. The plate by André Dutertre is no exception (fig. 2). The quick recession of pyramids into the distance describes the progressive simplification from right to left of heterogeneous, irregular materials into unified, ideal geometric form. Distance turns the variable phenomena of our world into the view from nowhere of orthographic projection.[7] Yet Dutertre's picture also compels us to move in the opposite direction from left to right, from distance to closeness.

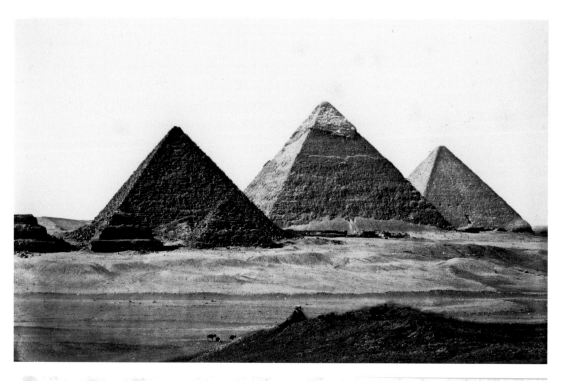

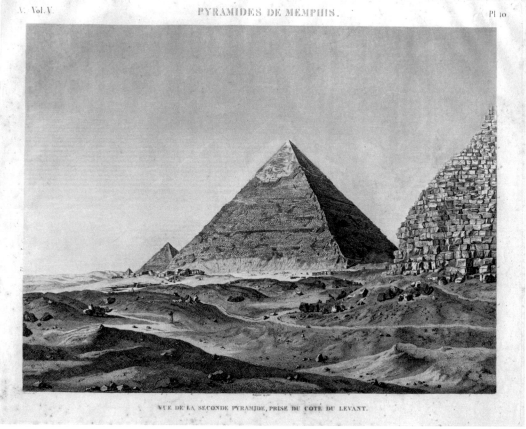

VUE DE LA SECONDE PYRAMIDE, PRISE DU COTE DU LEVANT.

What makes his picture extraordinary is the view at right of a pyramid from very close. Proximity, Dutertre's representation tells us, disintegrates conceptual unities into a material irregularity that verges on the formless.

When Frith turned to the Pyramids as seen from up close, he, like many other voyagers, stated that their sudden vastness was oppressive. Here is the phenomenological contradiction that interests me: even as the viewer gets closer to the Pyramids they seem far away, but then suddenly one feels overwhelmed or dominated. Abruptly the Pyramids feel huge. Of course, not everyone agreed: Vivant Denon, Napoleon's arts administrator, claimed that the Pyramids appeared disappointingly small up close until he began to measure their constituent stones:

> On approaching these colossal monuments, their angular and inclined
> form takes away from the appearance of their height, and deceives the eye:
> besides, as everything that is regular is small or great only by comparison,
> these masses, though they surpass every object that surrounds them, yet
> do not equal the extent of a mountain (the only great body with which the
> mind naturally compares them), the spectator is astonished to feel within
> himself an abatement of that impression which they had produced while
> at a distance; but as soon as he begins to measure by a known scale these
> gigantic productions of art, they recover their immensity.[8]

According to many, apprehension of the Pyramids' colossal size depended on knowing the size of their constituent parts. For Immanuel Kant, German theorist of the sublime, the challenge was to simultaneously experience the Pyramids' parts and the overwhelming whole. To appreciate their immensity, according to Kant, we need to appreciate their composite man-made character. Kant takes the need to apprehend the constructed character of the Pyramids so much for granted that he does not defend this presumption:

> [Claude Étienne] Savary's observations in his account of Egypt [demon-
> strated] that in order to get the full emotional effect of the size of the
> Pyramids we must avoid coming too near just as much as remaining too
> far away. For in the latter case [being too far away] the representation of
> the apprehended parts (the tiers of stones) is but obscure, and produces no
> effect upon the aesthetic judgment of the subject. [However,] in the former
> [being too close],... it takes the eye some time to complete the apprehen-
> sion from the base to the summit; but in this interval the first tiers always
> in part disappear before the imagination has taken in the last, and so the
> comprehension is never complete.[9]

Like Denon, Kant assumes each pyramid's immense scale could only be appreciated if the viewer was aware of its constitutive parts, its making. For Kant, there can be no aesthetic judgment without seeing the layers of rocks; the Pyramids must be seen as man-made. I am inverting Kant's emphasis. His concern is our incapacity to comprehend the overwhelming, colossal, pyramidal whole when visiting a monument that up close can appear to be a pile of rocks. Kant conjures an experiential, phenomenological amnesia; only so many rocks can be remembered at a time. One never arrives experientially at a summation of the parts.[10]

My emphasis, by contrast, is that some effort must be exerted (perhaps especially in two-dimensional representation) to prevent the accumulation of discrete rocks from disappearing altogether, given the power of the simplified geometric form to subsume irregularity and formal complexity. So many photographs of the Pyramids attest to that absorption of particularity by simplified geometric shape. Thus while Kant and Savary worried that pyramids disintegrated into heaps of rocks, I worry that tiers of rocks disappear into ideal form, or perhaps into Frith's distant view wherein the pyramid always appears the same. And when the tiers of rocks disappear, we lose awareness of the sustained labor that made the Pyramids remarkable. For this reason I especially appreciate the accomplishment of Dutertre's plate, the rare image capable of conveying the Pyramids' immensity as well as their composite—that is, man-made—character.

What Kant and I share is an anxiety that we cannot hold together whole and part, an awareness of colossal form and constituent material. Photography would seem the medium least likely to resolve the quandaries posed either by me or by Kant. On the one hand, photography cannot stop individual parts from being subsumed by the ideal whole when the pyramid is seen from a distance, whether in shadow or in light: this is another way to interpret Frith's remark. And on the other hand, photography does not allow us to see the pyramid as whole monument while up close to its constituent stones. Take, for example, the remark made by one of the medium's most thoughtful skeptics, Lady Elizabeth Eastlake, writing in 1857: "[Art's] great aim is to produce a whole; the more photography advances in the execution of parts, the less does it give the idea of completeness."[11] The painter Eugène Delacroix made the same point, seeing a photograph as an arbitrary fragment wherein the contingent details, "more often than not, obstruct the view because they occur in the foreground."[12] Frith expressed similar complaints.

Luckily, the Pyramids were surrounded by empty deserts. Yet that absence of obstruction also undermined our capacity to read the Pyramids' size in distant views: in such photographs, whether by Frith or Maxime Du Camp or countless

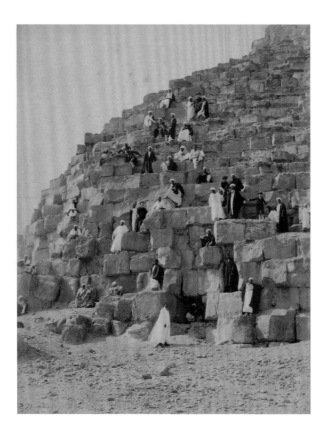

others, how can we ascertain how many miles separate us from the Pyramids (see fig. 1)? By contrast, proximate views privileged the parts but prevented us from seeing the monuments in their entirety. How then could a photographer most effectively represent the colossal? To some degree, the colossal depends on our awareness of the difference between what we know by seeing and what we know (and make) by moving our bodies. Perhaps this explains the popularity of photographs and stereoviews that represent tourists and Egyptian guides clambering up the Pyramids' stone blocks (figs. 3, 4). Although stereoviews reproduced the long views of photographs, more often they moved in close, and the effects of their proximate views were remarkably anchored to the body's physical experiences. Oliver Wendell Holmes, the most enthusiastic of earlier admirers of the stereoview, describes his experience looking at stereoviews through lenses thus: "I creep over the vast features of Ramses, on the face of his rockhewn Nubian temple; I scale the huge mountain-crystal that calls itself the Pyramid of Cheops. I pace the length of the three Titanic stones of the wall of Baalbec—mightiest masses of quarried rock that man has lifted into the air."[13] Holmes is conjuring a physical activity as much as an optical one: he creeps; he scales; he paces. And to some extent, he is right. Exploiting the fact that our two eyes see the world differently because they are some two and a half inches

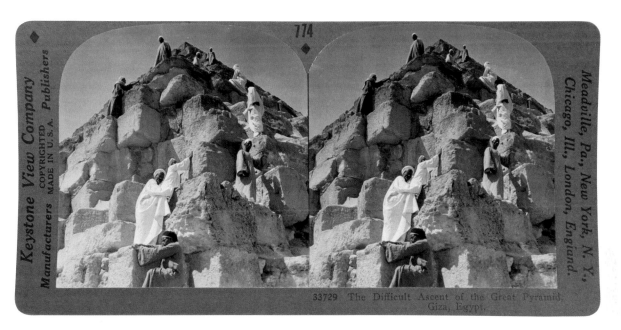

Fig. 3.
Second pyramid of Gizah, late 1800s.
Albumen print.
Collection of Darcy Grimaldo Grigsby.

Fig. 4.
Keystone View Company (American stereograph studio, 1890s–ca. 1970s).
The Difficult Ascent of the Great Pyramid, Giza, Egypt, 1890s, stereoview.
Collection of Darcy Grimaldo Grigsby.

apart, the photographic stereoview provides us with two dissimilar images that we optically conjoin, thereby reproducing our sense of depth.[14]

Seen through lenses, the Keystone stereoview titled *The Difficult Ascent of the Great Pyramid, Giza, Egypt* conveys the sheer size of the Pyramids' constituent blocks in a way few photographs manage (see fig. 4). Indeed, stereoviews offer exceptionally successful illusions of rocks as three-dimensional volumes. Stereoscope, a word coined by Charles Wheatstone, who invented the medium, means "to see solids," but the term *solid* is misleading because of its implication of material density.[15] What stereoviews offer is not so much a sense of solidity as a sense of dimensionality (I would be inclined to use the word *volume*), but even here we need to be cautious. If we look at another stereoview, *The Sphinx, Gizeh, Egypt,* through the provided lenses—showing the pyramid seen from a distance—the stereoscopic illusion emphasizes the overlap of hard-edged flat shapes (fig. 5). Like a theater's wings, these flat shapes create a sense of layered space even as they tend to flatten the volumes themselves. Immediately we appreciate why stereoviews fill their foregrounds with persons and animals: they serve as the requisite overlapping planes, but as flat planes such figures are especially frightening. While their three-dimensionality is somewhat suggested from our point of view—at least light-colored drapery balloons out

toward us—the far side of the people (and animals too for that matter) disappears and we see them as eerily bifurcated bodies. Dimensional on one side; entirely absent on the other.

What stereoviews dramatize is the incommensurability between one lateral plane and another. Their most powerful effects derive from staggered hard-edged shapes in the foreground or middle ground. Our heightened sense of depth results *less* from an illusion of the three-dimensionality of solids or volumes and more from a powerful apprehension of the abrupt gaps between things. In this stereoview, we see a gap between the shallow sandy foreground stage upon which the figures and animals stand, and the dramatic drop behind it (see fig. 5). The stereoview is a mechanism by which emptiness is most effectively conjured. Materiality appears to erupt in a series of staccato flat edges that emphasize not things but the intervening spaces between them.

And scale? The strangeness of stereoviews lies in the way they turn vast material things into images, images unable to convey their immensity. Stereoviews make colossi appear like models. A writer reviewing the Crystal Palace exhibition (1851) for a London paper argued that the stereoviews of the immense exhibition resembled "a view as if the pictures were taken from a small model of the building brought sufficiently near for the whole to be within the distance influenced by the angle of the eyes. In fact, instead of seeing the object itself, you see a miniature model of it brought close to the eyes; so that, in this instance, the stereoscopic Daguerréotypes actually surpass the reality."[16] Physiological factors explain why, in stereoviews, big things seem to be miniature models. Here were images that the eye alone could never have achieved. The nineteenth-century theorist of vision David Brewster believed that the lenses of stereoscopic cameras should not be farther apart than human eyes, which he generalized as some two and a half inches apart—but he made one exception, and it was for "colossal statues" and buildings, which needed to be viewed at a great distance in order to be seen in their entirety.[17]

The problem was that distance diminished the appearance of three-dimensional relief. Human eyes are too close together to allow for the binocular parallax required to create a sense of relief in very distant objects. Brewster's answer was to propose increasing the distance between the stereoscopic camera's two lenses. He explains that for an object to appear in relief, we need information about the sides of the object normally eclipsed when the object is seen at a great distance. Enlarging the distance between the camera's two lenses to capture the sides of the colossal object would permit us to see it in relief as our own eyes could not. But the problem, as Brewster himself concedes, was that the colossus appeared to be a miniature model. The stereoview produces "the impression of viewing a reduced copy of the oversized structure."[18] Here again we encounter a

Fig. 5.
Keystone View Company (American stereograph studio, 1890s–ca. 1970s).
The Sphinx, Gizeh, Egypt, 1890s, stereoview. Collection of Darcy Grimaldo Grigsby.

Fig. 6.
Keystone View Company (American stereograph studio, 1890s–ca. 1970s).
Looking Up an Angle of the Great Pyramid, Showing the Difficulties of Its Ascent, Egypt, 1890s, stereoview. Collection of Darcy Grimaldo Grigsby.

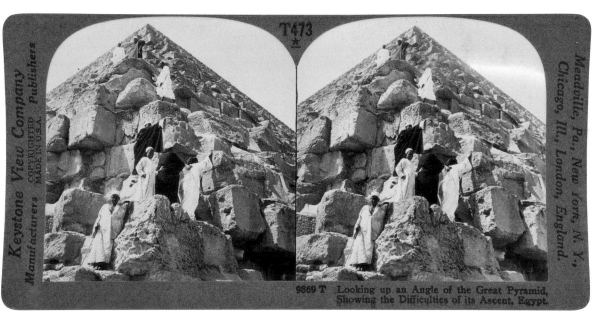

perceptual bind: knowledge of the entirety of the actual colossal monument is gained by making it appear miniature and unreal.

In stereoviews, we are made aware of the dimensionality of the world. Our sense of the vast emptiness of intervening gaps is heightened, but the materiality of our world is also compressed, flattened into disparate planes, and made toylike. So much space looms between such miniature things. And stereoviews of long views of the Pyramids seldom convey their immensity, even their dimensionality; they appear as the constant and distant image Frith complained about. The faraway pyramid is flattened because we cannot see its sides. The proximate views are better, but how effectively can they convey the endlessness of these rising tiers of rocks? Or the height of these monuments? When one studies the stereoviews titled *Looking Up an Angle of the Great Pyramid, Showing the Difficulties of Its Ascent, Egypt* and *The Difficult Ascent of the Great Pyramid, Giza, Egypt* without viewing lenses, one notes the way the single photograph seen by the naked eye emphasizes the distance between us and the highest figures ascending the man-made mountain (fig. 6; see fig. 4). But looking at them through lenses, one sees how riveting the foreground becomes. Here is an area of heightened dramatic contrast: each rock, each crevice is distinct and separate, and the most proximate rocks are simply astonishing. The empty spaces between things are irresistible. By contrast, the extension into the distance, which in this case is also the height of the receding ascent, appears less dramatic. Without the lenses, the farthest figures had appeared very, very small; the pyramid seemed to rise to tremendous heights because the higher figures were so diminished relative to the foreground figures. Yet seen through lenses, the stereoview makes those highest figures appear larger and they therefore seem closer; the portion we see of the pyramid appears less high and the pyramid therefore less colossal.

These differences between the effects of stereoviews with or without lenses or between photographs and stereoviews seen through lenses are due to what scientists call size constancy.[19] Size constancy is the reason we see the distant girl in a psychology illustration as much larger than her size on the surface of the picture (fig. 7). When we look at the world we tend "to restore the 'real' characteristics of an object despite adverse stimulus-conditions."[20] This phenomenon is what one scientist has called our "phenomenal regression to the 'real' object."[21] Thus we tend to see distant persons as larger than they appear because we know what size they are. Representations often mitigate this effect but not entirely. The more we are aware of the representation's surface, the harder it is to sustain the illusion and the more we are inclined to acknowledge the discrepancy in size of near and far objects.

When we look at a stereoview through lenses, the photographic surface seems to disappear and we approximate actual binocular vision. For this reason, size constancy operates in viewing a stereoview to a greater degree than it does in viewing a photograph. Thus, viewing a stereoview, objects in the distance appear larger and the distance itself less deep. Photographs therefore suggest certain kinds of immensity far more effectively than stereoviews; photographs better evoke an extension into the distance because faraway figures (or identifiable things) appear much smaller. What the stereoview does that the photograph cannot is suggest the three-dimensionality of proximate things and the extent of the space between one thing and another. Yet the stereoview is disconcerting because its effect is discontinuous. Rocks appear relatively solid or three-dimensional, but people appear as only slightly dimensional cutouts. The discrepancy is strange and confusing. Somehow we perceive the empty space between foreground rock and the rock behind it, but the figures do not seem to fill that space; we feel we can sense the width of the rocks upon which the figures stand but not the thickness of the people.

What feels certain is that people can offer an approximate measure of height. I say "approximate" because some are adults and some are children, some are men and some are women, and because figures in the distance do not appear

Fig. 7.
Edwin G. Boring
(American, 1886–1968).
Size-Constancy in a Picture.
From *The American Journal of Psychology* 77, no. 3 (1964): 497.

as small (or as distant) as they are. Still, the stereoview allows us to scale the Pyramids, to cite Holmes, and that word is appropriate: stereoviews better than photographs permit us to imagine not just a bodily relationship to its parts but a virtual experience of its size.

Indeed, I would argue that *Looking Up an Angle of the Great Pyramid, Showing the Difficulties of Its Ascent, Egypt* (see fig. 6) succeeds much as Dutertre's engraving does. This stereoview suggests both the Great Pyramid's part and its entirety and I think it does so to some extent with or without lenses. In answer to Kant's anxious fear of a phenomenological amnesia as we ascend the pyramid and forget the rocks behind us, here is a representation that suggests the materiality of the gigantic rocks as well as the shape and height of the pointed pyramid created by those individual parts. While I admit that the height (what in this context I might call the distance up and back) is less acute here when seen with lenses, I think the sacrifice is warranted by the technology's strange capacity to convince us that we ourselves scale immense rocks. After all, no technology, no form of representation, allows us to have our cake and eat it too: we must choose between the effect of distance and the effect of materiality. And like so many nineteenth-century viewers, I willingly draw a cumbersome apparatus up to my eyes in order to pretend I know what it is like to scale the pyramid itself, one rock at a time, without forgetting the entirety of this seemingly timeless geometric form.

Notes

This essay overlaps with my discussion of stereoviews in chapters five and six of my book *Colossal: Engineering the Suez Canal, Statue of Liberty, Eiffel Tower, and Panama Canal* (Pittsburgh: Periscope, 2012). I also discuss Napoleonic representations of ancient Egypt's pyramids in chapter one. Unless otherwise indicated, all translations are mine. Julie Wolf photographed the illustrations in my collection.

1. Dominique François Arago, "Report of the Commission of the Chamber of Deputies," in Alan Trachtenberg, ed., *Classic Essays on Photography* (reprint, Stony Creek, Conn.: Leete's Island, 1980), 17. For the original French, see "Rapport à la chambre des députés, 3 juillet 1839," in André Rouillé, ed., *La photographie en France: Textes & controversies; Une anthologie, 1816–71* (Paris: Macula, 1989), 36–43. Arago continues by arguing that photography would also assist mapping: "Since the invention follows the laws of geometry, it will be possible to reestablish with the aid of a small number of given factors the exact size of the highest points of the most inaccessible structures."

2. Arago, "Report," 17.

3. Cited in Geraldine A. Johnson, ed., *Sculpture and Photography: Envisioning the Third Dimension* (Cambridge: Cambridge Univ. Press, 1998), 4.

4. Henry Cammas and André Lefèvre, *La vallée du Nil: Impressions et photographies* (Paris: L. Hachette, 1862), 191.

5. Cited in Julia Ballerini, "Photography Conscripted: Horace Vernet, Gerard de Nerval, and Maxime Du Camp in Egypt" (PhD diss., City University of New York, 1987), 219. On Frith, see Douglas Nickel, *Francis Frith in Egypt and Palestine: A Victorian Photographer Abroad* (Princeton: Princeton Univ. Press, 2003); and Carol Armstrong, *Scenes in a Library: Reading the Photograph in the Book, 1843–1875* (Cambridge, Mass.: MIT Press, 1998).

6. See chapter one of Grigsby, *Colossal.*

7. On orthographic projection, see Thomas Nagel, *The View from Nowhere* (New York: Oxford Univ. Press, 1986), cited in Lorraine Daston, "Objectivity and the Escape from Perspective," *Social Studies of Science* 22 (1992): 599.

8. Cited in Elliott Colla, "Hooked on Pharaonics: Literature and the Appropriation of Ancient Egypt" (PhD diss., University of California, Berkeley, 2000).

9. Immanuel Kant, "Analytic of the Sublime," in idem, *Critique of Aesthetic Judgement*, trans. James Creed Meredith (London: Clarendon, 1911; reprint, Oxford: Clarendon, 1991), 99–100.

10. Whitney Davis, "Opticality and Rhetoricity in Paul de Man's 'Historical Materialism,'" in idem, *Replications: Archaeology, Art History, Psychoanalysis* (University Park: Pennsylvania State Univ. Press, 1996).

11. Cited in Nickel, *Francis Frith in Egypt and Palestine,* 90.

12. Cited in Patrick Maynard, *The Engine of Visualization: Thinking through Photography* (Ithaca, N.Y.: Cornell Univ. Press, 1997), 212.

13. Oliver Wendell Holmes, "The Stereoscope and the Stereograph" [1859], in Vicki Goldberg, ed., *Photography in Print: Writings from 1816 to the Present* (Albuquerque: Univ. of New Mexico Press, 1988), 109.

14. David Brewster, "Account of a Binocular Camera, and of a Method of Obtaining Drawings of Full Length and Colossal Statues, and of Living Bodies, which Can be Exhibited as Solids by the Stereoscope," *Transactions of the Royal Scottish Society of Arts* 3 (1851): 259–64, reprinted in Nicholas J. Wade, ed., *Brewster and Wheatstone on Vision* (London: Academic, 1983), 218–21; and David Brewster, "Stereoscopic Journeys," *Eclectic Magazine of Foreign Literature, Science, and Art* (1857): 560–61. For secondary sources, see Robert J. Silverman, "The Stereoscope and Photographic Depiction in the Nineteenth Century," *Technology and Culture* 34, no. 4 (1993): 729–56; Nancy M. West, "Fantasy, Photography, and the Marketplace: Oliver Wendell Holmes and the Stereoscope," *Nineteenth-Century Contexts* 19 (1996): 231–58; Laura Burd Schiavo, "From Phantom Image to Perfect Vision: Physiological Optics, Commercial Photography, and the Popularization of the Stereoscope," in Lisa Gitelman and Geoffrey B. Pingree, eds., *New Media, 1740–1915* (Cambridge, Mass.: MIT Press, 2003), 113–37; Rosalind Krauss, "Photography's Discursive Spaces: Landscape/View," *Art Journal* 42 (1982): 311–19; Michel Frizot, "Surface and Depth," in Françoise Reynaud, Catherine Tambrun, and Kim Timby, eds., *Paris in 3-D: From Stereoscopy to Virtual Reality, 1850–2000*, exh. cat. (Paris: Booth-Clibborn, 2000), 30–35; Jacques Ninio, "Three Dimensional Perception," in Françoise Reynaud, Catherine Tambrun, and Kim Timby, eds., *Paris in 3-D: From Stereoscopy to Virtual Reality, 1850–2000*, exh. cat.

(Paris: Booth-Clibborn, 2000), 17–22; and Jonathan Crary, *Techniques of the Observer: On Vision and Modernity in the Nineteenth Century* (Cambridge, Mass.: MIT Press, 1992). For an illuminating criticism of Crary's *Techniques of the Observer,* see David Phillips, "Modern Vision," *Oxford Art Journal* 16, no. 1 (1993): 129–38.

15. Charles Wheatstone, "Contributions to the Physiology of Vision—Part the First: On Some Remarkable, and Hitherto Unobserved, Phenomena of Binocular Vision," *Philosophical Transactions of the Royal Society* 128 (1838): 371–94, reprinted in Nicholas J. Wade, ed., *Brewster and Wheatstone on Vision* (London: Academic, 1983), 70.

16. Cited in Silverman, "The Stereoscope and Photographic Depiction," 749.

17. Brewster, "Account of a Binocular Camera," 259–64.

18. Silverman, "The Stereoscope and Photographic Depiction," 748.

19. On size constancy, see Edwin G. Boring, "Size-Constancy in a Picture," *American Journal of Psychology* 77, no. 3 (1964): 494–98; C. Oliver Weber and Natalie Bicknell, "The Size Constancy Phenomenon in Stereoscopic Space," *American Journal of Psychology* 47, no. 3 (1935): 436–48; and Stanley Coren, "A Size-Contrast Illusion without Physical Size Differences," *American Journal of Psychology* 84, no. 4 (1971): 56–66.

20. Weber and Bicknell, "The Size Constancy Phenomenon," 436.

21. Weber and Bicknell, "The Size Constancy Phenomenon," 436–37.

LUKE GARTLAN

DANDIES ON THE PYRAMIDS
Photography and German-Speaking Artists in Cairo

During the winter months of 1875/1876, a group of six male travelers posed for a photographer on the outskirts of Cairo (fig. 1). In their self-conscious display of sartorial fineries and foppish poses, the group portrait bespeaks their collective performance of masculine artistic swagger and urbane identity, yet the signs of their actual location and pursuits are merely evoked in the pyramidal stack of luggage directly behind them, with wooden easels at either base extending from the photograph's corners toward the summit of gathered hats. The setting itself is all but erased by the washed background, the tightly cropped space, and the low camera angle. Their foreground rapidly gives way to an absence of detail at the limits of daytime photography's technical capability. Within this confined, indeterminate space, the six sitters are compelled to overlap one another in front of the camera, to bunch together and accept, if not embrace, the physical conditions of their altered travel arrangements.

Almost half a century later this photograph appeared in the published correspondence of the group's host and ostensible leader, the Viennese Orientalist painter Leopold Carl Müller, with the associated caption: "A Pleasurable Society. Prince Karl Khevenhüller, Gnauth, Lenbach, Makart, Huber, and Müller. After a photograph by Steiner in Cairo."[1] Such textual framing of the photograph underscores the subjects' implied priorities, with the collective pursuit of leisure placed before individual professional aspirations. The caption also confirms the identities of the renowned sitters and their hired photographer: from left to right, the Austrian prince Karl Khevenhüller, the Stuttgart architect Adolf Gnauth, the Munich painter Franz von Lenbach, and the Viennese artists Hans Makart, Carl Rudolf Huber, and Leopold Carl Müller. The Viennese commercial photographer Ludwig Steiner had been resident in Cairo since the mid-1860s, catering to the expanding foreign market for local souvenirs of Egypt.[2] As a German-speaking expatriate, he represented an obvious companion on their excursion consistent with the shared imperial, all-male criterion of inclusion in the party.

Although the group photographs that resulted from this excursion are few in number and scattered in various archives, there are several reasons to examine the conditions of their production and designation as "Orientalist" photographs.

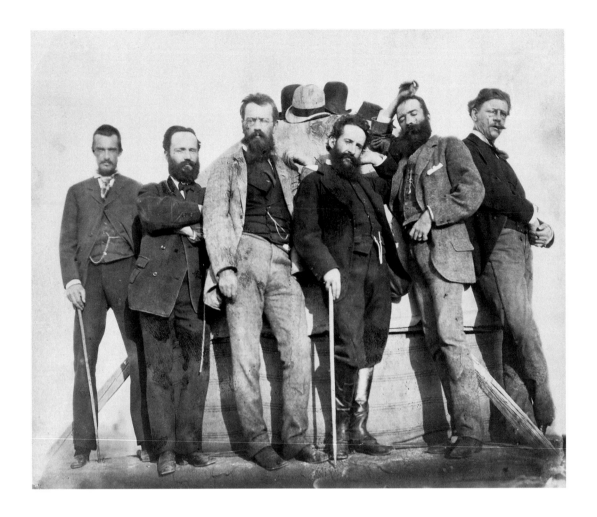

Fig. 1.
Attributed to Ludwig Steiner
(Austrian, dates unknown).
Untitled (Group portrait of
Prince Karl Khevenhüller, Adolf
Gnauth, Franz von Lenbach,
Hans Makart, Carl Rudolf
Huber, and Leopold Carl
Müller), 1875–76, albumen
print from collodion-on-glass
negative, 21.5 × 26.5 cm
(8½ × 10½ in.).
Salzburg, Salzburg Museum.

At a broad level, this essay aims to contribute toward a shift in critical debate
from Anglo-French Orientalism to the cross-cultural encounters and histories
of other regional axes, such as between Vienna and Cairo. Whereas some of
these travelers working in the high cultural product of oil painting are well
known to art historians, their Orientalist pursuits have received much less
critical scrutiny than their Anglo-French contemporaries. In the preface to his
landmark publication *Orientalism*, Edward Said acknowledged that his analy-
sis could not "do justice to…the important contributions to Orientalism of
Germany, Italy, Russia, Spain, and Portugal."[3] Yet even among this list of omit-
ted countries, the Austrian Empire—one of the preeminent European pow-
ers of the nineteenth century—is most conspicuous by its absence. As James
Clifford has noted, Said's critique of an Anglo-French cultural tradition com-
plicit in the subtle justification of those nations' colonial projects required him
to marginalize the Orientalist traditions of Central Europe.[4] Under the influ-
ence of postcolonial theory, visual historians have centered their inquiries on

those photographers of colonial powers, mainly Britain and France, and have shied away from the study of photographers from other European nations with their own distinctive political relations to non-European societies. In this sense, postcolonial scholars have reinterpreted the empirical research of earlier photographic historians but have not necessarily disputed the subject of inquiry. Only in recent years have some scholars begun to examine the Orientalist cultural products of the Austro-Hungarian Empire,[5] reflecting not only a renewed awareness of the historical specificities of "regional" relations with the Ottoman Empire but also, however unacknowledged, current social debates and anxieties on immigration and cultural diversity in Austrian society.

Whatever the caption ascribed to the group photograph might imply, it would be misguided to dismiss the artists' activities in Egypt as the trivial pastimes of holiday excursionists, not least because such a position risks reinscribing a naturalized division between work and leisure pivotal to the discursive operations of Orientalism. The bourgeois separation between the *work* of scholarship and the *leisure* of tourism masks their common roles in "knowing the Oriental." Through their diaries, travelogues, postcards, photographs, and other cultural productions, European tourists were no less involved in the production of the "Orient" than their erudite counterparts in such emergent disciplines as archaeology, anthropology, and philology. As the principal protagonists of the late-nineteenth-century German-speaking art world, instrumental in the emergence of the modern professional artist and its state institutions, these cultural luminaries held considerable authority well beyond the commercial products of their visit to Egypt. Moreover, while some members of the circle are little known today, others continue to enjoy notable reputations—if not outright resurgences—thanks to several major retrospective exhibitions, associated publications, and in one case, a dedicated museum.[6]

With the notable exception of the scholarship of Bodo von Dewitz, the group photographs examined in this essay have been considered either within the context of the sitters' painterly output or as a curious sideline illustrative of their leisurely pursuits in Egypt.[7] Recent major exhibitions of Orientalist visual culture may have drawn attention to these photographs, but only insofar as they inform their subjects' paintings and activities. This is inadequate, and not only for its uncritical appraisal of photographs as self-evident visual documents but also because the reduction of photography's role to the preparatory gathering of pictorial source materials neglects the significance of the social practice of photography in the artists' collective experience of Cairo.

To be specific, I want to examine the significance of these outdoor photographs—and indeed photography itself—as productive and expressive of male bonding within the traveler-artist circle. Here I argue for the centrality

of same-sex intimacy in the travels of Orientalist artists and photographers. Although the art historical monograph has tended to reinforce the impression of isolated travel and personal experience, artists often ventured abroad together in tight-knit groups or met with associates in colonial centers and resorts.[8] Photographic portfolios of such artistic circles may be rare, but they became increasingly common with the advent of the Kodak camera, which combined relative ease of use and economy with a compact design and the convenience of dry-plate negatives. Traveling with fellow artists and colleagues in each instance, Henri Evenepoel, Gabriele Münter, and August Macke packed cameras in their luggage on their visits to North Africa in 1897, 1905, and 1914, respectively, attesting to the prominence of photography in modern artists' colonial repertory and its mediation of their experience.[9]

In addition to this recognition of the collective aspect of Orientalist visual culture, these photographs require an approach attuned to the historical and imperial contingencies of male interpersonal gestures and mannerisms. Social historians have argued that the nineteenth century witnessed a greater range of acceptable codes of behavior between men, particularly before the construction of the "homosexual" emerged in European medical and criminological discourses in the last quarter of the century.[10] As David Deitcher has noted in his important study of male-male intimacy in nineteenth-century American photographs, "the twentieth century inclination to classify human intimacies in terms of either a normal or a deviant sexuality has made it difficult for historians to come to terms with the meaning of more fluid affections."[11] Deitcher cautions against the ahistorical desire to project contemporary sexual identities onto historical photographs, but he also rails against the failure of historians of photography to acknowledge, let alone analyze, the occasional signs of affection and familiarity between men in photographic portraiture.[12] In the context of nineteenth-century Orientalism, this silence is all the more egregious given the prominence accorded homoerotic desire in the colonial archive. For many European male travelers, whatever their presumed sexual orientation, Egypt was a realm suffused with the erotic promise and the concomitant threat of encounters with uncertain polymorphous sexualities. To partake of "the homoerotics of Orientalism" was one of the key privileges of the male colonial tourist, but it could also threaten to disrupt the normative discourses of sexual and gender identity in European society.[13] Ultimately, however, the interpretation of these group photographs as resistant to dominant notions of colonial masculinity and sexuality is undermined in light of their broader collective activities in Egypt.

Posing issues of homosociality and homoeroticism in connection with these photographs inevitably invites speculation on the sitters' sexual orientations. It

is certainly not my intention to assign fixed identities to these artists according to a register of modern sexual categories, but rather to suspend the default assumption of heterosexuality in favor of an emphasis on ambiguity and uncertainty. This essay argues that the colonial stage for the photographic session facilitated the performance of homosocial desire—however tentative, covert, and unrealized—between members of this artistic fraternity. Following Eve Kosofsky Sedgwick's influential model, I employ the terms *homosocial* and *homoerotic* not in opposition to one another but as a continuum of complex interpersonal male desires and emotional attachments encoded in the subtle gestures and associations of their photographic session.[14] In this regard, it is important to note that these commissioned photographs were private mementos of the artists' travels together, neither intended for circulation nor necessarily used for professional purposes. The very privacy of these group photographs is instructive.

Like their British and French counterparts, these German-speaking artists traveled to Egypt on the modern transportation networks and established tourist infrastructure of the colonial period. On 19 November 1875, the members of this artistic clique embarked aboard a steamer from Trieste, then the major port for the Austro-Hungarian Empire, bound for Alexandria.[15] Waiting for them in Cairo, Leopold Carl Müller had already arrived eight days earlier on his third visit to the city.[16] He was staying in the French enclave at the Hôtel du Nil, where a quarter of a century earlier Gustave Flaubert and Maxime Du Camp had lodged during their visit to Egypt. Furthermore, the initial impressions of his compatriot guests did not differ markedly from the well-worn Orientalist clichés of the era. Soon after his arrival, Franz von Lenbach wrote home to his family in Munich: "Cairo is wondrous beyond all expectations, with each of its half million inhabitants stranger than the next, the streets, temples, peoples, animals and other sites look as if a thousand years ago, such as one might imagine Babylon."[17] Such rhetoric is all too familiar to the model of the Orientalist tourist as *flâneur,* a disembodied wanderer about the streets, and to the romantic myth of Egypt's cultural stasis.[18] Yet by this time, Cairo had undergone such an extensive program of urban reform that the artist's words belied the modernization of the city and its institutions.[19]

My concern with the artists' group photographs centers on their collective experience of sightseeing and the common desire for corporeal detachment as a condition of homosocial interaction. Despite the potential use of grand monuments as exotic backdrops, Steiner's photographs do little to invoke the spectacle of tourist sightseeing in Egypt. The photographer selected not the sites encountered on their excursion but his clients' desired state as urbane men of leisure. Nonetheless, the pleasures of the insouciant, all-male party also had

their trials and irritations. Writing on 7 December 1875, Müller acknowledged his responsibilities and frustrations as chaperone, in correspondence with the Viennese artist Ferdinand Laufberger: "Dearest Friend! I am, as you no doubt know, once more in my beloved Cairo—and I'm entranced. You also know that Makart, Huber, and Lenbach are here. I've lost a lot of time with them sightseeing, etc. In Trieste, Pettenkofen once again developed a fear of water and turned around, although he was absolutely determined to come here. The idiot made the trip all the way from Paris via Vienna to Trieste!!"[20] As the steamer's passenger list indicates, the Viennese genre painter August von Pettenkofen had indeed changed his mind at the last moment and remained behind in Trieste.[21] Lenbach complained of three days' seasickness aboard the steamer and perhaps contemplated the wisdom of the Viennese painter's last-minute decision not to accompany his colleagues.[22] In their private correspondence the metropolitan artists' veneer of worldly professionalism is found to be all at sea, ill-equipped to handle the altered travel conditions despite the comforts of modern transportation. Whatever their individual ambitions, a tension existed between the professional aspirations and indolent pursuits of the circle's members.

To enable the pretense of potential activity, Müller soon arranged for his colleagues to take up residence in the spacious Musafir Khana Palace, granted with the permission of Ismail Paşa, the khedive of Egypt and Sudan.[23] In their new quarters, the artists established their studios, decorated with carpets and other ornamental acquisitions, in a manner reminiscent of previous artistic cultivators of an Eastern masquerade. To complete their Oriental transformation, the new residents hired numerous servants, a porter (described by Müller as "a beautiful brown Abyssinian"), and arranged for a guard "always to stand before the gate." Three weeks after his guests' arrival in Cairo, Müller boasted to his sister Amalie in correspondence, "I have spent much, but now live like a pasha."[24] He invokes the Orientalist masquerade of harem master, memorably encapsulated forty years earlier by William Makepeace Thackeray's account of the artist John Frederick Lewis in Cairo, but on this occasion shared with fellow roommates and travel companions.[25]

Despite these spacious new premises, the painters' activities with easel and brush were modest at best during their three months in Cairo. While Makart reportedly completed eight large paintings during his stay, Lenbach produced little of much consequence.[26] By mid-February 1876, the two artists and lifelong friends undertook an excursion to nearby Memphis before shortly thereafter parting ways.[27] On 3 March, Lenbach noted in correspondence from Athens that he had left Cairo eight days earlier and planned to return home via Corfu and Italy. By contrast, Makart had decided to extend his travels along the Nile to Thebes.[28] As the circle disbanded and its various members found their own

routes home, the communal bonds that had characterized their voyage finally yielded to their conflicting personal and professional goals. The results of their visit were inevitably disparate given the differences in the artists' career stages and ambitions, but as Müller had implied with evident frustration, the group members were all too often occupied embracing the Orientalist lifestyle of nonchalant excess to benefit from the potential market opportunities.

It was the camera, rather than the artists' own traditional tools of picture making, that catered to their desire for a collective means of masculine self-stylization and fantasy. Indeed, the artists brought their own photographic equipment on the voyage and several members appear to have been involved in its use in their new quarters. Carl Rudolf Huber was a keen amateur photographer and has often been credited with these images,[29] but the single attribution of authorship belies the group working methods of much nineteenth-century photography. The wet collodion process, with its technical requirement for the rapid preparation, exposure, and development of the glass negative, and the cumbersome darkroom operations and chemical procedures, often necessitated the aid of "assistants" alongside the photographer behind the lens. The practicalities of the process decreed an order of collaboration, contrary to the art historical impetus to attribute works to a single individual. Almost certainly, the production of these works was a common enterprise between the housemates, which functioned as an expression of their authority pivotal to the fabrication of a credible mythology of the studio-harem.

Within their studio space, the artists employed the camera to render numerous "photographic studies" of their hired female models, naked or dressed in few garments and usually presented before a plain backdrop in direct sunlight (fig. 2). Often composed of two or more models arranged in close proximity—both to the picture plane and one another—these studio works accord with the camera's role in the construction of masculine fantasies of cultural and sexual control, thinly veiled as ethnographic documentation or artistic source materials, and thus became central to the artists' activities in their new abode. However much scholars attempt to locate the pictorial sources for the artists' paintings in these photographs, thereby attaching a putative intention beyond the eroticized conditions of their production, such comparisons are vague and unconvincing.[30] Reporting on their living quarters in Cairo for the *Allgemeine Zeitung,* an anonymous journalist attested to the close association of erotic fantasy and the practice of photography in the studio's daily operations: "The artists had taken to calling the Musafir Khana the madhouse and it was indeed a crazy place. The Arab models who had been initially rather bashful, eventually became so bold as to wander around in the nude quite unashamedly.... The photographic apparatus was in constant use, and the most reckless postures

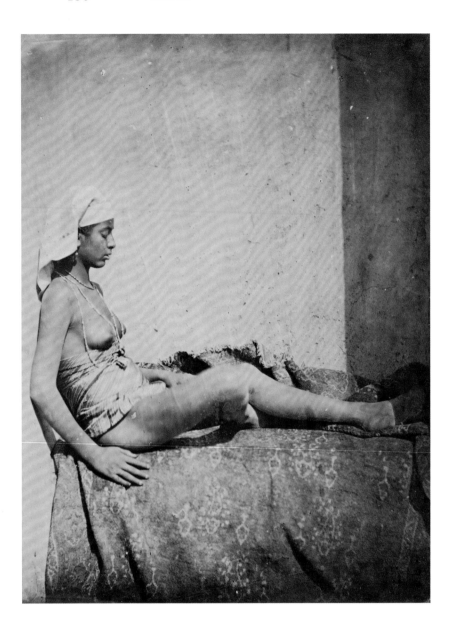

Fig. 2.
**Attributed to Carl Rudolf Huber
(Austrian, 1839–96).**
Untitled (Nude woman sitting
on carpet with her back against
a wall), 1875–76, albumen
print from collodion-on-glass
negative, 24.3 × 18 cm
(9⅝ × 7⅛ in.).
Los Angeles, Getty Research
Institute.

were portrayed, of which even the less indecent defy description."[31] With their eyes often closed or averted and their bodies accessorized to accentuate their otherness, the models are enlisted to corroborate the artists' collective fantasy of Oriental female subservience. No longer seemingly content with the traditional asymmetrical power relations between male painter and female model, the atelier's transformation into a photographic studio promoted the collective eroticization of the Oriental woman through the models' continual instruction and manipulation before the camera.

In fact, the artists' homosocial bonds may well have extended to the pursuit of sexual services from their models. According to the art historian Emil

Pirchan, writing in terms suggestive of his own revelry in the salacious colonial exploits of his predecessors, Makart during his time in Cairo "adventured in the dangerous wine taverns of the harbor district, where he found brown-skinned Nubian girl models, voluptuous fellah women, Sudanese prostitutes, and magnificently mature, all-giving Arabian dancers, true Sphinxes, who enchanted his ever watchful eyes."[32] In the dialectical language of attraction and repulsion characteristic of colonial attitudes toward women in Egypt, Makart's proclivity for "Oriental orgies" was adjudged the source of the venereal disease that ultimately curtailed his life.[33] Although these claims are themselves embroiled in misogynistic colonial ideologies of sexual mastery and the diseased body of the Oriental woman, Makart's search for prostitutes and studio models appears plausible in view of the above-cited newspaper report and the pervasiveness of the colonial trade in sex. I do not intend to rehearse here the arguments that have regarded the prostitute as an emblem of European urban modernity, other than to point out that the avant-garde celebration of the subject as an unstable yet exemplary signifier of modern life maps awkwardly upon the colonial arena—a disparity further marked by the art historical neglect of the colonial prostitute in comparison to the attention afforded the theme in European contexts.[34] Nonetheless, if the prostitute's sexualized body became the locus of profound male anxieties of desire and disgust (the latter signaled most forcefully in the specter of syphilitic contraction), the colonial inflection of these metropolitan fears only enforced the centrality of the exchange of women between men to its operations. Whether or not Makart's colleagues participated or even joined him in these sexual antics, their communal act of photography functioned as its pictorial surrogate, enabling the affirmation of homosocial bonds through the continual instruction and commodification of women before the camera.

In contrast to this photographic project of the heterosexualized studio space, the artists' decision to hire a local photographer and fellow compatriot to accompany them on their sightseeing excursion resulted in a strikingly unconventional group of photographs directed on their own selves. These works avoid the stereotypes of much period photography produced for the tourist trade, which some members of the entourage also purchased for their personal collections.[35] Whereas most transient visitors acquired their souvenir photographs from ready-prepared studio stock, with perhaps the inclusion of a studio portrait session, the hiring of a professional photographer implied a different set of priorities. Rather than the formation of an archive of clichéd, packaged subjects and sites, the photographer turned to the privileged conditions of their colonial realm—of shared company on a terrace café or camel excursions.[36] At the edges of these photographs, the servants and guides stand silent, reduced to signifiers of their colonial masters' authority and leisure.

Nonetheless, these photographs do not deny the colonial habitus as the necessary corollary to a feigned authenticity that eschews the historical conditions of their production.

The most playful, even whimsical, of these group portraits neither include local guides nor occur before the familiar mise-en-scène of the tourist route (fig. 3). Beneath a modest wooden structure, five members of the confraternity gather around the large central frame of Franz von Lenbach. Precariously overlooking his companions, Huber perches seemingly trapped between his roof support and the upper edge of the photograph, perhaps reminiscent of an angel hovering above a scene of the nativity but transposed into the secular realm of modern tourism. He personifies the tourist fantasy of detached observance from a vantage point above the fray. However one may interpret this curious position above his companions, it renders legible the self-conscious theatricality of their photographic project. As with each of these photographs, the range of individual bodily demeanors and sartorial modes differentiates each figure and, in the artists' physical association, implies their simultaneous hierarchical position within the group. Makart stretches out resplendent before the camera, a recumbent dandy in knee-high boots, bowler hat, and cane, and yet his position at the feet of his colleagues also situates him within a familiar trope of Oriental subservience. Müller distinguishes himself from his companions through the sartorial addition of the tarboosh, or fez, to signify his claims of local knowledge. He is the only figure to acknowledge a companion directly, peering upward at Lenbach's imposing countenance in mock imitation of the master-servant dialectic of Orientalist imagery. Throughout this series of photographs, the companions enact the visual codes of submission and sensual reverie toward one another, signified in the suggestive motifs of closed eyes and furtive glances, incidental touch and proximity, and languid, stretched, and contorted poses. It is in these minor gestures that their homosocial bonds flirt with becoming tacit avowals of homoerotic sentiment.

The camera valorizes the intimate association of bodies: each figure adopts a certain posture, whether seated, upright, or recumbent, in relation to the other figures. In another photograph from the series, Lenbach rests against a sloping diagonal with his left knee raised, furnishing his companion with a makeshift seat (fig. 4). With Lenbach's eyes apparently closed, Huber and Müller fix their attention toward his outstretched torso, the surrounding terrain incidental to the dynamics of their homoerotic associations. Müller, seated on the right, directs his gaze through pince nez along the axis of his companion's reclining body. These photographic activities furnished the pretext for experiments in male passivity, which facilitated the breaching of social codes of masculine behavior and implied the possibility of alternative male relations. Yet the

Fig. 3.
Attributed to Ludwig Steiner (Austrian, dates unknown).
Untitled (Group portrait of Carl Rudolf Huber [above], Hans Makart [recumbent in foreground], and, from left, Adolf Gnauth, Franz von Lenbach, Leopold Carl Müller, and Prince Karl Khevenhüller), 1875–76, glass plate positive reproduction after an albumen print, 9.3 × 11.8 cm (3¾ × 4¾ in.). Vienna, Österreichische Nationalbibliothek, Bildarchiv.

Fig. 4.
Attributed to Ludwig Steiner (Austrian, dates unknown).
Untitled (Group portrait of, from left, Adolph Gnauth, Franz von Lenbach [reclining], Carl Rudolf Huber, Hans Makart, and Leopold Carl Müller), 1875–76, glass plate positive reproduction after an albumen print, 8.9 × 11.7 cm (3½ × 4⅝ in.). Vienna, Österreichische Nationalbibliothek, Bildarchiv.

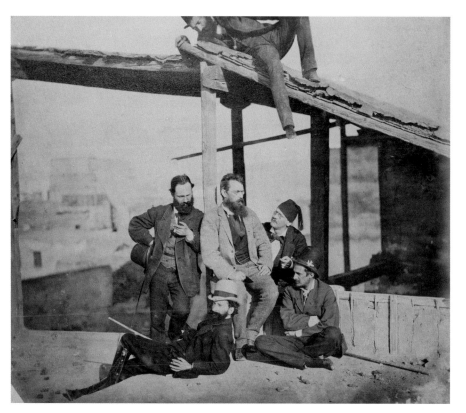

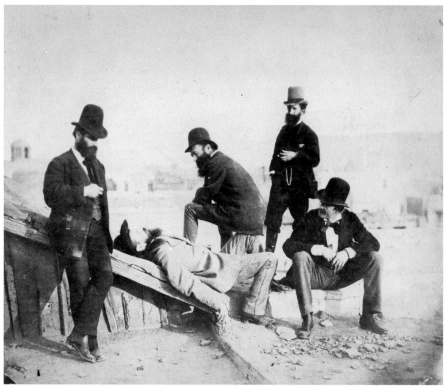

salutary *potential* of these photographic acts does not necessarily correlate with the disruption of dominant sexual and colonial ideologies. On the contrary, such unconventional forms of male-male association "are themselves generated from a locus of considerable political and artistic power."[37] At once divorced from and enabled by the political conditions of their photographic session, the sitters' intimacies merely evoke the possibility of alternative subjectivities as emblematic of their privilege within the broader structures of colonial and patriarchal order.

The same nondescript site—where the ground rubble intersects with the slope of a simple structure, albeit turned ninety degrees—appears to have been chosen for perhaps the most enigmatic of these group portraits (fig. 5). Deitcher's aphoristic claim finds its most evocative testament in this photograph: "It is as if men put themselves together more inventively back then."[38] Spread across the pictorial space of the photograph, all six companions, despite their urbane garments, have cast themselves on the ground in an assortment of poses and contortions to form the rough suggestion of a circle. Carefully orchestrated in advance, the photographic "sitting" sanctioned the performance of an entire corpus of extended, crossed, folded, stretched, and interlocked limbs. As Bodo von Dewitz has argued, this photograph exemplifies the artists' desire "to attempt a calculated break with convention and demonstrably flaunt this permissive and relaxed life."[39] However, that such physical contraventions signified a bohemian rejection of bourgeois society downplays both the colonial conditions of these photographs' production and the implicit male-male intimacy of the artists' interactions. While the travel companions' enthusiasm for such photographic self-fashioning was not exclusive to the outskirts of Cairo,[40] the sexual politics of colonialism sanctioned the fantasy of a group flirtation with homoerotic subjectivities in which the feigned closure of eyes implied a lack of awareness of the interpersonal familiarities evident between one another—of a hand brushed against a companion's beard or a foot lodged between another's thighs.

In other instances, the dynamics of masculine abjection and subjection are turned inward, most strikingly in the left-corner contortions of Prince Khevenhüller. Lying facedown and grabbing his ankles, as if hog-tied, Khevenhüller turns away from his companions and their comparative physical nonchalance, his body isolated from the comforts of their incidental touch and stretched taut from the exertions of his posture. At the upper center of the photograph, Lenbach's relative attentiveness, suggested by his twisted torso, raised head, and bent left knee, signals his dominion over the group. Here again, the sitters adopt the codes of masculine domination and subordination in relation to one another, familiar to the trope of Oriental master and slave. Further

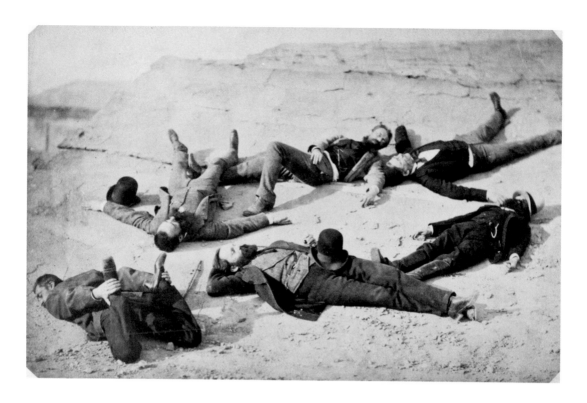

details add to the erotic resonance. Such puerile visual jokes as the strategic placement of a bowler hat over the crotch of one figure, positioned front and center in the photograph, registers the heightened sexuality of their communal relations. Photography served the group as a means to displace their masculine anxieties in the performance of their own homosocial desires.

Yet while this private commission enabled the travel companions to vent their collective fantasies and breach orthodox codes of male-male presentation before the camera, how were their activities received in Vienna? Did these photographs remain private mementos or find their way into the public realm? Certainly the scarcity of the photographs and, where available, their provenance histories suggest that they remained confined to the artists' personal archives. Nonetheless, this does not preclude the possibility that a limited circle of associates had access to the photographs or that the public was ignorant of the artists' activities. In examining these idiosyncratic photographs, I want to consider the pretensions of the artists' group in terms of a cartoon reenactment of their voyage, published soon after their return in one of Vienna's major illustrated newspapers, the *Neue Illustrirte Zeitung* (fig. 6). Like its counterparts in France and England, such as *L'Illustration* and the *Illustrated London News,* this weekly broadsheet catered to a middle-class readership eager for topical news and entertainment, which affirmed their national and imperial worldview.

Fig. 5.
Attributed to Ludwig Steiner (Austrian, dates unknown).
Untitled (Group portrait of Carl Rudolf Huber, Franz von Lenbach, Hans Makart, Adolph Gnauth, Leopold Carl Müller, and Prince Karl Khevenhüller in Cairo), 1875–76, albumen print from collodion-on-glass negative, 15.6 × 24.2 cm (6⅛ × 9⅝ in.). Munich, Dietmar Siegert Collection.

I. Band. 1876. Neue Illustrirte Zeitung. Illustrirtes Familienblatt. Nummer 14. Seite 221.

Eine Reise nach Egypten.

Federzeichnung von L. v. Frecskay.

Whatever the limited circulation of these photographs, the publication of this full-page cartoon testifies to the public interest in the artists' exploits in Egypt.

Casting a critical, even derisive spotlight on the group's activities, this twelve-part cartoon demonstrates a surprisingly detailed knowledge of the voyage and its potential for satirical commentary. From Pettenkofen's change of heart to the party's residential arrangements, the chronological sequence of cartoons draws attention to the public awareness and potentially critical reception of the voyage in Vienna. The cartoons summarize, if not crystallize, some of the key tropes of Orientalist visual culture. In the first cartoon of the third row, for example, Hans Makart rapidly renders his model on his canvas, paint dripping on the floor from his palette, as a eunuch bears down on him in the background. The cartoonist depicts the painter in the process of transforming a racial stereotype of black womanhood into the harem fantasy on canvas. Notwithstanding the racist ideologies that underpin the model's representation, the cartoon implicitly questions the process of harem mythmaking in oil paint. Indeed, the work on the artist's canvas closely matches a painting exhibited soon after his return at the seventh annual exhibition of the Künstlerhaus in Vienna titled *Egyptische Tänzerin* (1876; Egyptian dancer).[41] Although now lost, this painting was later reproduced in deluxe editions such as Georg Moritz Ebers's two-volume study *Aegypten in Wort und Bild* (1878–79; Egypt in word and picture) and the rare volume of xylographs published as the *Hans Makart-Album* (ca. 1881) (fig. 7). Such accurate details point to the cartoonist's intimate familiarity with the artists' voyage and its pictorial outcomes.

The cartoon emphasizes the male bonds of communal pleasure that underpinned the travelers' encounter with the Orient. In contrast to the familiar heterosexual fantasy of the harem, the adjacent cartoon in the third row testifies to the shared spheres of masculine pleasure implicit in their excursion photographs. Champagne glasses aloft, Lenbach straddles a pyramid flanked by his two companions, Makart and Huber. The couplet beneath this cartoon parodies their Orientalist search for answers to the purported mysteries of the East: "Lenbach sits pyramid-like, the others right and left / They seek the riddle of the Sphinx in the bottom of the bottle."[42] The caricature mocks their voyage as one marked by flamboyant excess rather than earnest application, and in the small details of their portrayal—of a hand placed on a companion's knee, or a finger dipped in a glass or plugging a champagne bottle—evocations of homoeroticism further underscore the delineation of their masculine bonds. Reading these cartoons in relation to the photographic orchestrations of self and group in the environs of Cairo, their portrayal bespeaks the colonial privilege of playful self-fashioning as a collective enterprise. The metropolitan reception of their voyage suggested here implies that the central role of shared male fantasies

Fig. 6.
**László Frecskay
(Hungarian, 1844–1916).**
Eine Reise nach Egypten.
From *Neue Illustrirte Zeitung,*
2 April 1876, 221.
Vienna, Österreichische
Nationalbibliothek.

Egyptische Tänzerin.

threatened to disrupt the production of authoritative Orientalist fictions. Like the photographs, the artists' attention was all too often directed toward their performance of social and cultural unity.

In many respects the correspondence, photographs, paintings, and practices of this artistic fraternity are representative of their desire to partake of the conventions of mainstream Orientalism. Yet their voyage did not necessarily meet with uncritical voices in Vienna. Importantly, the accompanying short melodic couplets of the cartoon at times make use of colloquial Viennese dialect or *wienerisch*. In the first cartoon of the second row, for example, Müller welcomes his fellow compatriots with greetings strongly suggestive of his regional background: "'Grüß Gott!' ruft Maler Müller, 'ihr da, ist ja prächtig, / Servus, alte Spezi's! das freut mich niederträchtig.'" ("Greetings!" calls the painter Müller, "you're here, that's splendid / Hello, old pals! This pleases me no end.") By doing so, the artists' backgrounds are localized and their visit defined within the specific cultural dialogues between Vienna and Cairo. Far from worldly, cosmopolitan artists accustomed to oceanic travel and cultural transition, the caricature presents members of the group as ill-equipped to benefit from their voyage: Pettenkofen decides against the journey at the last moment, fearful of the ocean passage; Carl Gangolf Kaiser returns home after a fortnight in Cairo, unable to handle the heat; and Lenbach, on his homeward voyage with pockets out-turned, is robbed of all his possessions in Naples.

The incisive edge to this cartoon suggests that the caricaturist did not necessarily identify with the Viennese swagger of these metropolitan artists. As an illustrator born and trained in Budapest, László Frecskay perhaps harbored his own skepticism of the Habsburg capital and its fashion for exotic subject matter.[43] In 1867, he had moved to Vienna and built his reputation as a caricaturist working for several illustrated journals. This was the same year as the so-called Compromise (*Ausgleich*) between Austria and Hungary, which led to the transfer of limited political rights from Vienna to Budapest and the formation of the Austro-Hungarian Empire. In this context, the cartoon challenges the metropolitan artists' authority to translate their experiences into convincing pictorial products. Frecskay's cartoon was not his first of these artists, and his detailed knowledge of their voyage may well have been informed by his direct personal connections within the Viennese art world.[44] Whatever their professional association, his caricature presents a satirical assessment of the artists' voyage distinguished by misadventure and farce rather than professional achievement. As if to underscore the point, Frecskay's subsequent cartoon of the annual exhibition at the Künstlerhaus in Vienna included caricatures of two paintings: *Egyptisches Längenmaß* (Egyptian linear measure), which mocked the elongated female form of Makart's *Egyptische Tänzerin;* and *Ein Goldrahmen mit*

Fig. 7.
Hans Makart (Austrian, 1840–84).
Egyptische Tänzerin.
From *Hans Makart-Album: 64 Holzschnitte nach Makarts Gemälden* (Vienna: Franz Bondy, [ca. 1881]), pl. 30. Vienna, Wienbibliothek im Rathaus, Druckschriftensammlung.

Staffage (A gold frame with staffage), which derided Pettenkofen by implying that he could exhibit little more than a frame, having abandoned his participation in the voyage.[45] For those increasingly discontented minorities within the Austro-Hungarian Empire, the politics of such metropolitan representations of imperialist adventure and its proponents' feigned cosmopolitanism must have appeared familiar to their own ambiguous situation as exoticized others *and* fellow citizens.

Certainly, these group photographs could be interpreted as the reclamation of a visual technology and social practice—the camera and the photographic session itself—that had become prominent features of contemporary Ottoman and Egyptian self-representation. Nor were such contestations limited to Cairo. In Vienna, Frecskay's caricature lampooned the artists' performance of the kind of metropolitan élan and masculine self-assurance evident in their photographs—a critique that points to the potential of other networks of regional exchange outside the dominant areas of art historical scholarship. Yet such insights or shifted frameworks do not preclude these urbane artists from complicity in the politics of colonial representation. Photography played a central role in the mapping of "those fantasized geographies of male desire,"[46] but the uncertainties in male subjectivity performed in these photographs do not absolve its participants of collusion in the operations of Orientalism. Homoerotic desire and colonial privilege are indissoluble features of such photographic portfolios, yet the question "*in what ways?*" all too often escapes critical consideration.

If one can characterize these group photographs on the outskirts of Cairo as "Orientalist," it is not due to their use of familiar sites or local stereotypes to render legible and self-evident the lessons of cultural difference; rather, it is the reduction or usurpation of location transformed into photographic space. Egypt appears but the stage for the artists' self-absorbed exploration of their own male identities and colonial pleasures. Whereas their studio photographs of female models fabricated place through the deployment of the usual props and poses from the visual lexicon of Orientalism, their outdoor session before the photographer's lens stripped the colonial landscape of its familiar, albeit codified, mise-en-scène. In a process converse to the making of studio photographs, the tableau vivant pleasures of these artists coincided with an apparent denial of place. The amorphous, unremarkable location selected for the session implies a collective desire for discretion, perhaps occasioned by a tacit embarrassment with their tomfoolery, beyond the critical attentions of local bystanders and fellow tourists. The subjects' desires to partake of such imaginative performances may point to the provisional disturbance of their imperialist and sexual certainties, but such intimate male-male gestures and subjectivities

coincided with an attendant erasure of not only the conditions of the photographs' production but also the very signifiers of colonial locality. To characterize this small cache of photographs as "Orientalist"—manifest in a form that seemingly removes the pretense of "Oriental" representation altogether—is to recognize the sitters' collective desire to close their eyes to the colonial circumstances of their commission and partake of the intimate liberties and fantasies of homosocial attachment.

Notes

I am grateful to Ali Behdad and Roger Benjamin for their thoughtful feedback on earlier drafts of this essay, and to Karin Althaus, Bodo von Dewitz, Gabriele Hofer-Hagenauer, Erhard Koppensteiner, Uwe Schögl, and Dietmar Siegert for their assistance in the preparation of this study. This research was undertaken with the support of a research grant from the Carnegie Trust for the Universities of Scotland. Unless otherwise indicated, all translations are mine.

1. "Eine Lustige Gesellschaft: Fürst Karl Khevenhüller, Gnauth, Lenbach, Makart, Huber, Müller: Nach einer Aufnahme des Photographen Steiner in Cairo." Adalbert Franz Seligmann, ed., *Carl Leopold Müller: Ein Künstlerleben in Briefen, Bildern und Dokumenten* (Vienna: Rikola, 1922), opposite 110.

2. Timm Starl, *Lexikon zur Fotografie in Österreich* (Vienna: Albumverlag, 2005), 464.

3. Edward Said, *Orientalism* (London: Routledge & Kegan Paul, 1978), 17.

4. James Clifford, "On Orientalism," in idem, *The Predicament of Culture: Twentieth-Century Ethnography, Literature, and Art* (Cambridge, Mass.: Harvard Univ. Press, 1988), 267.

5. For an introductory discussion, see Robert Lemon, *Imperial Messages: Orientalism as Self-Critique in the Habsburg "Fin de Siècle"* (Rochester, N.Y.: Camden, 2011), 1–14. On Orientalist visual culture in the Habsburg Empire, see Erika Mayr-Oehring and Martina Haja, eds., *Orient: Österreichische Malerei zwischen 1848 und 1914,* exh. cat. (Salzburg: Residenzgalerie Salzburg, 1997); and Erika Mayr-Oehring and Elke Doppler, eds., *Orientalische Reise: Malerei und Exotik im späten 19. Jahrhundert,* exh. cat. (Vienna: Wien Museum in Kooperation mit der Residenzgalerie Salzburg, 2003).

6. I refer here to the Stadtische Galerie im Lenbachhaus, Munich, the former residence of Franz von Lenbach, opened in 1929. Hans Makart was the subject of two major exhibitions in Vienna in 2011. See Ralph Gleis, ed., *Makart: Ein Künstler regiert die Stadt,* exh. cat. (Munich: Prestel, 2011); and Agnes Husslein-Arco and Alexander Klee, eds., *Makart: Painter of the Senses,* trans. Jane Michael, exh. cat. (Munich: Prestel, 2011).

7. Bodo von Dewitz, "*Tatsachen sind so wunderbar an die Stelle von Vermutungen getreten:* Zur Rezeptionsgeschichte des *Orients* im Malerei und Fotografie des 19. Jahrhunderts," in Ulrich Pohlmann and Johann Georg Prinz von Hohenzollern, eds., *Eine neue Kunst? Eine andere Natur! Fotografie und Malerei*

im 19. Jahrhundert (Munich: Schirmer/Mosel, 2004), 257–65; Bodo von Dewitz, "Bohemiens: Die Inszenierung des Künstlers in der Photographie des 19. Jahrhunderts," in Roland Kanz, ed., *Das Komische in der Kunst* (Cologne: Böhlau, 2007), 186–209; and Bodo von Dewitz, "*So denkt man sich in etwa Babylon*: Fotografien einer Künstlerreise nach Ägypten im Jahr 1875," in idem, ed., *La Bohème: Die Inszenierung des Künstlers in Fotografien des 19. und 20. Jahrhunderts* (Göttingen, Ger.: Steidl, 2010), 105–7, 374–75.

8. For example, Hollis Clayson has examined the "intense camaraderie" of the Orientalist painters Henri Regnault and Georges Clairin, who established a studio together in Tangier in 1870. Hollis Clayson, *Paris in Despair: Art and Everyday Life under Siege (1870–71)* (Chicago: Univ. of Chicago Press, 2002), 237–38, 268–72.

9. Roger Benjamin, "Die Morgenlandfahrt: Künstler der Moderne im Orient," in Roger Diederen and Davy Depelchin, eds., *Orientalismus in Europa: Von Delacroix bis Kandinsky,* exh. cat. (Munich: Hirmer, 2010), 212.

10. David Deitcher, *Dear Friends: American Photographs of Men Together, 1840–1918* (New York: Abrams, 2001), 51–62.

11. Deitcher, *Dear Friends,* 62.

12. Deitcher's critique of an exhibition of daguerreotype portraits of gold rush miners in California is no less pertinent to much recent scholarship on Orientalist photography: "This silence regarding the affectionate poses adopted by some of the miners whose images survive to this day represents business-as-usual in the world of scholarly photo history, 'serious' collection, and museum display. It is consistent with the way prominent collectors, connoisseurs, and historians have allowed this aspect of nineteenth-century American photography to go, if not unnoticed, then unremarked on." Deitcher, *Dear Friends,* 86.

13. See Joseph A. Boone, *The Homoerotics of Orientalism: Mappings of Male Desire in Narratives of the Near and Middle East* (New York: Columbia Univ. Press, forthcoming); Joseph A. Boone, "Vacation Cruises; or, The Homoerotics of Orientalism," *PMLA* 110, no. 1 (1995): 89–107; and Todd D. Smith, "Gay Male Pornography and the East: Re-Orienting the Orient," *History of Photography* 18, no. 1 (1994): 13–21.

14. Eve Kosofsky Sedgwick, *Between Men: English Literature and Male Homosocial Desire* (New York: Columbia Univ. Press, 1985), 1–2.

15. "(Personalnachrichten) Die berühmten Maler Makart, Lenbach u. Pettenkofen, Architekt Kaiser und Architekt Gnauth (aus Stuttgart), sind mit dem gestern um Mitternacht nach Alexandrien abgegangenen Lloyddampfer *Saturno* zum Winteraufenthalt nach Cairo abgereist. Auch der Reichsraths-Abgeordnete Graf Khevenhüller-Metsch mit Gema[h]lin haben sich mit demselben Dampfer nach Egypten begeben." [Personal news. The famous painters Makart, Lenbach and Pettenkofen, the architect Kaiser and the architect Gnauth (from Stuttgart), departed on a winter holiday for Cairo yesterday at midnight aboard the Lloyd's steamer *Saturno* bound for Alexandria. The representative of the Imperial Council, Count Khevenhüller-Metsch and his wife, embarked aboard the same steamer for Egypt.] *Die Triester Zeitung,* 20 November 1875, 5. Absent from the group photographs but listed in this report is the Viennese architect Carl Gangolf

Kaiser, who apparently stayed only two weeks in Egypt.

16. Leopold Carl Müller to Rudolf von Eitelberger, 20 November 1875, in Herbert Zemen, ed., *Leopold Carl Müller, 1834–1892: Ein Künstlerbildnis nach Briefen und Dokumenten* (Vienna: self-published, 2001), 236–37.

17. "Kairo ist über alle Erwartung fabelhaft, von den 500 000 Einwohnern ist einer merkwürdiger als der andere, die Straßen, Tempel, Menschen u. Thiere u. was es sonsten noch gibt sehen aus wie vor tausend Jahren, so denkt man sich [in] etwa Babylon." Neven DuMont collection, Cologne, cited in Rosel Gollek, "Lenbach in Ägypten," in Winfried Ranke, ed., *Franz von Lenbach, 1836–1904,* exh. cat. (Munich: Prestel, 1987), 129.

18. Ali Behdad, *Belated Travelers: Orientalism in the Age of Colonial Dissolution* (Durham, N.C.: Duke Univ. Press, 1994), esp. 57–58.

19. Lisa Pollard, *Nurturing the Nation: The Family Politics of Modernizing, Colonizing, and Liberating Egypt, 1805–1923* (Berkeley: Univ. of California Press, 2005), 40–45.

20. "Liebster Freund! Ich bin, wie Du ohnehin weißt, wieder in meinem geliebten Cairo—und bin entzückt. Daß Makart, Huber und Lenbach hier sind weißt Du auch. Ich habe mit ihnen ziemlich viel Zeit verloren mit Herumlaufen u. s. w. Pettenkofen ist in Triest wieder wasserscheu geworden und umgekehrt, obwohl er fest entschlossen war, hierher zu kommen. Da macht der Narr die Reise von Paris nach Wien und dann nach Triest!!" Leopold Carl Müller to Ferdinand Laufberger, 7 December 1875, in Seligmann, *Carl Leopold Müller,* 109.

21. The passenger report cited in note 15 suggests that Pettenkofen had boarded the steamer bound for Alexandria, but subsequent sources indicate he did not embark with his colleagues. *Die Triester Zeitung,* 20 November 1875, 5.

22. Gollek, "Lenbach in Ägypten," 129.

23. Müller to Laufberger, 7 December 1875, in Seligmann, *Carl Leopold Müller,* 109; and W. Wyl, *Franz von Lenbach: Gespräche und Erinnerungen* (Stuttgart: Deutsche Verlags-Anstalt, 1904), 66–67.

24. The preceding quotations derive from Müller's description of their lodging: "Ich habe mir einen ganzen Raum ganz reizend dekorirt. Die Wände und der Plafond sind mit Holzschnitzereien bedeckt, die 200 Jahre alt sind, und nun habe ich 9 Teppiche gekauft und einige Einrichtungsgegenstände. Ich habe viel ausgegeben, komme mir aber jetzt dafür wie ein Pascha vor…Wir haben uns eine Menge Diener aufgenommen, auch einen Portier (einen schönen braunen Abyssinier)." Müller to his sister Amalie, 18 December 1875, in Zemen, *Leopold Carl Müller,* 245.

25. On Lewis's harem masquerade in Cairo, see Mary Roberts, *Intimate Outsiders: The Harem in Ottoman and Orientalist Art and Travel Literature* (Durham, N.C.: Duke Univ. Press, 2007), 19–37.

26. Müller to Laufberger, 1 March 1876, in Zemen, *Leopold Carl Müller,* 248. Nonetheless, for a selection of Lenbach's paintings and sketches in Egypt, see Sonja Mehl, *Franz von Lenbach in der Städtischen Galerie im Lenbachhaus München* (Munich: Prestel, 1980), 85–88; and, for Makart's works, see Gerbert Frodl, *Hans Makart: Monographie und Werkverzeichnis* (Salzburg: Residenz, 1974), 349–50, 356–59.

27. "(Personalnachrichten) Die Herren Makart und Lenbach wollen von Kairo

aus noch einen größeren Ausflug nach Memphis machen und sodann über Griechenland und Italien Anfangs März nach Wien zurückkehren." [Personal news. Herr Makart and Lenbach want to make an even larger trip from Cairo to Memphis, and then return via Greece and Italy to Vienna by early March.] *Die Triester Zeitung,* 10 February 1876, 5.

28. Lenbach to J. v. W., 3 March 1876, quoted in Siegfried Wichmann, *Franz von Lenbach und seine Zeit* (Cologne: M. DuMont Schauberg, 1973), 54.

29. On Huber as a photographer, see Starl, *Lexikon,* 214. For further examples of this portfolio, see Bodo von Dewitz, *An den süssen Ufern Asiens: Ägypten, Palästina, Osmanisches Reich; Reiseziele des 19. Jahrhunderts in frühen Photographien,* exh. cat. (Cologne: Agfa Foto-Historama, 1988), 128–33; Pohlmann and von Hohenzollern, *Eine neue Kunst?,* 266–67; Landesgalerie Linz, Signatur F2960, Sammlung Frank, Oberösterreichische Landesmuseen, Linz, Austria; and the Ken and Jenny Jacobson Orientalist photography collection, 2008.R.3, boxes T35, T83, and T97, Getty Research Institute.

30. Ken Jacobson is representative of the desire to ascribe a visual association between the artists' painterly and photographic output and thus justify the latter's status as "photographic studies." Jacobson argues that some of the artists' paintings and published illustrations bear "a strong resemblance to some of the photographic studies," only to qualify this position elsewhere: "The prints in the book [Georg Ebers's *Egypt: Descriptive, Historical, and Picturesque*] reproduce figures that appear to be copied from photographic studies, though no Huber circle photograph is identical to any single print. In some examples in the Ebers book, however, *it certainly appears likely* that the photographs of Huber and colleagues or others were used for preparing works of art" (my italics). Ken Jacobson, *Odalisques and Arabesques: Orientalist Photography, 1839–1925* (London: Quaritch, 2007), 70–71, 244–45. Given the widespread use of photographs by Orientalist painters, it is notable how little use these artists actually made of their own photographs for their paintings and book illustrations.

31. "Die Künstler pflegten den Mussafir Chan das Narrenhaus zu nennen, und närrisch genug ging es darin zu: Die arabischen Modelle, die anfangs sehr schämig thaten, wurden schließlich so dreist, daß sie ganz ungeniert in Eva'scher Toilette herumliefen. . . . Die photographische Maschine wurde fortwährend gebraucht—es wurden die tollsten Posituren abconterfeit, Posituren, von welchen die minder unanständigen nicht zu schildern sind." "Hans Makart in Kairo," *Der Beilage der Allgemeinen Zeitung,* 27 September 1876, 4135, cited in Frodl, *Hans Makart,* 23.

32. ". . . abenteuerte er in gefährlichen Weinschenken der Hafenviertel, wo er nubische braunhäutige Modellmädchen, üppige Fellahweiber, sudanesische Liebesverkäuferinnen und herrlich gewachsene, alles gewährende arabische Tänzerinnen fand, wahre Sphinxe, die sein immer wachsames Auge entzückten." Emil Pirchan, *Hans Makart: Leben, Werk und Zeit* (Vienna: Wallishausser, 1942), 61.

33. Pirchan, *Hans Makart,* 61.

34. For example, see T. J. Clark, *The Painting of Modern Life: Paris in the Art of Manet and His Followers* (New York: Knopf, 1984; reprint, London: Thames & Hudson, 1985), 79–146; and Hollis Clayson, *Painted Love: Prostitution in French Art of the*

Impressionist Era (New Haven: Yale Univ. Press, 1991). In the colonial context, see Roger Benjamin, *Orientalist Aesthetics: Art, Colonialism, and French North Africa, 1880–1930* (Berkeley: Univ. of California Press, 2003), 165–66.

35. Makart's estate, auctioned soon after his death in 1885, included seventy-four photographs of "Egyptische Typen" and twenty-four cabinet-card format "Orientalische Costume-Bilder" among its 2,500 prints. A. Streit, *Katalog des künstlerischen Nachlasses und der Kunst- und Antiquitäten-Sammlung von Hans Makart* (Vienna: R. Waldheim, 1885), lot nos. 1060 and 1075.

36. For reproductions of these photographs, see Mayr-Oehring and Doppler, *Orientalische Reise,* 70, 223.

37. I am indebted here to Abigail Solomon-Godeau's study of ephebic masculinity in French neoclassical painting and in particular her analysis of Jacques-Louis David's *The Death of Joseph Bara* (1794). In a passage no less pertinent to the group photographs examined here, she argues with reference to this work, "it is necessary to distinguish the visual rhetoric of masculine disempowerment from its political reality, and the actual circumstances surrounding this particular painting." Abigail Solomon-Godeau, *Male Trouble: A Crisis in Representation* (London: Thames & Hudson, 1997), 135.

38. Deitcher, *Dear Friends,* 16.

39. Dewitz, "*So denkt man sich in etwa Babylon,*" 350.

40. Makart's love of photographic self-portraiture and fancy dress balls epitomized the artists' metropolitan enjoyment of such playful pursuits. For specific studies, see Elke Doppler, "Die Inszenierung des Künstlers: Hans Makarts Selbstbildnisse und Fotoporträts," in Ralph Gleis, ed., *Makart: Ein Künstler regiert die Stadt,* exh. cat. (Munich: Prestel, 2011), 40–49; and Uwe Schögl, "Hans Makart and Photography," in Agnes Husslein-Arco and Alexander Klee, eds., *Makart: Painter of the Senses,* trans. Jane Michael, exh. cat. (Munich: Prestel, 2011), 216–20.

41. Renata Kassal-Mikula, *Hans Makart, Malerfürst (1840–1884),* exh. cat. (Vienna: Historisches Museum der Stadt Wien, 2000), 119.

42. "Pyramidal sitzt Lenbach hier, die Andern rechts und links / Sie suchen in der Flasche Grund die Rebusse der Sphinx." L. v. Frecskay, "Eine Reise nach Egypten," *Neue Illustrirte Zeitung,* 2 April 1876, 221.

43. W. Aichelburg, "László Frecskay," in *Allgemeines Künstlerlexikon: Die Bildenden Künstler aller Zeiten und Völker,* vol. 44 (Munich: K. G. Saur, 2005), 260.

44. See László Frecskay, *Caricature of Makart, Lenbach and the Sculptor Victor Tilgnor* (Munich, Lenbach Archive, ca. 1872), reproduced in Sonja von Baranow, *Franz von Lenbach: Leben und Werk* (Cologne: DuMont, 1986), 27.

45. L. Frecskay, "Aus der Jahres-Ausstellung im Wiener Künstlerhaus," *Neue Illustrirte Zeitung,* 30 April 1876, 284. Even six months after the exhibition, Makart's portrayal of Egyptian women as thin and elongated was attested in the correspondence of a German tourist in Cairo. See B. B. Schwartzbach, "Aus dem Lande der Sphinx," *Die Gegenwart: Wochenschrift für Literatur, Kunst und öffentliches Leben,* 30 December 1876, 447. Pettenkofen regretted his decision not to accompany his colleagues to Egypt for the rest of his life, but he managed to ameliorate the professional cost of his landlubber anxieties by specializing in Hungarian peasant and "gypsy" scenes. Viennese critics such as Ludwig Hevesi

considered his paintings to be studies of regional exotica, analogous to the work of Eugène Fromentin in Algeria or Jean-Léon Gérôme in Egypt. Pettenkofen's career therefore exemplifies the Viennese exoticization of Hungarian society. For details, see Arpad Weixlgärtner, *August Pettenkofen,* vol. 1 (Vienna: Gerlach & Wiedling, 1916), 193; and Ludwig Hevesi, "Pettenkofen," *Fremdenblatt,* 24 March 1889, reprinted in Herbert Zemen, ed., *August Pettenkofen, 1822–1889: Sein künstlerischer Nachlass* (Vienna: self-published, 2008), 72.

46. Boone, "Vacation Cruises," 104.

HANNAH FELDMAN

FLASH FORWARD
Pictures at War

Unmooring the Orient

In order to consider a suite of photographs produced in Paris during the final year of the Algerian War of Independence (1954–62), this essay aims to issue a series of provocations and to perform a sequence of displacements that are as temporal and spatial as they are discursive and material. As concerns the first two of these categories, it needs to be said from the outset that this essay remains something of an outlier within the context of a collection of texts dedicated to that category of photography normally invoked by the nomination *Orientalist*. Indeed, this text considers neither late-nineteenth- nor early-twentieth-century photography, and certainly not photography taken in or of a place meant to correspond geographically to a region we might call the Middle East or North Africa. And this is precisely the point. Recalling Edward Said's claim that Orientalism is generated by an "imaginative geography" that has amalgamated a constellation of "ideological suppositions, images and fantasies about a currently important and politically urgent region of the world called the Orient," this article begins by proposing we reimagine this geography, or imagine it differently.[1] Situating the Paris photographs as straddling the line constructed long ago to demarcate "Occident" from "Orient" helps trouble the certainty that we know where Orientalism is or was, and when it was—suppositions that all imply Orientalism is over. Fixing Orientalism temporally and geographically in this way risks reinscribing the very same Orientalizing attributes of knowledge that Said hoped to undermine in his original analysis.[2]

If it is true that photography was an important tool in securing the imperial formation of the "Orient" during the mid- to late nineteenth century—which "Zoom Out: The Making and Unmaking of the 'Orient' through Photography," the conference that generated the impetus for this volume, took to be an establishing fact—then it is equally so that photography played a crucial role in the unmaking of the same a century later. This is especially true of a place I will, for now, call Algeria, but which I want to leave territorially vague for reasons that will become clear by the end of the text. Indeed, if what we now call the Algerian War of Independence was "une guerre sans visage,"[3] it is nonetheless

widely acknowledged that the French military apparatus (along with, to a different degree, the press) produced and helped circulate a vast store of images to help generate exactly such a "face"—and to thereby naturalize the alternating claims that Algeria should be maintained as integrally "French," "associated" with France, or, finally, severed quickly and completely as a place incompatibly "other."[4] It is still assumed, however, that the Algerian resistance on both sides of the Mediterranean produced few correlate images and that the image war was therefore unequal. This is most likely true to a certain degree, even if it does rest on assumptions about archival integrity that I will address below. Yet focusing on this imbalance of production risks overlooking the concrete efforts to achieve representation that were, in fact, deployed by an otherwise subaltern resistance to French imperialism. In turn, this allows the structural conditions of inequality to reinscribe themselves as structuring claims about history itself, thereby limiting how and what we can see, otherwise.

To oppose this formulation, I focus here on a different set of images from this war, images that in this context must also be considered as Orientalist in that they too construct and place an image of the "Orient," even if they do it differently and differentially. In fact, we might imagine these pictures as constituting the future tense of the images discussed elsewhere in this volume and hence as a "flash forward." The filmic reference here is deliberate and means to underscore the material shifts to which the Orientalist photograph is subject as it moves between the earlier epochs of Orientalism discussed elsewhere in this volume and the period—not to mention the place—I analyze. In this temporal trajectory, photography itself is transformed by the evolution of cinema and the rise of television just as—to flash forward once more—it has now been transformed again by the advent of digital media. The point is, photography is no more stable than the sites in which it is produced and which we "imagine" we know *through* it.

It is not surprising then that the stakes of these material shifts for a discussion of the sites of Orientalist photography are made clear in a 1923 advertisement for a 9.5 mm film projector, Pathé-Baby, designed by the French film house giant Pathé for home use (fig. 1). In this image, now collected as one of the latest-dated images in the Ken and Jenny Jacobson Orientalist photography collection at the Getty Research Institute, the still images of the desert landscape that constitute so much of the Orientalist archive are shown caught in interrupted motion as they are projected on the wall of an upper-class home in what we take to be the metropole. Here, two young boys, supervised by a young woman who looks more like a governess than a mother, enjoy what are emphasized as explicitly moving images of deserts and camels in relationship to the textual registers of static knowledge compiled in the neglected encyclopedias

Fig. 1.
Advertisement for 9.5 mm
film projector Pathé-Baby.
From *L'Illustration,*
17 March 1923.
Los Angeles, Getty Research
Institute.

17 Mars 1923 L'ILLUSTRATION Annonces — 7

LA CINÉMATHÈQUE
Pathé-Baby

A côté de la bibliothèque déjà si belle et si précieuse, chaque famille crée une cinémathèque PATHÉ-BABY, véritable encyclopédie vivante.

En vente chez tous les marchands d'appareils photographiques et dans les Grands Magasins. Pour tous renseignements et l'adresse de notre agent le plus proche, demandez le catalogue à :

L'appareil prêt à fonctionner **275** fr.
Films 5 et 6 fr.

PATHÉ-CINÉMA
Service AR
20 bis, rue Lafayette — PARIS

stacked to the left. That this photographic movement is harnessed within the reassuring domestic sphere is also instructive. Indeed, as photographs begin to move—both from the site of their making into the metropolitan domestic interior and from static depictions of an unchangeable landscape to kinetic representations of the same—we begin to see more clearly how photography is much more than a vessel *through* which sites are made. On the contrary, the analysis below means to highlight how photographs themselves do as much making and unmaking on their own despite, perhaps, being otherwise presumed mere secondary sites of inscription. In moving us closer to understanding what may or may not be "photography's Orientalism," and whether it is inherent or contingent to the medium, this shift requires us not only to question what it is that we mean by "Orientalist" but even more importantly to question how we understand photography. In particular, it means ascribing a specific agency, for lack of a better word, to the camera—a mechanical object that Vilém Flusser convincingly named an "apparatus" to indicate its simultaneously productive and dependent capacities—and to suggest that *this* agency is what is put into play by subjects in pursuit of achieving representation or, in other words, of becoming photographic events.[5]

Archives and Agency

As suggested above, between 1954 and 1962 the French army produced vast numbers of images, many of which were, for instance, published in photo journals intended to show conscripts news from home as well as local scenes of battle. Conscripts themselves were enlisted in this production, and each military unit was charged with an amateur troop photographer. Their charge was not only to document scenes that might be mobilized for propagandistic purposes but also, as Marc Garanger's famous headshots of Kabyle Berbers have come to attest, to survey the indigenous populations.[6] Such documentation was meant to enable what Abdelmalek Sayad and Pierre Bourdieu would call the *déracinement* of the population: once identities were transposed to the identity documents necessitated by French state bureaucracy, groups were available to be comprehensively relocated to the *centres de regroupement* that the French set up across the country.[7]

Many of these images have become quite famous, and some have even achieved the status of iconic images: they are included in important collections and have, as a totality, generated scholarly analyses that either decry their Europeanizing imperatives or locate in the sitters' gazes the signs of insurrectional commitment that would, in fact, lead to the overthrow of the French colonial regime. Of the many photos shot by French professionals and amateurs

during the war, more than one hundred thousand are now consultable in the special branch of the archives of the Ministère de la défense dedicated to the Établissement de communication et de production audiovisuelle de la défense (l'ECPAD) in Nanterre, and the early opening of military archives means more will soon be available. In Algiers, however, cardboard boxes of photographed and rephotographed news clippings, stock photos, and smaller collections of private archives sit uncataloged and largely unstudied at the Centre nationale de documentation de presse et d'information (CNDPI), having long been subject to political debates that unfolded in the aftermath of independence. Thus, what has been repeatedly acknowledged as an originary dissymmetry of production might be better understood as a dissymmetry of and in the archive. In turn, this dissymmetry has reproduced itself within analyses that assume that because we have not seen images they do not exist. This is not to say that in the future, we will not know that the Algerians also produced photographs or that images were produced "of" them that were "for" them as well. Pierre Bourdieu's photographs of Kabyle populations and the urban conditions of Algiers during the war maintain an ambiguous status in this regard, but those of the Dutch photographer turned Front de libération nationale (FLN) ally Kryn Taconis; the Yugoslavian photojournalist Stevan Labudovic; and the self-appointed staff photographer of the Gouvernement provisoire de la République Algérienne (GPRA) Mohammed Kouaci are less ambivalent.[8] Indeed, some of Kouaci's most iconic post-independence photographs demonstrate what should be similar investments in making and remaking the "Orient" in accordance with mythic properties. And, yet, they are different: rather than passive and feminized, for example, the "Orient" as it is pictured in this street scene of a post-independence parade is cast as heroic and stable, triumphant rather than trounced (fig. 2).

Photographs like Kouaci's are not collected by the Getty Research Institute, nor were they shown in the *Walls of Algiers* exhibition that took place there in 2009. Of course, there are historical reasons for such absences, and the fact that collections are always only as robust as the markets from which they are built does not merit extended preoccupation. It does bear noting, however, that Kouaci's images feature prominently in both xeroxed and painted copies in several of Algiers's own institutions, including the aforementioned CNDPI, the Musée national du Moudjahid, the Musée de l'armée, and the tiny house museum in the Casbah dedicated to Ali La Pointe. The point here is less that Algerians prefer an Algerian's presentation of their shared history—indeed, this is contradicted by the prominent place afforded figures like Taconis in some of these same institutions. Rather, that these images are copied and recirculated as pictures remarkable for what they captured and how they did so—rather

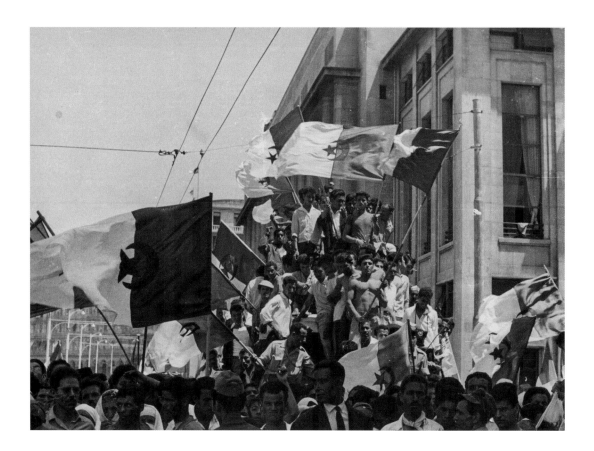

Fig. 2.
Mohammed Kouaci
(Algerian, 1929–96).
Independence celebrations in
Algiers on 5 July 1962, black-
and-white photograph.

Fig. 3.
"Tortures" committed
during the Algerian War of
Independence, ca. 1961.
Color photograph, 9 × 13 cm
(3⅝ × 5⅛ in.).
Los Angeles, Getty Research
Institute.

than as objects of inherent authentic or aesthetic value—suggests something important about how photographic images and the agency ascribed them were understood by populations other than the French during a war of admittedly unequal access to dominant means of representation.

Such access had already been a question during the war itself, when figures from the international Left took an interest in documenting the Algerian cause in order to make visible the atrocities being committed by the French state in the name of what it called France. Strangely enough, a few of the images that resulted from this effort have made their way into the Getty Research Institute archives, where they are also joined now and again by amateur troop photographs such as, for example, those collected in the pedagogical dossiers of the Association connaissance de l'histoire de l'Afrique contemporaine (ACHAC). The most striking of these politically motivated photos appear in the papers of Gloria de Herrera, a Los Angeles–born art restorer best remembered for having executed a number of Henri Matisse's late-period cutouts, but also an important artist in her own right. Living in France during the war, de Herrera's political commitments had led her to join the ranks of the so-called *porteurs-de-valise* who transported funds from Paris to the

FLN ranks in Europe, and she was, in fact, one of the two dozen artists and intellectuals arrested for such activities in February 1960. Unlike her French partners, de Herrera were quickly released, however, and did not participate in the famous Jeanson trial, which in and of itself became an important turning point for French attitudes toward the war.[9]

Before her arrest, de Herrera had traveled to Algiers with Dominique Darbois, another *porteur-de-valise,* to document the training camps run by the military correlate to the FLN, the Armée de libération nationale (ALN). Darbois's photographs were published in 1960, making her one of the first photographers to publish wartime photos of Algeria in the name of what she described as peace and justice.[10] Darbois's faith in the power of what it would mean to "see" the evidence provided by both brutalized bodies and well-intended efforts at Algerian organization (schools, hospitals, and the like) would find an echo a year later in Jean-Paul Sartre's preface to Frantz Fanon's *Wretched of the Earth* (1961), wherein Sartre argued that the shame of having *seen* the evidence of the abuses committed in their name should have convinced the French public to oppose the continued occupation of the Algerian territories.[11]

In the de Herrera papers, a folder described simply as containing "atrocity photos" and labeled presumably in de Herrera's hand as "Photos tortures/ Algérie 1961" contains two such photos, otherwise not published by Darbois in her 1960 book and not exactly of the genres represented in that volume (fig. 3).[12] Perhaps more than any other kind of image, these—with abject and tortured bodies lying prostrate on the ground, dead or nearly so, bleeding, naked, maimed—manifest the fate of the Orientalist photograph in the

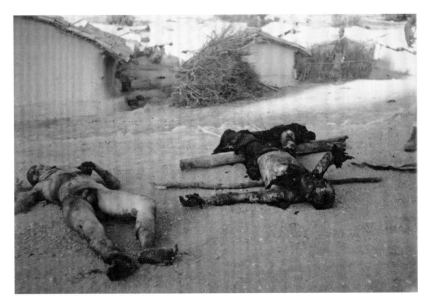

century and a half of its movement: time and place remain perpetually static and just beyond history, while the lurid imaginary of catastrophe has replaced that of sexual fantasy. Such a correspondence has been underscored by terms like *war porn,* which Jean Baudrillard coined after 9-11 to name images like these, and it is certainly by now something of a scholarly truism that such photographs further discipline bodies, situating relations of power ambiguously, but, finally, without organizing to contrast or challenge them. Against what is presented as the naive humanism of a figure like Sartre, for example, the aesthetic philosopher Jacques Rancière tells us that these images do nothing but evoke identifications with the victimized and so enact nothing on the level of politics, which depends instead on a disidentification with the authority that excludes rather than on empathic projections with those who are excluded.[13]

But do they? Or, rather, did they? And if they did, does that mean that they do so always? And what does it mean that we have now become as confident that we should look away from these images as we might once have been to believe that they would tell us something? It is true that de Herrera's atrocity photographs tell us little. Without caption beyond the handwritten notation "Photos tortures," we are hard-pressed to determine who committed the crimes depicted here or on which side of the war they fought. We might deduce from Darbois's and de Herrera's sympathies that the pictures document tortures committed by the French, but that would be imprecise and premature. The photographs communicate little about *that* kind of identity-based agency.

But this silence is instructive. Not only were images like the one reproduced here not circulated in Darbois's book—which, even stripped of such extreme images of violence or horror, could still find a publisher only in Milan—they also were not circulated in the French press (in France or in French Algeria).[14] The FLN organ *El Moudjahid* had little money to publish photographs and, indeed, most of its first five years of production feature very few images altogether. The question becomes then how images such as these might have come to circulate in a public sphere that existed beyond the purview of in-the-know or like-minded audiences who would have known what they meant and what they meant to show. And, within the context of this analysis of Orientalist photography as following a course, albeit circuitous and complex, this question of circulation instantly returns us to what such means of access tell us about the cause of Algerian agency. Better, it prompts us to reconsider the stakes of being represented—that is to say, of submitting to an Orientalism precisely in order to contest and challenge the fixedness of such a gaze. To imagine what it means or what it might have meant to look at images like these during the war, and to

consider how that looking might have been conditioned less by codes of author-ship or subject position than by the technical aspects of photography's capacity to disrupt, I want to examine another set of images from the same period. These images also show us disciplined bodies, though in very different spaces and to very different effect.[15]

Re-siting the Orient

The three photographs to which I now turn document different moments in an anti-imperial protest that has come to assume a central place in both the histo-riography of the Algerian War of Independence and in the long *durée* of police violence in metropolitan France.[16] Famously now, on 17 October 1961, twenty to thirty thousand "Algerians" processed from the suburban quarters of Paris to contest a curfew issued by the prefect of police, Maurice Papon.[17] Their instruc-tion to do so had come from the Fédération de France du FLN (FF-FLN) lead-ership in Switzerland, with the reluctant support of the GPRA in Tunis. As has become well chronicled in the half century since 1962, the peaceful refusal by the "Algerians" of Papon's curfew was met with extreme violence by the French security forces. While contemporaneous police accounts reported that two of the protesters had been mortally wounded and that the "Algerians" had fired first, testimonial and archival evidence has more recently confirmed the num-ber of casualties as closer to one hundred, dozens of whom were shot, beaten to death, or drowned.

Papon's curfew was intended as more than a security measure in a time of war, even if unnamed as such. Indeed, it was also an imperial maneuver designed to restrict the rights of what the letter of his decree called "Français musulmans d'Algérie"—but which, importantly, police practice designated to be whomever appeared *visible as* a "French Muslim from Algeria"—to circu-late on the streets of Paris after 8 p.m. and to thereby enjoy the same "right to the city" exercised by other "Français."[18] What the FF-FLN–orchestrated protest depended upon, then, to stage the disruption necessary to make the stakes of Papon's intervention clear was therefore not just the symbolic occu-pation of space or even its practical repurposing. Instead, it required a "spec-tacular" occupation that would take visual form within the territory marked by the intersection of the rapidly commodifying public sphere and the so-called public space of the city.[19] In a prescient foretelling of Roland Barthes's much more famous description of being photographed as providing occasion to con-stitute oneself as a "self," the FF-FLN leadership anticipated the confirmation of presence that could result only through the view of those cameras that would rush to capture the spectacular disagreement within the normal distribution of

appearances generated by the sudden and unanticipated arrival of more than twenty thousand "Algerian" working class in the more exclusive districts of the French capital.[20]

A photograph taken by an unknown photojournalist collected in the archives of the photographer Jacques Boissay provides a case in point (fig. 4).[21] The picture, for which no publication record exists, shows a mass of protesters several hundred deep in front of what was then the rather remarkable marquee of the Berlitz Theater, situated at the junction of the Boulevard des Italiens and the Rue de la Michodière in the middle of the *grands boulevards.* Out of context, it might even appear that the picture documents a crowd anxiously waiting for the opening of a blockbuster. Indeed, the top half of the night scene is illuminated from above by the glow of a few arched streetlamps and from behind by the neon lights spelling out the name of the film, *Le cave se rebiffe* (1961), then playing at the Berlitz, and projecting the visage of its star, Jean Gabin, who played a master counterfeiter newly returned to France from a "tropic retreat." The irony secured by the well-lit face of the man made famous for his role as Pépé le Moko in the eponymous Orientalist film (1937), in which the young Gabin takes refuge from the police in the labyrinthine streets of Algiers's Casbah, may not have been lost on the photographer. Gabin's likeness is once again situated in relationship to what here appears to be an Algerian street scene, which is to say a street scene populated by what appear to be Algerian subjects in full possession of their right to the leisure spaces of the urban context in which they are seen, posing.

The picture is animated by the discrepancy between Gabin's rather dour, pallid countenance and that of the crowd of mostly dark-skinned men over whom his image looms. Like Gabin, the majority of men in the crowd are visible from the chin up, their short-cropped dark hair echoing his dark hat. On the left side of the picture, the men appear content, determined. Farther back, the photograph catches hands lifted as if in midcheer and more than a few chins tilted upward as those in the rear of the column attempt to peer over the heads of those in front. The protesters wear raincoats and many sport ties and jackets, presumably their finest, or what the press at the time widely—and with customary lack of cultural sensitivity—reported as their "Sunday best."[22]

In the very center of the photograph, almost directly beneath Gabin, stands a well-dressed man. Facing the viewer, his erect posture neatly divides the picture into two equal halves along the buttons of his overcoat, up the line and knot of his tie, through the "V" of his sweater's neck, along the perfectly symmetrical contours of his profile, and through the seam of the marquee. His centrality to the image is underscored by the lightness of his coat, which pulls our eyes toward him. Most striking, however, is his gaze, which returns, calmly and

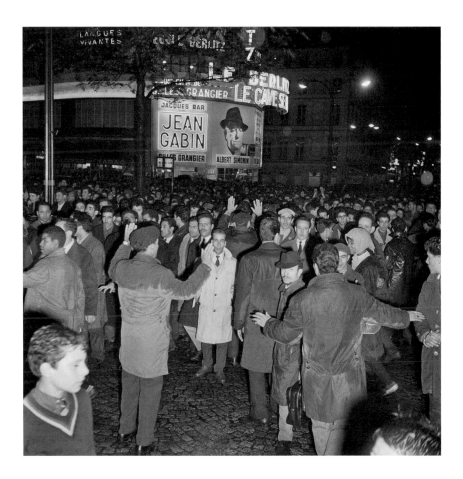

Fig. 4.
**Manifestation in Paris,
17 October 1961.**
Black-and-white photograph.

with the slightest hint of a smile, the gaze of the photographer. He seems quite aware of posing, of inviting the viewer to look at him and to make of him an image like that of the hero-criminal Gabin some fifty feet above.

Men like this might well have ended up dead, a fact confirmed by other photographs taken that evening. Those photographs, shot at much greater risk and under much more adverse conditions than the Boissay picture, have been much more successful in entering the "historical" record, perhaps because of the ways in which they adhere to the Orientalist expectations outlined above in relationship to the photographs that de Herrera either took or collected (the bodies are passive, wounded, defeated, and disciplined), perhaps because of the authority of their "maker," or perhaps because they too are extraordinary in what they document against all odds. Of the dozen or so photos documenting the death and torture that took place on 17 October 1961, I am here most interested in several shot by Elie Kagan, a freelance photographer who had developed strong relationships with many left-leaning organs despite—or maybe because of—his propensity for political outbursts and bad behavior, and who has since become well known for his photographs of the May and June protests in France in 1968.[23]

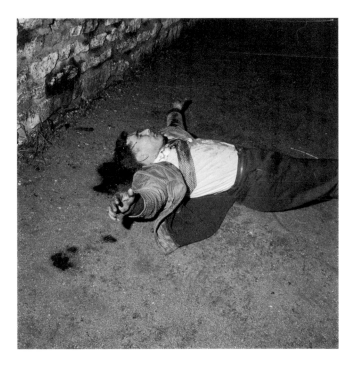

Fig. 5.
Elie Kagan (French, 1928–99).
Wounded man (Abdelkader Bennehar) on the Rue de Paquerettes, Nanterre, 17 October 1961, black-and-white photograph.

Fig. 6.
Elie Kagan (French, 1928–99).
Arrested manifestants at the Métro Place de la Concorde, Paris, 17 October 1961, black-and-white photograph.

Contrary to assertions that photographs like Kagan's were never printed and were routinely confiscated by the police, several of the bloodier images Kagan took were actually printed in *France Observateur, L'Express, L'Humanité,* and *Témoignage Chrétien.* In a full-page spread on 26 October, for example, *France Observateur* ran the Kagan photograph reproduced here alongside an article titled "Aucun français ne peut plus ignorer ça" (Not a single Frenchman can ignore that [this] any longer) by François Furet under the pseudonym "A. Delcroix" (fig. 5). In the photograph, a man lies dying. His right arm stretches toward the viewer as he struggles to lift himself from the cement on which he has fallen, his jacket splayed underneath him.[24] The foreshortened perspective makes the bloodied knuckles of his hand loom large and draws the viewer's attention to yet more blood: staining the front of his white shirt, darkening the cement below his head, and running in a neat stripe down his forehead toward a dark brow, where it crosses with the blood that has already pooled in the furrowed creases there.

According to some accounts, Kagan was not, in fact, in Nanterre by chance or by virtue of his intrepid politics. Rather, his presence at the manifestations seems to have been suggested by local FF-FLN leadership, a supposition that indicates that they anticipated exactly what the outcome of the manifestation might be.[25] As such, it is not at all implausible to suggest that some of what we see in front of Kagan's lens was explicitly staged as a "spectacle" for the lens, and this precisely in order to show us something on behalf of a people who could

otherwise show very little and who had little access to the means of representa-
tion. So, while it was Kagan who pressed the shutter release, the photographic
agency in question here was not just that of the FF-FLN but also that which
materialized through the prosthesis of the camera.

Why this matters is made even more apparent in other Kagan photographs
from the same night. Indeed, many of Kagan's photographs of the event have
become iconic, radically displacing images like the Boissay image (see fig. 4)
or the many others circulating in the press in the days just after the 17th of
October that showed the almost leviathanlike mass of protesters on the central
boulevards. To be sure, we might ascribe the popularity of photos like Kagan's
to the sensationalism of the Orientalist fantasy they cannot help but represent:
the body of the Arab is disciplined and defeated, made impassive and vulner-
able to the symbols of French power and cultural authority. As such, in these
images we might say the Orient is "fixed" once again, located and pinned down
like the impossible objects with which Michel Foucault begins his *Archaeology
of Knowledge* and on which Said develops his thinking about the discursive
emblems of representation.

But to be blunt about the obvious: *this* space is different and fixing it *here*
means something different. In this second Kagan photograph, after all, we are
now well within the heart of the metropolitan capital, much as we were in the
Boissay photograph (fig. 6; see fig. 4). And, in fact, the picture is hardly fixed or
still. Taken without a flash from the inside of a Metro car as it pulls out of the

station, the image is best understood as part of a stop-motion film sequence, the lack of focus demonstrating Kagan's discretion as he used his camera to shoot hundreds of Algerian men being arrested. In this particular photograph, which is more frequently reproduced than others from the sequence, we see twenty or thirty of these men in near focus under signage marking the Metro stop as Place de la Concorde and under an advertisement for the dish soap Rex, which only underscores the "whitewashing" vision that needs (still) to keep the Algerians out of the public view. The men in the foreground face the wall, their heads bowed beneath the weight of their clasped hands. Other images from the same sequence show us this multitude expanding back into the space of the station, staring out toward the people on the train who, history tells us, refused to see them in return regardless of what Kagan's camera shot.

Although it was probably not their intent to be photographed here, tens of feet below the Place de la Concorde, the protesters' presence at this important site cannot but resonate symbolically, and not only for the martyrlike implications of the Rex above their heads or for the irony revealed by the manner in which they are handled by the police just below the French word for "peace." As Maurice Agulhon explains, the Place de la Concorde has long been a potent symbol of the French capital, wherein it means to unite a political Left and Right as contained within the east and west of the city.[26] As such, this site also constitutes a synecdoche of the nation, a function signaled by the symbolic representations of each of eight major French cities that flank it.

Thus, one of the most striking legacies of the Kagan photos of the arrested protesters at the Place de la Concorde might be the evidence they provide of what we must understand, finally, as the FF-FLN's image politics. The sequence—and in particular this single, blurred frame—shows us not just the Algerians after all but, significantly, their subordination at the symbolic center of the French nation. Moreover, the photograph does so in a way determinedly visible to a public constituted *here* as a self-consciously national one. This reinscription of the Algerian in the French national body and its public sphere assumes additional significance in light of François Furet's instruction in the *France Observateur* article named above. Furet instructs the French reading public to be a mobile urban public and to travel in order to "see" the truth of the suburban ghettos where the Algerians live. Kagan's Concorde picture, we might understand, instead travels for them, providing visual access to an Algerian France in their midst. Yes, this is also an image of the "Orient" as it is imagined and constructed by the order of the imperial police and so too an image therefore of Orientalism. But this time the unstable, unfixed identity that is imaged pertains to France itself. The "Orient" has, in other words, here come home to roost; it is the Occident that is being made and unmade from its very

center and by the oppression of the very bodies that, by 1961, it had hoped to occlude from its national vision.

Of course, this is precisely the image that colonialist France needed to refuse, perhaps even more so than that of a police gone overboard as in those of Kagan's other photographs that were much more widely published at the time. At a time when the War of Independence could not be named as such, the claims of others to the space of the metropole—real or symbolic—could not be allowed, and especially not on the level of the image. In that sense, the plenitude and presence announced in photographs of 17 October 1961—like the Boissay photograph above and the elision announced by Kagan's Concorde photograph—might be thought of as partaking in what Georges Didi-Huberman has elsewhere implored us to see as "refutations snatched from a world bent on their impossibility."[27] Here that world is one that the French, and not just Papon but the majority of the populace, wanted "to obfuscate, to leave wordless and imageless," much as the Nazis with whom Didi-Huberman's analysis is concerned had aspired to leave the world of the camps they created.[28]

Didi-Huberman's pleas for a reinvigorated ethics of looking at photographs and seeing "something" in the "nothing" they picture for us finds a useful correlate in the work of the political theorist Ariella Azoulay. In her writings about images issuing, for example, from the occupied Palestinian territories, Azoulay suggests we need to reconsider our responsibility to the images of catastrophe that dominate our mediascape, which is to say exactly those same images that Baudrillard would have had us refuse as "war porn." She argues that it is precisely through the negotiations of gaze and contingent reality enabled by these pictures that those who are governed *without* the rights of citizenship achieve membership in a community that exceeds and so might challenge state sovereignty.[29] In that sense, and in light of the photographs analyzed here, we might say that colonialism's contradictions with the modern nation-state can be found in precisely this circulation of public images. Indeed, it is within the visibility enabled by this circulation that those who are codified as unequal by the colonial state have a chance to make claims to the ideals of egalitarian citizenship that undergird the French republic. In this instance, the "right to the city" and the right to be seen and so counted as such would be chief among them.

Following Azoulay's prompt to focus on the claims made by both the photograph and its subjects on *those who see* the images in front of them prompts us, in turn, to challenge a certain mediaphobia engendered by years of post-Debordian cultural analysis, which has taught us that the state's control of spectacle precludes any nonstate disruption. That this position has crippled our capacity to read the kinds of subaltern agency that might be mobilized by the photographic image should, by now, be clear. The images of the Algerian

War of Independence discussed above—images that can exist only as a result of the very real consequences of the merged Orientalist and colonialist trajectory mapped across the images examined elsewhere in this volume—confirm the spatial dislocations of the Orientalist photograph from lands once perceived as distant to the spatial territory that is defined only ever possibly as "here and elsewhere," to twist the title of Jean-Luc Godard and Anne-Marie Miéville's famous 1975 film. However, unfixed and moving, these images need not be read in only one way. In fact, resisting the Orientalizing history they encapsulate demands they must not be. Otherwise—to flash forward once again to 2005— we will only ever see the "Orient" presented in the spectacular press photographs of the French urban uprisings of that year in the fixed terms set more than a century ago.

Notes

1. Edward Said, "Orientalism Reconsidered," *Cultural Critique* 1 (1985): 90.
2. The seminal reference is, of course, Edward Said's *Orientalism* (New York: Vintage, 1978).
3. This phrase is derived from Benjamin Stora's "Les photographies d'une guerre sans visage: Images de la guerre d'Algérie dans les livres d'histoire(s)," in Naaman Kessous, C. Margerrison, A. Stafford, and G. Dugas, eds., *Algérie: Vers le cinquantenaire de l'Indépendance; Regards critiques* (Paris: L'Harmattan, 2009), 13–27.
4. Benjamin Stora has led the effort to challenge this supposition. See, for example, "Des photos sur des mots," in Éléonore Bakhdatzé, ed., *La guerre d'Algérie* (Paris: Hoëbeke, 2007), 6, Stora's short preface to that recent collection of Agence France Presse photographs. Writing frequently on the copious French production, Stora has also championed the move to consider the war "une guerre inégalitaire" in terms of its image production. See Laurent Gervereau and Benjamin Stora, eds., *Photographier la guerre d'Algérie* (Paris: Marval, 2004). Todd Shepard's *The Invention of Decolonization: The Algerian War and the Remaking of France* (Ithaca, N.Y.: Cornell Univ. Press, 2006) provides the best account of the political investments in and ramifications of an *Algérie française* or an *Algérie algérienne*.
5. Vilém Flusser, *Towards a Philosophy of Photography* [1983], trans. Anthony Mathews (London: Reaktion, 2000).
6. Marc Garanger's photographs of these women have been published as *Femmes algériennes* (Paris: Contrejour, 1982; reprint, Paris: Contrejour, 2003). Several of his prints are held by the Getty Research Institute.
7. Pierre Bourdieu and Abdelmalek Sayad, *Le déracinement: La crise de l'agriculture traditionelle en Algérie* (Paris: Minuit, 1964).
8. Bourdieu's photographs have been published by Francz Schultheis and Christine Frisinghelli as *Images d'Algérie: Une affinité élective* (Paris: Actes Sud, 2003). A small percentage of Kouaci's archive has recently been published as *Mohamed Kouaci, 1956–1963* (Algiers: Casbah, 2007).

9. For more on this trial, see Francis Jeanson and Marcel Péju, *Le procès de Réseau Jeanson* (Paris: Maspero, 1961).

10. Dominique Darbois and Philippe Vigneau, *Les Algériens en guerre* (Milan: Feltrinelli, 1960). A number of unpublished snapshots by Darbois are also included in the Gloria de Herrera papers, 980024, box 5, folder 44, Getty Research Institute.

11. Frantz Fanon, *Wretched of the Earth* [1961], trans. Richard Philcox (New York: Grove, 2004), lxii.

12. Thanks to Andrew Perchuk for directing me to these photographs. Dominique Darbois has confirmed that she did not take the photographs (e-mail correspondence with the author, 18 October 2011). My thanks to Hannah Green for her indispensable assistance on this front.

13. Jacques Rancière repeats this argument about politics on several instances, most notably in his *Disagreement: Politics and Philosophy* [1995], trans. Julie Rose (Minneapolis: Univ. of Minnesota Press, 1999), 139. In his "The Cause of the Other," he explicitly connects this model of politics to what it is that photographic images can show us. Jacques Rancière, "The Cause of the Other" [1997], trans. David Macey, *Parallax* 4, no. 2 (1998): 28.

14. An "Algerian" press service (APS) was designated by the GPRA in Tunis on 1 December 1961, but did not become active until 1962.

15. In this suggestion that we imagine the stakes of viewing these photographs differently, I am indebted to insights about the stories one might imagine against the grain of the archive in order to "fabricate a witness to a death not much noticed" that Saidiya Hartman articulates so forcefully in her "Venus in Two Acts," *small axe* 26 (2008): 8. My thanks to Krista Thompson for directing me to Hartman's text.

16. I have expanded the language and argument here in relationship to these and other photographs in my book. See Hannah Feldman, *From a Nation Torn: Decolonizing Art and Representation in France* (Durham, N.C.: Duke Univ. Press, forthcoming).

17. The literature on the 17 October 1961 events is vast and subject to numerous debates about archival veracity, access, and historical method. The most complete account is provided in Jim House and Neil MacMaster, *Paris 1961: Algerians, State Terror, and Memory* (Oxford: Oxford Univ. Press, 2006). Unless otherwise noted, details about the protest and its suppression recounted here stem from this account. It should also be noted that, in addition to scholarly accounts, the events are the subject of several feature films, documentaries, art exhibitions, popular music lyrics, memorials, published testimonials, and a few novels.

18. *Communiqué du préfet de police de Paris, rendu public le 6 Octobre 1961, instituant le couvre-feu,* as reprinted in Olivier Le Cour Grandmaison, *Un crime d'état à Paris* (Paris: La Dispute, 2001), 204–5. The phrase "right to the city" comes from Henri Lefebvre, "The Right to the City," in *Writings on Cities,* trans. and ed. Eleonore Kofman and Elizabeth Lebas (Cambridge, Mass.: Blackwell, 1996), 158.

19. For more on the planning of the manifestation, see the documents collected by and reprinted in Mohammed Harbi as "Dossier sur certain aspectes occultes du F.L.N. en France," in *Sou'al: Revue quadrimestrielle* 7 (1987): 19–110. In particular,

see "Document 21," a letter written by Kaddour [Ladlani] on behalf of the Comité fédéral de la fédération de France du FLN, 10 October 1961, describing the actions that should be taken to respond to Papon's curfew. Here, Kaddour insists that these responses "doivent être spectaculaires [must be spectacular]" (75).

20. The Barthes description reads: "Now, once I feel myself observed by the lens, everything changes: I constitute myself in the process of 'posing.' I instantaneously make another body for myself, I transform myself in advance into an image." See Roland Barthes, *Camera Lucida: Reflections on Photography,* trans. Richard Howard (New York: Hill & Wang, 1981), 10.

21. The photo was likely originally shot for Europress but is now contained in the Roger-Viollet archive, which assumed the Boissay archives several years ago.

22. Such descriptive phrasings have become standard in more recent historiography as well.

23. See Elie Kagan et al., *Mai '68 d'un photographe* (Paris: Layeur, 2008).

24. Jean-Luc Einaudi has since discovered that the man, whom Kagan's photographs helped him identify as Abdelkader Bennehar, died two days later from a blow to the head with a blunt instrument. This blow would have occurred after Kagan and an American journalist took Bennehar to a hospital, an event Kagan also documents. See Jean-Luc Einaudi, "Elie Kagan, le témoin," in Jean-Luc Einaudi and Elie Kagan, *17 Octobre 1961* (Paris: Actes Sud, 2001), 29. This small book reprints most of the Kagan photographs taken on 17 October 1961, which are now archived in the Bibliothèque de documentation internationale contemporaine in Nanterre.

25. This is the version supported, for instance, in Paulette Péju, *Ratonnades à Paris* [1961] (Paris: La Découverte, 2000) and in the new postface that François Maspero wrote for the republication of this early condemnation of the police violence.

26. Maurice Agulhon, "Paris: A Traversal from East to West," in Pierre Nora and Lawrence Kritzman, eds., *Realms of Memory: The Construction of the French Past* (New York: Columbia Univ. Press, 1998), 535.

27. Georges Didi-Huberman, *Images in Spite of All: Four Photographs from Auschwitz,* trans. Shane B. Lillis (Chicago: Univ. of Chicago Press, 2003), 3.

28. Didi-Huberman, *Images in Spite of All,* 20.

29. Ariella Azoulay, *The Civil Contract of Photography,* trans. Rela Mazali and Ruvik Danieli (New York: Zone, 2008).

ROB LINROTHE

TRAVEL ALBUMS AND REVISIONING NARRATIVES
A Case Study in the
Getty's Fleury "Cachemire" Album of 1908

Two unusual photographs from an otherwise rather conventional travel album documenting a trip to India in March of 1908 offer the opportunity to reconsider some fundamental assumptions about photography (figs. 1, 2).[1] The photographs were acquired on a tour of India by a French fine cloth merchant, Paul Fleury, who was accompanied by Marie Fleury, either his wife or a relative. One of many albums assembled to in some way document their overseas travels, this volume represents "Cachemire," which is stamped in gold on the leather cover. It includes commercial photographs of famous locations in Kashmir, India. Several of the photographs depict Srinagar, the summer capital of the princely state of Jammu and Kashmir, which in 1908 was presided over by Maharaja Pratap Singh (1848–1925), also pictured in the album, under the harsh scrutiny of British colonial rulers. In addition, the album contains a surprising number of images of Ladakh and Zangskar, two culturally Tibetan and Buddhist regions incorporated into the territory of Jammu and Kashmir.

The two aforementioned photographs depict a prominent Buddhist teacher born in Zangskar who resided in Ladakh but is also known to have visited the capital cities of Srinagar and Jammu. It is possible that the Fleurys actually encountered him; however, there is no basis for this assumption, since the album includes many photographs that were either taken long before their visit or of places to which they could not have traveled during their visit (including remote Ladakh and Zangskar). Moreover, while many of the album's handwritten labels are accurate, these incorrectly identify the teacher. Nevertheless, my fieldwork in Ladakh and Zangskar has enabled the identification of the photographs' subject and the discovery that these two photographs circulated locally. Copies of them (along with similar photographs) were owned by the teacher in question, as well as by his successor. This article attempts to suggest that the functions of the photographs in Ladakh and Zangskar—and in Tibetan culture widely—call into question the universal relevance of Western theories of photography that associate portrait photography with the apprehension of death, loss, and memory. While I make no claims to represent a distinctive culturally Tibetan understanding of photography, here I record my own observations of these and other photographs operating within Tibetan networks of meaning.

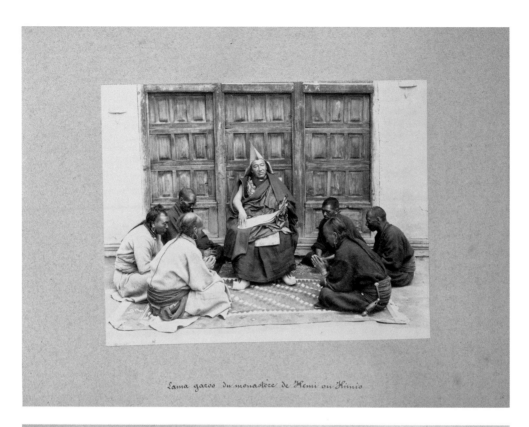

Lama garoo du monastère de Hemi ou Himis

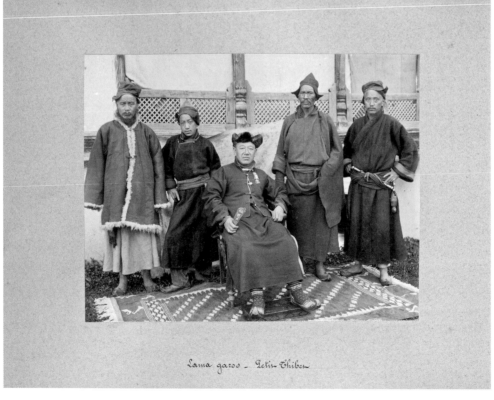

Lama garoo - Petit Thibet

In one of the two well-composed photographs of the same man in the Fleury album, he is dressed in the full robes of a teacher of the Tibetan Geluk Buddhist order and appears with a group of followers before a set of three wooden doors (see fig. 1). He is named in the Fleury caption as Lama Garos of Hemis Monastery (which belongs to the Drukpa Kagyu, not the Geluk, lineage). In the second photograph, he is dressed in the more casual robes of an esteemed monk, wears a prominent medal, and is surrounded by some of the same lay and clerical followers (see fig. 2). Here they appear before a wooden balcony, but in both photographs the identical dhurrie, or flat-weave rug, is present and the main figure has the same comfortably authoritative presence.

In 1922, Cecil Tyndale Biscoe published one of the photographs and attributed it to R. E. Shorter (see fig. 1).[2] He captioned the photograph "The Buddhist Abbot and his Celas or Pupils" but gave no further information. I showed the photograph to my friend Karsha Lonpo, a learned monk, teacher, and local historian in Zangskar. He identified the subject not as a putative Lama Garos of Hemis but as the predecessor of an important Tulku, or reincarnation, who had recently died: Kushok Bakula Rinpoche of Spituk and Sankar Monasteries. Indeed, in Bakula's 2001 Tibetan autobiography we found both of the Fleury album images along with a third, possibly related, photograph.[3] The caption for the figure 1 photograph reads, using an honorific title (*sku gong*): "[My] Previous Incarnation together with students." The figure 2 caption reads: "[My] Previous Incarnation in the Jammu royal palace inner apartments wearing a medal together with his attendants." And the caption for the third photograph, in which the main figure is hatless and surrounded by masked dancers, attendants, and three dogs, reads: "[My] Previous Incarnation together with Tantric Cham [masked dance] performers in the King's palace at Jammu."[4]

Once clued in to his actual identity—*not* Lama Garos, and *not* from Hemis Monastery as on the Fleury album's labels—it was relatively easy to find out more about this man. He was the eighteenth incarnation of Bakula, named Lobzang Yeshe Stanba Gyaltsan (1860–1917), born to the king of Zangla in Zangskar.[5] He was the abbot of the important Spituk Monastery near Leh, the capital of Ladakh. The photographs by Shorter at the palace of Maharaja Pratap Singh were most likely taken on one of Kushok Bakula's several possible visits, probably in the 1890s. The year of the one documented visit, when he received an invitation from Maharaja Pratap Singh himself, is unknown, but a Ladakhi historian, Nawang Tsering Shakspo, has provided some details.[6] Based on a number of accounts, including critical British ones, the maharaja was a deeply religious man. Much to his sorrow, he was childless, but he heard from one of his ministers who had visited Ladakh that the abbot of Spituk Monastery was a learned incarnate lama with powers that could bless the maharaja with

Fig. 1.
Attributed to R. E. Shorter.
The eighteenth Kushok Bakula Rinpoche seated with six devotees (mislabeled *Lama Garos du monastère de Hemi ou Hémis*), before 1908, albumen print, 17.9 × 23.2 cm (7⅛ × 9⅛ in.).
From Paul Fleury, "Cachemire," travel album, 1908.
Los Angeles, Getty Research Institute.

Fig. 2.
Attributed to R. E. Shorter.
The eighteenth Kushok Bakula Rinpoche seated with four acolytes (mislabeled *Lama Garos—Petit Thibet*), before 1908, albumen print, 18.1 × 23.5 cm (7⅛ × 9¼ in.).
From Paul Fleury, "Cachemire," travel album, 1908.
Los Angeles, Getty Research Institute.

issue. The maharaja sent an invitation, and Kushok Bakula and his entourage were welcomed in the Jammu Palace with great respect. Bakula stayed there in prayer for seven days with the ruler in attendance. According to Nawang Tsering Shakspo, "after Maharaja Pratapa Singh, his son Maharaja Hari Singh (who is said to have been born after Bakula Lobzang Eshey's prayer) came to the throne."[7]

Hari Singh is generally accepted as Pratap Singh's nephew (the son of his brother Amar Singh), not his son. If he was the progeny attributed to Kushok Bakula's rituals, then the latter's visit must have taken place sometime before Hari Singh's birth in 1895.[8] Alternatively, perhaps the photograph was taken ten years earlier, in 1886, during Pratap Singh's installation as maharaja at the Jammu Palace, because an extensive delegation from Ladakh attended, including a number of abbots and masked dancers.[9]

The eighteenth Kushok Bakula's spiritual powers and personal magnetism were mentioned by some of the westerners who met and left accounts of him. Those by missionaries are anxious and cynical if not spiteful, whereas those by mountaineers are filled with praise.[10] The Italian mountaineer Filippo de Filippi knew him well and also photographed him. He was most impressed with Bakula, describing him as having "great dignity of bearing united to a benign aspect and exquisitely courtly manners...a great gentleman, great in heart and in bearing."[11] Kushok Bakula's role in public and religious affairs and his closeness to the royal family of Stok were recognized by the local government as well.[12]

In the summer of 2010, several photographs—including photographs identical to figures 1 and 2—were framed and displayed in Spituk Monastery's reception hall, as they had been for many years. The third photograph of the eighteenth Bakula, which appears in the autobiography mentioned above, was also among them. It had a visible photographer's mark reading "R. Korz, Simla," suggesting an otherwise unknown photographer based in Simla.

The eighteenth Kushok Bakula maintained his headquarters at Spituk Monastery, but he built Sankar Monastery, northwest of Leh, in 1890. This became his primary personal residence, as it was for his successor, the nineteenth Bakula, author of the book that included the same photographs as those in the Fleury album. In 2009, after showing copies of the Fleury photographs to monks at Sankar Monastery, I was escorted into various rooms, all closely connected to both Bakulas. In Bakula Rinpoche's sleeping chamber, there is a collection of sculpted and painted deities along with a few framed paintings and photographs of religious figures, including his predecessor, the eighteenth Bakula (figs. 3a, 3b). In pose and dress this photograph resembles the Fleury photograph, but it isolates the subject, which makes it suitable from the Tibetan perspective for introduction into a different kind of "album" collection. Here

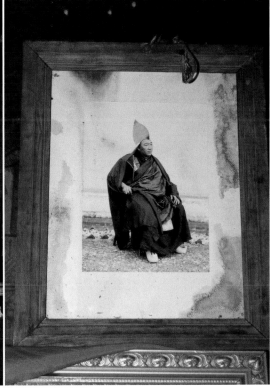

the photograph is hung *above* images of deities. In Tibetan Buddhist practice, the placement of deities is meaningful; one would not hang a snapshot of an ordinary person above an image of deities, so this photograph and this man were being given a high status.[13] Most likely, the photograph was previously owned by its subject, the eighteenth Bakula Rinpoche, and was later inherited, along with the monastery itself, by his successor, the nineteenth Bakula. It was certainly placed and looked at by the nineteenth, as the room had not been modified since the recent death of the nineteenth Bakula.

I want to explore the implications of that private gaze, within his bedroom, of a man who genuinely believed that he was looking at a photograph of a former version, a previous incarnation, of himself. Surely this way of looking at photographs is radically different from the one assumed in Western photographic theory. It is an unusual example but indicative of a profound, subtle, and widespread attitude toward identity and existence that must certainly affect the meanings that photographs accrue. Here I make a brief digression into the entrenched association of photography with memory and mortality in Western theorizing.

In many histories of photography, the focus returns to memory and loss, to the recursive distancing between the indexical representation and the lost

Fig. 3a.
Interior of nineteenth Kushok Bakula's sitting and bedchamber in Sankar Monastery, Leh Ladakh (Jammu and Kashmir, India), with framed photograph of the eighteenth Kushok Bakula (upper right) (see fig. 3b).

Fig. 3b.
Framed photograph of the eighteenth Kushok Bakula (see fig. 3a, upper right).

living presence that the photograph can never bridge.[14] Roland Barthes, in *Camera Lucida,* famously pairs photography and death. He writes about "that rather terrible thing which is there in every photograph: the return of the dead."[15] "With the Photograph, we enter into *flat Death.*"[16] "[The] photograph tells me death in the future…I shudder…*over a catastrophe which has already occurred.* Whether or not the subject is already dead, every photograph is this catastrophe."[17] Susan Sontag sharpens this association. She writes, "All photographs are *memento mori.*" They are "a mournful vision of loss," and the "link between photography and death haunts all photographs of people."[18] In Walter Benjamin, too, we find photography and the melancholic memorial entwined. "In the cult of remembrance of dead or absent loved ones, the cult value of the image finds its last refuge. In the fleeting expression of a human face, the aura beckons from early photographs for the last time. This is what gives them their melancholy and incomparable beauty."[19] Derrida's work on photography is similarly represented as underscoring photography as a mourning for the here-now that is irretrievably absent and archived as a loss.[20]

Entrenched as this position is, given Bakula's perspective in looking at photographs of his own preincarnation, can we assume a melancholy cult of absence, or self-alienation? It seems to me, in his relation to a photograph of his earlier self, or body, he is his own proof of presence, of identity. I bring this up in light of what Chris Pinney has recently called (or called for) "a new 'World History of Photography.'" In the endeavor to radically rethink "questions of centre and periphery,"[21] I believe we have to take account not just of technological and political circumstances but also of particular historical consciousnesses that lead to alternative modes of spectatorship.

In the familiar Western context, the photograph generally evokes exactly that which will never be restored after death: the quickened body. As we have seen, the photograph has been theorized as stimulating an inconsolable memory of the dead, the lost past, and a reminder of our own inevitable mortality. We must be careful not to universalize this thanatography for all beholders, because not everyone shares that historically constructed cognitive orientation. To be sure, the deaths of loved ones and ultimately of what we may for convenience call "oneself" are generally recognized as inevitable, and the usual desire is for those deaths to be delayed as long as possible.[22] But not everyone sees this self as wholly discrete or essential, as uniquely coming into being, and as either being dissolved without remnant at physical death or preserved as a soul into eternity. Hindus in South Asia and Buddhists throughout Asia see the self in a very different way: as a temporary, interdependent phenomenon creating the illusion of continuity that can persist across lifetimes. Anything born must die, but if one sees that there is no essential self, death takes on a very different

valence.[23] Once that illusion of selfhood is transcended in the consciousness streams of those considered to have attained enlightenment—such as Bakula— they are believed to continue manifesting in bodies that regularly wear out, but are renewed, time and again.

What would someone with such a worldview make of a photograph of someone he has come to believe, in all sincerity, to have been "himself" in a previous life? While this may be an extreme case, does it not require that a different attitude toward a photograph be imagined? Without losing its poignancy and mystery, might a photograph be more (or less) than a trigger for the sense of the irrevocable loss of the past? Might it not even suggest a *continuity* between the past and present and a promise of the future?

If one sees death as inevitable but not absolute, photographs might take on a different relation toward the past and present. If the physical body is understood in a different way (and by "understood" I do not refer to the intellectual grasp of a theory but to an internalized root metaphor, a fundamental cognitive orientation), grasped not as a representation of actual reality but of appearance, wouldn't the indexicality of photographs hold even less of a sentimental lure, less of a seductive hook into (mis)reading appearance and reality?

An embedded sense of cyclical time and recurring incarnation engenders an understanding that persons are not just "then." The beings whose forms are traced in photographs may in one sense be no more, but within a few years are believed to be back in the "now" in another form. Based on my study of Tibetan religious art and practice, this correlates closely to what I have perceived as a Tibetan Buddhist experience of the immanence of deities. Deities appear to have a timeless, ubiquitous presence though they manifest as individuals very much in the present. Again, while conscious of and uncomfortable with my own role as purporting to somehow speak for "the Tibetans," I do not believe this is simply some Orientalist fantasy projected onto Buddhists (Tibetans in particular) but rather something they experience on a daily basis, as the controversies over the reincarnations of the most recent Panchen Lama and Karmapa suggest.[24] Although they have registered in a range of Western media, including film, the reincarnating Dalai, Panchen, and Karmapa Lamas are just three of the many hundreds of such incarnation lineages still operative among Tibetans.

It is these factors—simultaneity of past and present and immanence of deities—that probably prepared the way for the inclusion of photographs into Tibetan contexts of religious imagery.[25] Because a deity is both everywhere and also localized in a consecrated image, a deity is "everywhere/always" and "here/now." It was an easy extension to consider the photograph of a departed teacher as comparable to a consecrated sculpture or painting of the very deity manifesting that body, just as the Dalai Lama is taken as a manifestation of the

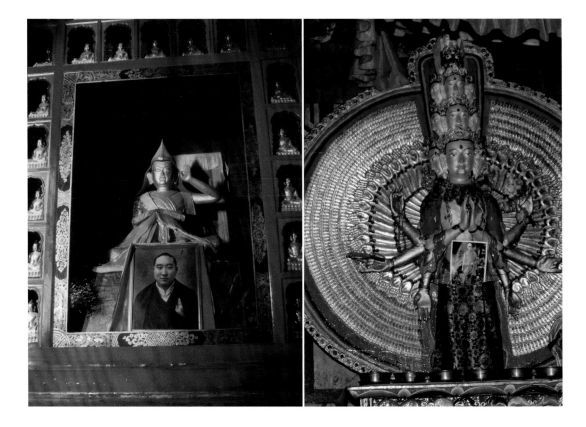

Fig. 4.
Photograph of the tenth
(alt. seventh) Panchen Lama
Lobsang Trinley Lhündrub
Chokyi Gyaltsen (1938–89)
with offering scarf, placed in
front of Tibetan altar cabinet
with metalwork images of
Buddhist deities and teachers
in the chambers of Lama
Kalsang Losal, Sengge Shong
Monastery, Rebgong (Amdo-
Qinghai, People's Republic
of China).

Fig. 5.
Photograph of H. H. the
fourteenth Dalai Lama Tenzin
Gyatso (b. 1935) on Tibetan
Buddhist altar, attached to an
image of one thousand–armed
Avalokiteshvara sculpture,
Sankar main assembly hall,
Leh Ladakh (Jammu and
Kashmir, India).

bodhisattva Avalokiteshvara and the Panchen Lama is a manifestation of the Buddha Amitabha.

In Tibetan cultural regions, photographs of both living and passed-away teachers appear to be treated identically to sculpted and painted images of teachers and deities (figs. 4, 5). Whether or not they are framed, the photographs are placed on altars and cared for like a sculpture or painting of a deity or teacher: butter lamps are lit below them and they are draped with ceremonial scarves (*katak*). Sometimes they are inserted on or in reliquaries or attached to sculptures. At times, a photograph is integrated into a painting, either by cutting out a face and pasting it onto a painting or by painting on the photographic print, leaving the face and exposed skin unpainted. Often, there appears a hybrid quality to such images, where the photographic part is naturalistic while the surrounding areas use a different system of painting conventions. Although photographs are now used by artists as models for paintings, paintings were also undoubtedly used as models for photographs: the compositions of many formal portraits of high lamas were based on a familiar style used in painted portraits (figs. 6, 7). Understood in the way I am trying to suggest, it is easy to see how and perhaps why photographs have been integrated seamlessly and by manifold means into Tibetan pictorial and ritual practices.

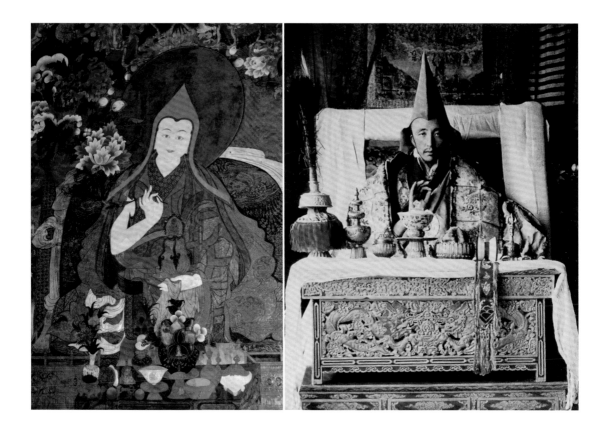

In Tibetan contexts I expect that a photograph would be thought of as the marks left by the photograph's subject (not the taker) through the mediation of the technology. As such, the photograph rather easily finds a place among the various types of relics that Buddhists acknowledge, including physical body relics, "touch relics" (things a great being has touched), indexical relics like footprints and handprints (though they also become touch relics unless they are reproduced as an ideal), and relics of mind (the Buddha's teachings are also considered his relics, as bringing him present to the beholder).

In conclusion, the photographs in the Fleury albums were, to quote Elizabeth Edwards, "part of the representational machine by which the construction and circulation of images worked within the trade routes of colonialism."[26] What began as commercial photographs "produced for a tourist market in exotica" were also collected by anthropologists and "became absorbed into the discourse of type within anthropological evaluation."[27] Other European missionaries, explorers, colonialists, and sportsmen collected similar images. Some of these photographs, notably the portraits, also circulated within networks of those represented in the photographs. They were claimed by locals and by the subjects themselves, and the meanings they simultaneously supported outside the colonial archive produce not so much "an 'indigenous' counter-narrative"[28] as

Fig. 6.
Painter unknown.
The eleventh Dalai Lama, Khedrub Gyatso (1838–55), mid-1800s, distemper mural with glue binder, dimensions unknown. Samye, Tibet, Utse Hall (second floor).

Fig. 7.
The nineteenth Kushok Bakula Rinpoche, 1942, photograph, dimensions unknown.

"alternative histories."[29] In envisioning how photographs have operated and continue to operate in Tibetan contexts since then, I have suggested that differences in presumed worldviews affect the meanings derived from the same images. We do not know the Fleurys' intentions for or interpretations of their "Cachemire" photographs. Even if, along with many tourists, the Fleurys participated in the exoticization of locales and nameless "typical" natives, for locals reading their own photographs such an Orientalist projection was nearly as irrelevant as ethnographic classification or colonial surveillance narratives.

In following these photographs back into Indian Tibet, one finds they continued to be understood and have meaning long after they were enclosed within a travel album in 1908 or acquired by the Getty Research Institute in 1991. The meanings of photographs certainly derive from constitutive relations and discourses of power that are inevitably local.[30] We are obliged to understand that political and social power was triangulated among the religious elite of Ladakh, the maharaja of Kashmir, his appointed representatives, and the quasi-official representative of British colonial rule. Even more importantly, and probably much more of a challenge, we must take seriously the mental typologies and weltanschauung of the photographs' subjects and local viewers, for in allowing themselves to be represented, they were also performing for local beholders who would understand and treat some of these objects as relics not of absence but of presence.

Coda

The twentieth Bakula Rinpoche, Thubten Ngawang Norbu, was born 23 January 2006, at Tega Village in Nubra, to the north of Leh. He was recognized as the reincarnation in March 2008, brought to Spituk Monastery on 6 August 2010, and "enthroned" on 12 August. On 21 August, I accompanied my friend Karsha Lonpo, who had known the nineteenth Bakula for many years, to Spituk Monastery so he could reintroduce himself to the very young incarnation. As a gift, I offered the boy copies of the Fleury photographs of his predecessor, the eighteenth Kushok Bakula. He quickly took them out of my hand and, while listening to Karsha Lonpo respectfully remind him of their previous interactions, played with the photographs. He stared at them with concentration and pushed them to and fro on the low table before which he was seated, looking back and forth at Karsha Lonpo and the photographs. He seemed fascinated by them. Perhaps when he is older, it will be possible to interview him about what he thinks when he sees "himself" in alternative form. He is not the only Tibetan incarnation who, through at least three generations now, has possessed and deployed photographs of himself or his predecessors.[31] The self-reporting

of the individual thoughts and reactions to such photographs might be no more than anecdotal evidence. However, observed usage by many Tibetans of photographs representing respected teachers suggests they are treated just like other religious objects: as religious "supports" (Tib. *rten*). That is, they are physical objects perfumed by the body, speech, or mind of transcendent enlightenment. While they can operate as a channel for feelings of loss or grief (as reminders of the inevitability of death), they are also able to provoke an awareness of continuity and return.

Notes

1. I gratefully acknowledge Fran Terpak, Mary Roberts, and Julia A. Thomas for their help and inspiration during the research and writing of this essay on the ninth of eighteen Fleury albums acquired in 1991 by the Getty Research Institute (91.R.5).

2. C. E. Tyndale Biscoe, *Kashmir in Sunlight and Shade* (London: Seeley, Service, 1922), opposite 212.

3. Ba ku la thub bstan mchog nor, *Rang rnam padma dkar po'i phreng ba* (Leh, India: Paljor, 2001), pl. 2–4.

4. Tibetan captions translated by author.

5. A short biography is found in Nawang Tsering Shakspo, "The Role of Incarnate Lamas in Buddhist Tradition: A Brief Survey of Bakula Rinpoche's Previous Incarnations," *Tibet Journal* 24, no. 3 (1999): 41–44. He was educated in Tibet at Drepung Monastery, where he received the Geshe Lharampa degree, and passed away in 1917 at sTongde Monastery near his place of birth, Zangla, Zangskar, India.

6. Nawang Tsering Shakspo, "History of Buddhism from 1834–1947," *Ladakh Prabha* 5 (1987): 66–67. That he was occasionally in Srinagar is documented by the fact that Lord Roberts (1832–1914) and Ahmad Shah both (separately) encountered him there, the former probably in 1889. See E. F. Knight, *Where Three Empires Meet: A Narrative of Recent Travel in Kashmir, Western Tibet, Gilgit, and the Adjoining Countries* (London: Longmans, Green, 1896), 129, 529; Ahmad Shah, *Four Years in Tibet* (Benares, India: E. J. Lazarus, 1906); and Frederick Sleigh Roberts, *Forty-One Years in India: From Subaltern to Commander-in-Chief* (London: Richard Bentley and Son, 1898 [1897]), http://www.gutenberg.org/files/16528/16528-h/16528-h.htm#535, accessed 29 May 2010. Ahmad Shah met Kushok Bakula in Srinagar in both 1894 and 1895. Shah, *Four Years in Tibet,* 6–7, 23.

7. Shakspo, "History of Buddhism," 67.

8. It may also explain the large, commercial studio–framed portrait of Amar Singh now in the reception hall of Spituk Monastery, marked "Bhedwa" of Bombay.

9. Munshi Tshe ring dpal rgyas added a description of the coronation of Pratap Singh in Jammu in 1886. A. H. Franke, *Antiquities of Indian Tibet: The Chronicles of Ladakh and Minor Chronicles* (Calcutta: Government Printing, 1926), 143–45.

10. See, for example, Jane E. Duncan, *A Summer Ride through Western Tibet* (London: Smith, Elder, 1906), 113. The Indian Christian missionary Ahmad Shah

is more favorable toward Kushok Bakula but criticizes him as taking too active a role in "worldly affairs." Shah, *Four Years in Tibet,* 6.

11. Filippo de Filippi, *The Italian Expedition to the Himalaya, Karakoram and Eastern Turkestan (1913–1914)* (London: Edward Arnold, 1932), 271. A similar impression is found in Giotto Bainelli, *Buddhists and Glaciers of Western Tibet* (New York: E. P. Dutton, 1934), 73–74.

12. This is documented in the exchange of confidential letters involving the Wazir Wazarat, Hashmat Ullah Khan, representative of the maharaja of Jammu and Kashmir's government in Leh during some rather delicate negotiations of 1911. See Nawang Tsering Shakspo, "Ladakh's Relations with Other Himalayan Kingdoms," in Helmut Krasser et al., eds., *Tibetan Studies: Proceedings of the 7th Seminar of the International Association for Tibetan Studies, Graz 1995* (Vienna: Verlag der Österreichischen Akademie der Wissenschaften, 1997), 2:669–76. Isabelle Riaboff also documents Kushok Bakula's influence on government in reorganizing districts within Zangskar: in 1901, "following Bakula Rinpoche's request, Zangskar was detached from Paldar to join the newly constituted Kargil *tehsil.*" Isabelle Riaboff, "Distant Neighbours Either Side of the Omasi La: The Zanskarpa and the Bod Communities of Paldar," in Martijn van Beek and Fernanda Pirie, eds., *Modern Ladakh: Anthropological Perspectives on Continuity and Change* (Leiden, Neth.: Brill, 2008), 103.

13. Some sense of the superior position of the teacher is found in a text by Grags pa rgyal mtshan (1147–1216) discussing the insertion of relics into *stūpas.* He writes, "Even though (some) say that relics of lamas abide in the *harmikā* [near the top of the dome of the *stūpa,* below the spire], I consider that it accords with the dharma [Buddha's teaching] if they abide as high as possible, since (the lamas) are the essence of all the Buddhas." Quoted in Yael Bentor, "On the Indian Origins of the Tibetan Practice of Depositing Relics and *Dhāraṇīs* in Stūpas and Images," *Journal of the American Oriental Society* 114, no. 2 (1995): 256. I thank my colleague Sarah Jacoby for pointing out that an image with disciples such as figure 1 would not have been appropriate for incorporating into the religious context of the arrangement.

14. There is, with Barthes and Benjamin, if not Charles Baudelaire, a sense of the betrayal of the photograph for not being able to truly mediate between the time of the photograph's making and the time of its viewing, of not being able to do anything but tantalize with the promise of representing the past person or place and ultimately only underscoring the sense of loss.

15. Roland Barthes, *Camera Lucida: Reflections on Photography,* trans. Richard Howard (New York: Hill & Wang, 1981), 9.

16. Barthes, *Camera Lucida,* 92, emphasis in original.

17. Barthes, *Camera Lucida,* 96, emphasis in original. Others have noticed this grim association in Barthes. See Jay Prosser, "Buddha Barthes: What Barthes Saw in Photography (That He Didn't in Literature)," in Geoffrey Batchen, ed., *Photography Degree Zero: Reflections on Roland Barthes's* Camera Lucida (Cambridge, Mass.: MIT Press, 2009), 91; and Michael Fried, "Barthes's *Punctum,*" in Geoffrey Batchen, ed., *Photography Degree Zero: Reflections on Roland Barthes's* Camera Lucida (Cambridge, Mass.: MIT Press, 2009), 150.

18. Susan Sontag, *On Photography* (New York: Farrar, Straus, & Giroux, 1973), 15, 67, 70.

19. Walter Benjamin, "The Work of Art in the Age of Its Technological Repro-ducibility: Second Version," in Walter Benjamin, *The Work of Art in the Age of Its Technological Reproducibility, and Other Writings on Media,* ed. Michael W. Jennings et al. (Cambridge, Mass.: Belknap, 2008), 27.

20. Michael Naas, "'Now Smile': Recent Developments in Jacques Derrida's Work on Photography," *South Atlantic Quarterly* 110, no. 1 (2011): 205–22. My thanks to Julia A. Thomas for calling this to my attention.

21. Christopher Pinney, "Centre and Periphery: Photography's Spatial Field," *Marg* 61, no. 1 (2009): 103.

22. See, for example, the study of grief among Tibetan Buddhist Gurungs, for whom "death is conceived in Buddhist terms." Ernestine McHugh, "Reconstituting the Self in a Tibetan Tradition: Models of Death and the Practice of Mourning in the Himalayas," in Helmut Krasser et al., eds., *Tibetan Studies: Proceedings of the 7th Seminar of the International Association for Tibetan Studies, Graz 1995* (Vienna: Verlag der Österreichischen Akademie der Wissenschaften, 1997), 2:633–37.

23. In the *Avatamsaka sūtra,* this is explained as follows: "Among all things in their frailty, void of any enduring disposition, those who are born, necessarily possess death, and those who are not born, necessarily do not die. If [both of] these are extinguished, this is to be taken as the highest of joys." Hermann-Josef Röllicke, "The *Avatamsaka-Sūtra* as a 'Bodhi Mandala Text,'" in Francesca Bray et al., eds., *Graphics and Text in the Production of Technical Knowledge in China: The Warp and the Weft* (Leiden, Neth.: Brill, 2007), 321. The *Daśabhūmika sūtra* similarly explains, "Not born and also not extinguished, / Not ever-lasting and also not broken-off, / Not one and also not different, / Not come and also not gone." Röllicke, "The *Avatamsaka-Sūtra,*" 330.

24. Cf. Isabel Hilton, *The Search for the Panchen Lama* (New York: Norton, 1999); and Michele Martin, *Music in the Sky: The Life, Art, and Teachings of the 17th Gyalwa Karmapa Ogyen Trinley Dorje* (Ithaca, N.Y.: Snow Lion, 2003). Another person also claims to be the Karmapa, supported by the Shamar Rinpoche. Some sense of the controversy is portrayed in a front-page story by Jim Yardley in the *New York Times* of 8 February 2011: "As India Scrutinizes a Lama, Signs of a Wary Eye on Tibetans."

25. A discussion of Tibetan photography, including the terminology adopted to refer to it, is found in Clare Harris, "The Politics and Personhood of Tibetan Icons," in Christopher Pinney and Nicholas Thomas, eds., *Beyond Aesthetics: Art and the Technologies of Enchantment* (Oxford: Berg, 2001), 181–98. On Tibetan portrai-ture and self-portraiture, see Heather Stoddard, "Fourteen Centuries of Tibetan Portraiture," in Donald Dinwiddie, ed., *Portraits of the Masters: Bronze Sculptures of the Tibetan Buddhist Legacy* (Chicago: Serindia, 2003), 31–38.

26. Elizabeth Edwards, *Raw Histories: Photographs, Anthropology and Museums* (Oxford: Berg, 2001), 28.

27. Edwards, *Raw Histories,* 40. See also Elizabeth Edwards, "The Image as Anthropological Document: Photographic 'Types': The Pursuit of Method," *Visual Anthropology* 3 (1990): 235–58.

28. Edwards, *Raw Histories,* 107, following Bronwen Douglas.

29. Edwards, *Raw Histories,* 109.

30. Elizabeth Edwards, following John Tagg, points out that "the meaning of photographs resides in the discursive practices that constitute them and that they themselves constitute, from relations of power that constitute the conditions of existence for these photographs to current readings of the image." Edwards, *Raw Histories,* 108. A few years earlier, Christopher Pinney began his *Camera Indica* with a quote also from John Tagg. It maintains that photography "is tied to definite conditions of existence and its products are meaningful and legible only within the particular currencies they have. [Photography's] history has no unity." Christopher Pinney, *Camera Indica: The Social Life of Indian Photographs* (Chicago: Univ. of Chicago Press, 1997), 17.

31. H. H. the seventeenth Gyalwa Karmapa Orgyen Trinley Dorje is currently assembling an archive of photographs of his predecessor, the sixteenth Karmapa Rangjung Rigpe Dorje (1924–81); Lhundup Damchö, close disciple of H. H. the seventeenth Karmapa, personal communication, 12 May 2011.

JOHN TAGG

THE MUTE TESTIMONY OF THE PICTURE
British Paper Photography and India

In September 2007, the Metropolitan Museum of Art in New York opened its doors on a groundbreaking exhibition that sought to extend the history of what it called "British photographs from paper negatives" beyond the limits of the conventional account.[1] Presented as the first attempt "to explore the opening decades of paper photography in the country of its birth," *Impressed by Light: British Photographs from Paper Negatives, 1840–1860* also offered a foil to an earlier, equally unprecedented survey of French daguerreotypes, bolstering the claims of the British—or should one say English?—calotype process to be fully a rival to its French competitor.[2]

This explicit coupling of the story of the emergence and early deployment of a new imaging technology to a national theme was a distinctive feature of both exhibitions, only partially borne out by the nationalistic rhetoric through which the competing photographic processes were promoted at the time, in the first decade and a half of what the exhibitions remained content to describe as "the development of the new medium of photography."[3] Leaving the question of "the medium" to hang for the moment, it soon became apparent that the insistence of *Impressed by Light* on "British photographs," "British photographers," and "British artists" would prove equally unsustainable, since the borderline that was drawn was deceptive and its enforcement inconsistent. It was not just a matter of the vagaries of curatorial selection, however. Notions of national identity notoriously turn on the orbit of difference, introducing an unwanted element of uncertainty and deferral that, inevitably, has a corrosive effect on the confidently universalist language of masters and monuments, primacy and pre-eminence, characteristic of the house style of the Metropolitan Museum under the directorship of Philippe de Montebello.

The liberally used adjective *British* is, of course, particularly fraught. It has remained erratic in its definition and manifestly unreliable as a marker of allegiance. Here in the exhibition—ignoring the Dutchman Nicolaas Henneman, who gained admission solely as William Henry Fox Talbot's loyal retainer—photographers are variously identified as "English," "Welsh," "Scottish," and "Irish," and only in six inexplicably special cases as "British."[4] The curators did not invent the confusion, of course, and, when we arrive at last with the British

in India, we would do well to recall it was the English flag that flew over the coat of arms of the East India Company, whose motto was: *Auspicio regis et senatus Anglia* (By right of the King and the Senate of England). As Tom Nairn has argued, the strange absences and evasions of British statehood are rooted in the archaic peculiarities of the pre-modern formation of the English state that marked it out from the wave of state-ordered, nationalist capitalisms that emerged in the course of the nineteenth century.[5] For all the unifying effects of the Victorian capitalist economy, the centripetal pull of metropolitanism, and the political mobilization and spoils of imperialism, Britain always lacked the unity lent by the nationalist Imaginary, since it never had the second revolution that might have made it a modern nation-state. Instead, it chose Empire and self-proclaimed "Greatness." The same historical blockage accounts for the simultaneous universalizing and elision of Englishness in the consolidation of the Anglo-British state. The result is the singular instability of the very *Britishness* that the exhibition wants to hold in place as the marker of a guaranteed identity and a generalized authorial presence—the vantage point from which everything is seen and said.

Already, then, the framing of the exhibition shows cracks. Yet its story of "British photographs from paper negatives" had a decided momentum, capable of carrying it farther than we might have been led to expect. Previous accounts of the history of early photography had for the most part assumed an almost immediate decline in the use of Talbot's paper negative process following the introduction in 1851 of collodion glass negatives that seemed to combine the brilliance and precision of the daguerreotype with the reproducibility of the paper print. If it had held to this conventional knowledge, *Impressed by Light* would have come to an abrupt stop halfway round the first gallery, after a wall of Talbot and a wall of Hill & Adamson, William Collie, and Benjamin Brecknell Turner. Undeterred, however, the exhibition pressed on to reveal what it described as "a previously unrecognized artistic flourishing of the calotype among British photographers working on several continents during the 1850s."[6]

In keeping with the persistent national myth of the character-forming benefits of defeat, the spur to this flourishing proved to be a national humiliation of sorts. It was at the Great Exhibition of the Works of Industry of All Nations, held at the Crystal Palace in London in 1851, that the paying public had its first real chance to see the commercial and artistic potentialities of photography. The products of the camera thus took their place in the spectacle of industrial and technological marvels that now came to seem magically disconnected from the bitter labor struggles marking the preceding two decades. The only blemish for this grand British plan was that, as the *Reports by the Juries* subsequently recorded, all the gold medals went to American daguerreotypes and, more

stinging to some, to the superior, artistic calotype prints submitted by French exhibitors.[7] In the recoil of a suitably chastened national pride, the heroes of the Metropolitan Museum show—those cultivated English gentlemen of learning and leisure—found themselves compelled to organize for the improvement of national standards, helped along by the carefully negotiated loosening of Talbot's patent restrictions, which opened the way for the formation of the Photographic Society in 1853.

As their numbers grew, these gentlemen-amateurs (as the exhibition would have them) enabled the practice of photography to break out of the restricted circle of Talbot's relations, associates, and scholarly friends that had largely defined the limits of calotype practice in its first decade. Schooled as they were in the intimate pleasures of the connoisseurship of drawings and prints, these wealthy gentlemen, we are told, valued the paper print for its softening of detail, its massing of light and shadow, and its graphic smudginess, which seemed more artistic and, in any case, set their work apart from the mechanistic sharpness of the retail trade. It was a sense of distinction these gentlemen took to their weekend retreats, away from the clamor of city life and the din of industry. Nature as a mirror for English temperament, romantic ruins, striking geological features, ancient oaks, castles, vistas, landed property, good fishing, and hunting estates: this is what interested them and this is what the exhibition sets us up to expect—though it is then hard to fit the itinerant work of Roger Fenton or the steam locomotives of the dauntingly named James Mudd into this frame, a frame in which, as Geoffrey Batchen has remarked, "every image is presented as a singular act of personal expression, and therefore as artistic rather than capitalist in aspiration."[8]

Focusing on its story of the work of "men of learning and leisure" and their aspirations to photographic art, *Impressed by Light* cultivated a marked blind spot for the more mundane questions of production, replication, and the economy of images. Yet it was precisely in relation to these issues that the introduction of the negative-positive process and the discovery of the latent image represented seismic events. This other history, however, found itself all but entirely erased from the exhibition whose agenda, once the scene had been briefly set, hurried viewers on past Talbot's didactic double image of the Reading establishment—the quaintly suburban factory that Talbot set up in 1843 under the direction of his erstwhile valet, Nicolaas Henneman. Here, though, in the back garden, we briefly glimpse the kind of productivity Talbot himself imagined for his invention: reproductions of works of art, copies of engravings and prints, and the mass production of plates for photographically illustrated books like *The Pencil of Nature* (1844–46) and *Sun Pictures in Scotland* (1845)—all areas in which Talbot's process enjoyed success, even if it was never able to

compete with the daguerreotype for market share in the enormously profitable field of commercial portraiture. It is a back garden seen from the windows of a train that is going elsewhere. As Batchen again has sharply observed, *Impressed by Light* "carefully erases any signs of commerce or labor from the historical record, leaving the impression that the calotype was entirely the preserve of the independently wealthy."[9] In this, Batchen adds, the exhibition "repeats the efforts of the Photographic Society itself, which sought to maintain a clear division between those 'in trade' and those 'in society.'"[10]

This division, however, was not perhaps as consoling as it ought to have been. The tight-knit preoccupation with the artistically validated picturesque themes of late romantic and naturalist art betrayed an overinsistent hymn to land, property, and place that, warding off the insecurities of the time, sought to offer the confirmation of continuity and belonging to relatively *arriviste* professional men—modernizers, technocrats, and industrialists who, focusing their cameras in their leisure hours, quite pointedly turned their backs on the dirt and conflict of the industrial sources of their new wealth.[11] It was a careful habit of shielding the eyes that they would take with them on their travels—first, on what the curators call "the New Grand Tour," seeking out the great sites and landscapes of European cultural heritage: the Acropolis, Pompeii, Rome; Bruges, Naples, Segovia, Madrid, Salamanca, Moscow, Malta; Mount Etna, the Alps, the Pyrenees.

Here, the sudden change of scene allowed the exhibition to mark another crucial factor prolonging the life of a process that the textbooks say was superseded after 1851 by the new glass plates. Collodion glass plates, in fact, represented a far from convenient choice for the traveling photographer. They were heavy and fragile and they had to be exposed in the camera and developed while still wet—so they had to be prepared and processed on the spot, meaning that the camera operator had to transport an entire photographic laboratory and track down local sources of chemical supplies. Lightweight paper negatives worked just as well when dry as when freshly prepared, so they could be made in advance, stored, exposed, and developed later, eliminating the need to travel with a portable darkroom.[12] These decided advantages came into their own particularly in hot countries, where wet-plate photographers had to labor in stifling darkrooms with sticky emulsions that were constantly in danger of picking up insects and dust. By comparison, for travelers of a certain class, the paper plate was a civilized convenience far from home.

The technical advantages of paper negatives made them attractive, however, not just to artistically inclined amateurs and men of means but also to entrepreneurs—enterprising characters such as Charles Clifford, who worked to make a business from the sale of images of the new tourist destinations, especially of

the architectural and archaeological marvels that began to be marketed to a new kind of consumer-traveler. We are dealing here with a different class of operator but also a different class of photographic product. This is not an insignificant point and the exhibition had to work hard to blunt its impact. For, even as it expanded its geographic range, calotype practice was also becoming diversified and institutionally stratified. Its story was no longer just the story of art and amateurism or, indeed, the story of a singular medium.

Fig. 1.
View of "Under an Indian Sky," the final gallery of *Impressed by Light: British Photographs from Paper Negatives, 1840–1860*, an exhibition held at the Metropolitan Museum of Art, New York, 25 September–31 December 2007.

In the exhibition itself, the dispersive momentum of travel, tourism, antiquities, and commerce gave visitors hardly a pause as it swept them into the last room—into a baked, dry, ochre world that sweltered "Under an Indian Sky" (fig. 1).[13] Yet something else will prove to haunt the humid, heat-hazed landscapes we find here, and it is at this juncture—with the story of the flourishing development of the self-consciously artistic "medium" already unraveling—that we are plunged into an encounter that suddenly outruns the stage managers' control. The calotype itself may have been well prepared to survive the rigors of the journey, readily adaptable, as it was, to work in hot and dusty climates. The exhibition narrative fares less well, changing color, losing its breath, and pulling up short on the banks of the Ganges at the Suttee Chowra Ghat in Kanpur, the major up-country bulking point for the cotton- and oil-seed trade along the river.

Fig. 2.
John Murray (Scottish, 1809–98).
Suttee Ghat Cawnpore, 1858, albumen silver print from paper negative, image: 33 × 43.1 cm (13 × 16¹⁵⁄₁₆ in.); mount: 40.3 × 51.6 cm (15⁷⁄₈ × 20⁵⁄₁₆ in.). New York, The Metropolitan Museum of Art.

Fig. 3.
John Murray (Scottish, 1809–98).
Suttee Ghat Cawnpore, 1858, paper negative, image: 38 × 48 cm (14¹⁵⁄₁₆ × 18⁷⁄₈ in.). New York, The Metropolitan Museum of Art.

The waters here, at least in the museum's print (fig. 2), are smooth and opaque, flat and impenetrable like the sky. The low, scattered trees could be coming into leaf or dying. The buildings behind the perimeter wall are hard to make out in the tangle of the trees' branches. The sun comes in low from the right. Nothing moves except one of the two men squatting on the open ground leading down to the river. The scene seems windless and airless. Even the two diminutive squatting figures who look back at the photographer seem only to point up the general sense of desertion and the distance that has opened between them and the camera lens. Like the curators, we may find it hard to resist taking the seeming lack of event as the sign of bleak emotion. This is certainly heavily overwritten ground. The inscription in the lower left corner of the large-scale print tells us this: *Suttee Ghat Cawnpore.* And, again, in pencil on the mount: *Chowrah Suttee or Massacre Ghat Cawnpore.* The exhibition title adds a third variant: *"Suttee Ghat Cawnpore," Scene of the Massacre—the* massacre, note.

The image, in all its inadequacy and excess, is caught in the field of the caption. There is a tear in the fabric of the exhibition's story. We have arrived at

the scene of horrendous events but also of the undoing of those great tales of British invention.

On 26 June 1857, after a twenty-day siege, an embattled party of British offi-cers and troops under General Sir Hugh Wheeler, together with the women, children, and servants who had taken refuge with them in their hastily fortified barracks at Kanpur, negotiated an agreement with the local rebel leader and self-proclaimed Pashwa, Nana Dhondu Punt, to give up their guns and treasure in return for boats to carry them from the Suttee Chowra customs ghat on the Ganges downstream to Allahabad. Early the next morning, however, as they boarded the vessels at the stepped embankment, the British detachment was mowed down by concealed artillery and rifle, with surviving troops and reput-edly all male children being cut to pieces by cavalry and locals who had joined the fray.[14] Some 120 to 130 women and children were then taken prisoner and confined in a house in the nearby compound. But on the evening of 15 July, as a British force of European, Madras, and Sikh troops with guns of the Royal and Bengal Artilleries approached Kanpur from Allahabad, leaders of the reb-els or perhaps the sepoy guards themselves resolved to slaughter the women

and children, who were shot and cut to pieces in the courtyard of the house in which they were imprisoned. It is said that the walls were covered with bloody handprints and the floor was littered with severed human limbs. The next day, the bodies of the dead, together with survivors, were thrown down a nearby dry well. It was the day before British forces recaptured Kanpur, bringing their own brutal reprisals, and exactly three weeks after the signing of the agreement to evacuate the entrenchment. As Lieutenant Colonel G. W. Williams, commissioner of military police, wrote in the synopsis of what he viewed as the "indisputably authentic" evidence he collated in 1859: "Grief here yields to indignation, and the thirst for revenge; yet adequate retribution can never be inflicted. The punishment of the crime is beyond the power of man."[15]

The army surgeon and photographer John Murray arrived at the scene that engrossed a nation in February 1858, less than a year after the massacres and a year before Lieutenant Colonel Williams began his investigation.[16] Williams, even after his "most searching and earnest inquiries," acknowledged the pain of representing unrepresentable events "over which," he wrote, "I would gladly draw a veil, but that duty forbids my concealing aught of the real facts attending the closing of the Cawnpore tragedy."[17] Murray, on direct commission from the governor-general, Viscount Charles John Canning, and following his habits of practice as well as Lord Canning's precise instructions to capture "as clear and complete an impression" as possible of the military works and sites associated with the mutiny, uncapped the lens of his camera and made his exposures: two views of the ghat on the Ganges; one of the hospital in General Wheeler's entrenchment; and one of the well itself, already on its way to becoming an actual and virtual pilgrimage site for the veneration by the British of their martyrs.[18] Of these, the exhibition, true to its bias, gives us only the finer quality negative (fig. 3) and a tonally harmonious print. But what do they show us? In this exhibition—or against it—not a little.

In 1858, the British dream of empire as a benign, civilizing, and mutually enhancing society found itself rudely shattered by a military rebellion of sepoys against British occupation that the British still remember as the "Indian Mutiny" and that their political class preferred at the time to see as the product of local misgovernment rather than as the direct outcome of endemic tensions created by the conditions and policies of British colonial rule.[19] The bitter anticolonial struggle, which for a time posed an effective threat to British control of the Gangetic Plain, brought appalling atrocities and reprisals from both sides that still live in the lexicons of national memory and that made it clear that the landscapes calmly surveyed by the camera were spaces of irreconcilable visions. Here, then, the story suddenly ceases to be one of the triumphal flourishing of photographic art, since the photographers of the Indian landscapes

gathered in the exhibition's final room—John Murray, officer in the Bengal Medical Service; the Madras Army captain Linnaeus Tripe; John McCosh, surgeon with the Bengal Native Infantry; Major Robert Tytler and Harriet Tytler, his wife; army engineer Charles Moravia; and Richard Oakeley, Fellow of the Royal Geographical Society—were themselves military officers and government appointees who, in the aftermath of the Sepoy Rebellion, mobilized the latest imaging technology for the purpose of mapping, graphing, and marking out for memory an occupied territory that had proved so suddenly and violently unreadable to the British authorities and forces.[20]

Contrary to what is implied by the sweep of the exhibition, however, this is not how the camera came to the subcontinent. As John Falconer and Christopher Pinney have shown, photography arrived in India as early as 1840, as an import variously taken up by enthusiastic amateurs, by those with an eye to commerce, and by individuals with aspirations to science.[21] And, as photographic practice steadily spread in the next decade and a half, it did so not solely in the hands of those linked in one way or another, through commercial, military, or administrative connections, to the agencies of the colonial state. By the mid-1850s, in Calcutta and Bombay numerous Indian-run studios were in business and, of the hundred members of the Photographic Society of Bengal, patronized by Lady Canning herself, about thirty were Bengalis.[22] As might be expected, given the way they learned their practice and given their desire to accommodate and adapt, these educated Indian amateurs and their commercial counterparts produced images of their countrymen and families not much different from the template images Europeans collected of themselves. But they were strikingly different from the photographs that began to accumulate through other channels.

By the mid-1850s, the colonial police had already begun using photography to identify victims and old offenders. There were also calls to photograph legitimate state pensioners in Bengal and prostitutes in Lucknow, and instructions were issued by the central administration for local governments to collect photographs of tribes and castes under their jurisdiction. Military officers were active in responding to such commissions, alongside clergymen, army doctors like Murray, and civil servants who were encouraged to take cameras with them on their travels and to deposit copies with the office of the governor-general. After "the great convulsion" of 1857, their efforts acquired an official standing, overseen by the Political and Secret Department and culminating in the publication between 1868 and 1875 of the eight volumes of *The People of India*.[23] This compendious work, compiled under the patronage of the then Viceroy Lord Canning, may have troubled members of an Indian elite to whom it was shown in the India Office Library in London, but it was not intended to speak to them.[24]

Rather, it was meant to educate the agents of a colonial service that, after 1858, fell directly under the British Crown. To such eyes, the eight bound volumes presented a comprehensive field guide to identifying the vexingly multifarious native groups that had so recently demonstrated attitudes to British rule ranging from acquiescence and compliance to fierce hatred and violent rebellion. There was thus a compelling relationship between the accumulation of photographic documents, the pacification process, and a recently unnerved concern to calibrate more finely the sustainability of British rule in India.[25] If Canning's ambitious photographic projects—including the commission to John Murray—lacked the systematization of later interventions, they even so marked the beginning of that process of collection, collation, categorization, and textualization through which the Indian subcontinent was gridded and framed as a field of knowledge, an administrative terrain, and a landscape of British institutional memory.

It was hardly unusual, of course, for colonies to be the testing ground for new techniques and technologies. This was obviously the case for military tactics and hardware, but it was also the case for techniques and technologies of visual control. Nowhere did these seem more needed than in India.[26] Colonial administrators and officials complained over and over again of the deceit they took to be inherent in the natives, clouding investigation and undermining the status of the evidence they collected.[27] The camera presented itself as a tool to solve this problem, promising more than just a means of procuring evidence. In what British officials saw as an environment of ignorance, superstition, and deceit, this latest product of British ingenuity seemed the very instrument to impress upon native minds once more the difficulty of escaping a superior colonial vigilance. As Samuel Bourne remarked in the narrative of his photographic expedition through Kashmir: "From the earliest days of the calotype, the curious tripod with its mysterious chamber and mouth of brass taught the natives of this country that their conquerors were the inventors of other instruments beside the formidable guns of their artillery, which, though as suspicious perhaps in appearance, attained their objects with less noise and smoke."[28]

Bourne's shameless image is brutally apt. In the years after the violent rebellion, guns and cameras rolled across the landscape in unsparing ways. In addition to hanging mutineers, the British had many they captured "blown from cannon"—a method of execution in which convicted rebels were set before a cannon's mouth and blown to pieces. Fomented in the aftermath of the Indian and other recent wars, this was, of course, the climate in which the jingoism of a fully imperial Britishness was, in effect, invented as an apparatus of civic capture and a means to mobilize the divided populations of England, Scotland, Wales, and Ireland. So, in India, some stood before cannon and others before cameras. It is indeed a telling image.

It seems that, from the viewpoint of the Suttee Chowra Ghat, here in the final room "Under an Indian Sky," there is little left unscathed in the history the exhibition has given us. The singular photographic medium, the gentleman's practice, the flourishing of art, the pride that all this is British: none of it survives. Whatever it may be that is, as Talbot wrote, "impressed by the agency of Light alone," it is not to be so lightly fixed. What is "brought out" in the sensitized paper always falls short of our investments and desires, whatever lens we take to it. But, then, as we try to say what we see, we find that what is stained into the paper goes beyond our stories and what it is we want. This, however, is not grounds for silence, any more than it is fodder for the banal belief that the picture speaks for itself. The puzzling impassiveness of Murray's *"Suttee Ghat Cawnpore," Scene of the Massacre* is itself a challenge as the place where a certain history comes to grief. The exorbitant, inadequate image burnt into the paper comes to us from somewhere else, but that is also its challenge. Before it, we are called to bear witness to its sight, to seek to grasp its resonance as a specific event of meaning, and to go on trying to find an idiom for whatever it is that Talbot again, musing on the prospect of loss, once called "the mute testimony of the picture."[29]

Notes

1. Perhaps at the outset I ought to say that I found myself rather anxious about my lack of credentials to speak on the topic at issue in this volume, and this anxiety no doubt set the course of the path I decided to follow. It may appear to have led me rather far from the intended destination. So I will have to ask to be given an extremely long leash in order to reach my goal, which is not the goal of unmasking a misrepresentation or reinstating some truth but, rather, that of following a certain history to the point where, on ground it was not the first to believe it had fully made its own, it begins to be unraveled by the very thing for which it thought to give us a story.

2. Quotations drawn from the exhibition texts came from the "Past Exhibitions" pages of the Metropolitan Museum of Art's website: http://www.metmuseum .org/special/se_event.asp?OccurrenceId={447A8D76-4D51-4E8C-B1A4-B888EF85D7CC}; and http://www.metmuseum.org/special/se_event .asp?OccurrenceId={5BC2298F-FC6B-11D6-94C7-00902786BF44}, accessed 2 April 2010. Almost identical versions of these texts are currently available at: http://www.metmuseum.org/exhibitions/listings/2007/impressed-by-light; and http://www.metmuseum.org/about-the-museum/press-room/exhibitions/2003/ first-survey-of-french-daguerreotypesmany-among-the-earliest-photo-graphs-ever-takenopens-at-metropolitan-museum-on-september-23, accessed 4 May 2012.

3. *Impressed by Light: British Photographs from Paper Negatives, 1840–1860*, exhibited at the Metropolitan Museum of Art in New York from 25 September 2007 to

31 December 2007, was described as "the first major exhibition to survey British calotypes," presenting "works by forty artists, including such masters as William Henry Fox Talbot, David Octavius Hill and Robert Adamson, Roger Fenton, Benjamin Brecknell Turner, and Linnaeus Tripe, as well as many talented but unrecognized artists" (see note 2). The majority of the works on view, it was also stressed, had never before been exhibited or published in the United States.

The Dawn of Photography: French Daguerreotypes, 1839–1855, on view at the Metropolitan Museum from 23 September 2003 to 4 January 2004, was presented as "the first survey of key monuments from photography's earliest moments," including "hitherto unseen examples of scientific, ethnographic, exploratory, and historical documentary photography of the 1840s and 1850s, as well as portraits, city views, landscapes, nude studies, and genre scenes that are renowned as key early monuments in the history of photographic art" (see note 2).

In the catalog accompanying *Impressed by Light,* the guest curator, Roger Taylor, also tells the story of being prompted by Janet Buerger, author of *French Daguerreotypes* (Chicago: Chicago Univ. Press, 1989), a catalog of the Cromer Collection in the International Museum of Photography at George Eastman House, to do something along the same lines for "British daguerreotypes." He replied that "a book on British calotypes might be more appropriate, as British photographers had invented the process." Roger Taylor, *Impressed by Light: British Photographs from Paper Negatives, 1840–1860,* exh. cat. (New York: Metropolitan Museum of Art, 2007), ix.

4. The photographers identified as "British" are the Englishmen Robert Henry Cheney, Alfred Huish, and John H. Morgan; the Scotsman John Muir Wood; the unplaced Charles Moravia; and Robert Christopher Tytler, born in India of an Irish father. Three other photographers are identified as "Unknown Artist, British School." As a servant of William Henry Fox Talbot, Nicolaas Henneman is allowed into the exhibition, though Dutch, while the important figure Antoine Claudet, who spent his entire photographic career in England, is excluded because he was born in France.

5. Tom Nairn, "The Twilight of the British State," in idem, *The Break-Up of Britain: Crisis and Neo-Nationalism,* 2nd ed. (London: Verso, 1981), 11–91.

6. See note 2.

7. *Reports by the Juries on the Subjects in the Thirty Classes into which the Exhibition Was Divided* (London: Printed for the Royal Commission by William Clowes & Sons, 1852).

8. Geoffrey Batchen, "Photography: Latent History," *Art in America* (2008): 57.

9. Batchen, "Photography: Latent History," 57. It is thus Batchen's view that the exhibition tells us "almost nothing" about "the actual history of the calotype." Batchen, "Photography: Latent History," 55.

10. Batchen, "Photography: Latent History," 57.

11. The displacement and fantasy investment negotiated through this attachment to the picturesque—which stripped the countryside and landed property of conflict and history, turning them into the tropes of an eternal Englishness—thus went beyond the compensations of an internal exoticism. Woven together with a simultaneous attachment to science and an archiving knowledge, they trace out a

pattern of strategic overcoding familiar from the scopic field of Orientalism.

12. In 1856, the Irish calotypist J. M. Murray had on hand papers that he had prepared in 1849 and 1850, still in usable condition. See Larry J. Schaaf with Roger Taylor, "Biographical Dictionary of British Calotypists," in Roger Taylor, *Impressed by Light: British Photographs from Paper Negatives, 1840–1860,* exh. cat. (New York: Metropolitan Museum of Art, 2007), 352.

13. "Under an Indian Sky" was the title given to the ochre-painted gallery that represented the final room and penultimate section of the exhibition. It is also the title of chapter nine of the accompanying catalog: Taylor, *Impressed by Light,* 118–31. The phrase was drawn from an "Address" in the *Journal of the Photographic Society of Bombay* (1855): 16, quoted in Taylor, *Impressed by Light,* 119.

14. W. J. Shepherd, *A Personal Narrative of the Outbreak and Massacre at Cawnpore, during the Sepoy Revolt of 1857* (Lucknow, India: printed at the London Printing Press, 1879), 70–79.

15. Lieutenant Colonel G. W. Williams, "Synopsis of Evidence of the Cawnpore Mutiny," in Noah Alfred Chick, *Annals of the Indian Rebellion, 1857–58* (Calcutta: Sanders, Cones, 1859), 668, 705.

16. An editorial in the London *Times* declared that the events at Kanpur "engrossed the attention of the whole country . . . for, whatever the issue of this rebellion, and whatever other prodigies and horrors it may bring forth, the Massacre of Cawnpore and the name of Nena Sahib will hold rank among the foulest crimes and the greatest enemies of the human race to the end of the world." Editorial, *The Times,* 17 September 1857: 8, column A, quoted in Taylor, *Impressed by Light,* 126.

17. Williams, "Synopsis of Evidence," 692.

18. Cannings's instructions to Murray were conveyed in a letter, now in the National Archives of India, from C. Beardon, secretary to the government of India, to John Murray, 22 January 1858, quoted in Taylor, *Impressed by Light,* 125.

19. See Christopher A. Bayly, *Indian Society and the Making of the British Empire* (Cambridge: Cambridge Univ. Press, 1988); and, more particularly, Rudrangshu Mukherjee, "'Satan Let Loose upon Earth': The Kanpur Massacres in India in the Revolt of 1857," *Past & Present,* no. 128 (1990): 92–116.

20. Not subject to quite the same constraints as the exhibition, though equally committed to artistic biography and to the same celebratory tone, the exhibition catalog briefly concedes that "[t]his relationship with officialdom is one of the features that distinguished Indian photography from its counterparts elsewhere and accounted for much of its direction during the 1850s and 1860s." Taylor, *Impressed by Light,* 127. For a less accommodating view of this "relationship with officialdom," see James R. Ryan, *Picturing Empire: Photography and the Visualization of the British Empire* (Chicago: Univ. of Chicago Press, 1997).

21. Christopher Pinney, *Camera Indica: The Social Life of Indian Photographs* (London: Reaktion, 1997), 17. In October 1839, William O'Shaughnessy reported to the Asiatic Society in Calcutta on his experiments with "photogenic drawing." In December of the same year, three long articles on Louis-Jacques-Mandé Daguerre's invention appeared in the *Bombay Times,* including a translation of Daguerre's own pamphlet on the daguerreotype. In Calcutta, cameras were

advertised for sale by January of the following year, and, by March 1840, *The Calcutta Courier* was reporting an Asiatic Society meeting in which daguerreo-types of Calcutta itself were exhibited. See Christopher Pinney, *The Coming of Photography in India* (London: British Library, 2008), 9. See also John Falconer, "Photography in Nineteenth-Century India," in Christopher Alan Bayly, ed., *The Raj: India and the British, 1600–1947* (London: National Portrait Gallery, 1991), 264–77.

22. When the Photographic Society of Bombay held its first meeting on 3 October 1854, three of its thirteen founding members were also Indian. On early Indian involvement in photography, see Falconer, "Photography in Nineteenth-Century India," 275–77; and John Falconer, *India: Pioneering Photographers, 1850–1900*, exh. cat. (London: British Library and Howard & Jane Ricketts Collection, 2001).

23. J. Forbes Watson and John William Kaye, eds., *The People of India: A Series of Photographic Illustrations, with Descriptive Letterpress, of the Races and Tribes of Hindustan*, 8 vols. (London: India Museum, 1868–75). For the history of the publication, see John Falconer, "'A Pure Labour of Love': A Publishing History of *The People of India*," in Eleanor M. Hight and Gary Sampson, eds., *Colonialist Photography: Imag(in)ing Race and Place* (London: Routledge, 2002).

24. The most striking expression of horror was voiced as early as 1869, in a letter from London to the Scientific Society at Allygurh by the prominent Indian Muslim political leader, judge, and educator Syed Ahmed Khan. Syed Ahmed Khan, quoted in Lieutenant Colonel George Farquhar Irving Graham, *Life and Work of Sir Syed Ahmed Khan* (Edinburgh: William Blackwood and Sons, 1885), 188–89. See also the discussion by Christopher Pinney in *The Coming of Photography in India*, 41–49.

 Pinney speculates that it was not so much denigrating photographs that outraged Syed Ahmed Khan as the implicit sleight of the unitary and normative framework that the collection as a whole imposed on the visibility of India's heterogeneous and hierarchically differentiated classes, castes, and communities, exhaustively subsuming them within the narrative economy of colonial administration. John Falconer takes a different view. He reads Syed Ahmed Khan's response to the photographs in *The People of India* as springing from the embarrassed recognition of what they reveal: "the lack of educational and social progress which, he felt, justly relegated his country to an inferior status and shamed his son into disowning it." Falconer, "'A Pure Labour of Love,'" 80. Drawing attention to this dispute while paying close attention to the circumstances described in Ahmed Khan's narrative, Ajay Sinha has tried to hold the conflicting interpretations of his letter together as indexical of the bundle of contradictory, self-assertive, and self-critical impulses felt by British-educated and "cosmopolitan" Indians, then and since, toward a "modernism" that is, at once, universalist and imperialist—a bundle of impulses that evokes a blush precisely at the point "where an Indian subject becomes aware of its own phantasmagoric appearance." Ajay Sinha, "Response: Modernism in India: A Short History of a Blush," *Art Bulletin* 90, no. 4 (2008): 567.

25. See Pinney, *Camera Indica;* and Christopher Pinney, "Colonial Anthropology in the 'Laboratory of Mankind,'" in Christopher Alan Bayly, ed., *The Raj: India and*

the British, 1600–1947 (London: National Portrait Gallery, 1991), 252–63.

26. On this, again, see Ryan, *Picturing Empire.*

27. Pinney, *Camera Indica,* 20. On "the untrustworthiness of native evidence in India," see, for example, Norman A. Chevers, *A Manual of Medical Jurisprudence for India, Including an Outline of a History of Crime against the Person in India,* 2nd ed. (Calcutta: Thacker, Spink, 1870), 85, cited in Pinney, *The Coming of Photography in India,* 19.

28. Samuel Bourne, "Narrative of a Photographic Trip to Kashmir [Cashmere] and Adjacent Districts," *British Journal of Photography* (1863): 51, quoted in Falconer, "Photography in Nineteenth-Century India," 264. Bourne's metaphoric linkage was not, however, new to such a colonial context. Traveling in Egypt with his friend Gustave Flaubert in 1849, the photographer and travel writer Maxime Du Camp complained of the difficulty he had in making his servant, Hadji Ismael, pose without moving in order to lend a sense of scale to landscapes and monuments. "I finally succeeded," he wrote, "by means of a trick whose success will convey the depth of naivety of these poor Arabs. I told him that the brass tube of the lens jutting from the camera was a cannon, which would vomit a hail of shot if he had the misfortune to move—a story which immobilised him completely, as can be seen by my plates." Gustave Flaubert, *Flaubert in Egypt: A Sensibility on Tour; A Narrative Drawn from Gustave Flaubert's Travel Notes and Letters,* ed. and trans. Francis Steegmuller (Boston: Little, Brown, 1972), 102.

29. In a "Notice to the Reader" inserted in the second fascicle of *The Pencil of Nature* (1844), William Henry Fox Talbot advised: "The plates of the present work are impressed by the agency of Light alone, without any aid whatever from the artist's pencil." In the same volume, in his notes on a calotype depicting several shelves bearing "articles of china," Talbot speculated that "should a thief afterwards purloin the treasures—if the mute testimony of the picture were to be produced against him in court—it would certainly be evidence of a novel kind." William Henry Fox Talbot, *The Pencil of Nature* [1844], facsimile edition (New York: Da Capo, 1968), pl. 3.

BIOGRAPHICAL NOTES ON CONTRIBUTORS

ESRA AKCAN is an assistant professor at the University of Illinois at Chicago. She received her architecture degree from Middle East Technical University and her PhD and postdoctoral degrees from Columbia University. Akcan has received awards and fellowships from the College Art Association, the Institute for Advanced Study in Berlin, the Sterling and Francine Clark Art Institute, the Graham Foundation for Advanced Studies in the Fine Arts, the Getty Research Institute, the Canadian Centre for Architecture, the Andrew W. Mellon Foundation, the Deutscher Akademischer Austausch Dienst (DAAD), the Kinne Fellows, and the Kress Foundation/American Research Institute in Turkey. She is the author of *(Land)Fill Istanbul: Twelve Scenarios for a Global City* (2004); *Çeviride Modern Olan* (2009); *Architecture in Translation: Germany, Turkey, and the Modern House* (2012); and *Turkey: Modern Architectures in History* (with Sibel Bozdoğan) (2012).

ALI BEHDAD is the John Charles Hillis Professor of Literature and chair of the English Department at the University of California, Los Angeles. He is the author of *Belated Travelers: Orientalism in the Age of Colonial Dissolution* (1994) and *A Forgetful Nation: On Immigration and Cultural Identity in the United States* (2005). He is also the coeditor of *A Companion to Comparative Literature* (2011). Behdad is currently completing a manuscript on Orientalist photography.

HANNAH FELDMAN is an associate professor of modern and contemporary art history at Northwestern University. Her book *From a Nation Torn: Decolonizing Art and Representation in France,* which is forthcoming from Duke University Press, considers the theorization of art and spectacle in Paris before and during the Algerian War of Independence.

LUKE GARTLAN is a lecturer in the School of Art History at the University of St Andrews, Scotland. He is the editor of the quarterly journal *History of Photography* and has held research fellowships at the University of Vienna, Nihon University, and the Australian National University. Gartlan is currently completing a manuscript provisionally titled *A Career of Japan: Baron Raimund von Stillfried and Early Japanese Photography.*

DARCY GRIMALDO GRIGSBY is a professor at the University of California, Berkeley. She specializes in eighteenth- to early-twentieth-century French and American art and visual and material culture. She is the author of *Extremities: Painting Empire in Post-Revolutionary France* (2002) and *Colossal: Engineering the Suez Canal, Statue of Liberty, Eiffel Tower, and Panama Canal* (2012). Grigsby is the recipient of numerous fellowships and awards from institutions including the Graham Foundation for Advanced Studies in the Fine Arts, the Andrew W. Mellon Foundation, and the J. Paul Getty Trust.

ROB LINROTHE is an associate professor in the Department of Art History at Northwestern University. He received a PhD in art history from the University of Chicago. Linrothe was a 2008–9 scholar-in-residence at the Getty Research Institute in Los Angeles and served as the inaugural curator of Himalayan art at the Rubin Museum of Art from 2002 to 2004. He specializes in Buddhist art from the Himalayas.

NANCY MICKLEWRIGHT is the head of scholarly programs and publications at the Smithsonian Institution's Freer and Sackler Galleries. She has a long-standing interest in the history of photography in the Middle East. Micklewright is the author of *A Victorian Traveler in the Middle East: The Photography and Travel Writing of Annie Lady Brassey* (2003), as well as numerous articles on the history of photography in the Ottoman world. She and Reina Lewis edited *Gender, Modernity, and Liberty: Middle Eastern and Western Women's Writings; A Critical Sourcebook* (2006).

CHRISTOPHER PINNEY is a professor of anthropology and visual culture at University College London. From 2007 to 2009 he was the Visiting Crowe Professor in the Department of Art History at Northwestern University. His research interests include the art and visual culture of South Asia, with a particular focus on the history of photography and chromolithography in India. Pinney has also studied Indian industrial labor and Dalit goddess possession. His publications include *The Coming of Photography in India* (2008) and *Photography and Anthropology* (2011).

MARY ROBERTS is the John Schaeffer Associate Professor of British Art at the University of Sydney. She is the author of *Intimate Outsiders: The Harem in Ottoman and Orientalist Art and Travel Literature* (2007). Roberts has co-edited four books: *Refracting Vision: Essays on the Writings of Michael Fried* (2000); *Orientalism's Interlocutors: Painting, Architecture, Photography* (2002); *Edges of Empire: Orientalism and Visual Culture* (2005); and *The Poetics and Politics of Place: Ottoman Istanbul and British Orientalism* (2011). She is currently completing a book on the artistic exchanges between Ottoman and Orientalist artists in nineteenth-century Istanbul.

JOHN TAGG is a professor of art history and comparative literature at Binghamton University, State University of New York. His books include *The Burden of Representation: Essays on Photographies and Histories* (1988); *Grounds of Dispute: Art History, Cultural Politics, and the Discursive Field* (1992); and *The Disciplinary Frame: Photographic Truths and the Capture of Meaning* (2009).

ILLUSTRATION CREDITS

This book draws heavily on the collections of the Getty Research Institute (GRI), especially the Pierre de Gigord collection of photographs of the Ottoman Empire and the Republic of Turkey and the Ken and Jenny Jacobson Orientalist photography collection. Credits to these collections are listed below as GRI Gigord and GRI Jacobson, respectively.

Photographs of items in the holdings of the Getty Research Institute are courtesy the Research Library. The following sources have granted additional permission to reproduce illustrations in this book:

BEHDAD

FIG. 1 Department of Special Collections, Charles E. Young Research Library, UCLA, TR16.8.D854e2
FIG. 2 GRI, 84-B30584
FIG. 3 GRI Gigord, 96.R.14**, box 49*
FIG. 4 GRI Jacobson, 2008.R.3, box T17
FIG. 5 Department of Special Collections, Charles E. Young Research Library, UCLA, TR16.8.H183s
FIG. 6 GRI, Middle Eastern and North African views and portraits, 93.R.72, box 1
FIG. 7 GRI Gigord, 96.R.14**, box 50*
FIG. 8 GRI Gigord, 96.R.14, box 11
FIG. 9 GRI Jacobson, 2008.R.3, box T15. © Dr. Edouard Lambelet, Lehnert & Landrock—Cairo.

PINNEY

FIG. 1 Reproduced by permission of University of Cambridge Museum of Archaeology & Anthropology (P.57068).
FIGS. 2, 4, 5 Photographer unknown
FIG. 3 Courtesy of Suresh Punjabi
FIG. 8 Courtesy J. Paul Getty Museum, 84.XM.705.1

ROBERTS

FIG. 1 Courtesy Bahattin Öztuncay.
FIG. 2 GRI Jacobson, 2008.R.3, box T96
FIG. 3 © 2011, Her Majesty Queen Elizabeth II, RCIN 407268
FIGS. 4, 6 GRI Gigord, 96.R.14, box 123
FIG. 5 Muzeum Narodowe w Krakowie, inv. no. MNK III-r.a-6688
FIG. 7 Courtesy the Yale Center for British Art
FIG. 8 GRI Gigord, 96.R.14, box 120a
FIG. 9 GRI Gigord, 96.R.14**, box 65*

MICKLEWRIGHT

FIG. 1 GRI Gigord, 96.R.14, box 38
FIG. 2 Photographer unknown. Gigord, 96.R.14, box 29
FIGS. 3, 4 Photographer unknown. GRI Gigord, 96.R.14, box 20
FIG. 5 Photographer unknown. GRI Gigord, 96.R.14**, box 69*
FIGS. 6, 7 Photographer unknown. GRI Gigord, 96.R.14, box 136a

AKCAN

FIG. 1 Collection Centre Canadien d'Architecture/Canadian Centre for Architecture, Montréal, PH1980:0198:001-005
FIG. 2 GRI Gigord, 96.R.14, box 101a
FIG. 3 GRI Gigord, 96.R.14, box 100
FIG. 4 GRI Gigord, 96.R.14, box 101c
FIG. 5 Collection Centre Canadien d'Architecture/Canadian Centre for Architecture, Montréal, PH1981:0348:020
FIGS. 6, 7 GRI Gigord, 96.R.14, box 12
FIG. 8 GRI Gigord, 96.R.14, box 11
FIG. 9 GRI Gigord, 96.R.14, box 3
Diagrams 1, 2 Prepared by Esra Akcan

GRIGSBY

FIG. 1 Adoc-photos / Art Resource, NY
FIG. 2 Courtesy the Bancroft Library, University of California, Berkeley
FIG. 3 Photographer unknown.
FIG. 7 From *American Journal of Psychology*. Copyright 1964 by the Board of Trustees of the University of Illinois. Used with permission of the authors and the University of Illinois Press. Photo: Julie Wolf.

GARTLAN

FIG. 1 Copyright by Salzburg Museum, Alpenstrasse 75, 5020 Salzburg. Foto NR. F 17313

FIG. 2 GRI Jacobson, 2008.R.3, box T97

FIG. 3 Österreichische Nationalbibliothek, Bildarchiv, Vienna, 223.014-B

FIG. 4 Österreichische Nationalbibliothek, Bildarchiv, Vienna, 223.018-B

FIG. 5 Dietmar Siegert collection, Munich

FIG. 6 Österreichische Nationalbibliothek, Vienna, 399.651-D. Neu. Mag.

FIG. 7 Wienbibliothek im Rathaus, Druckschriftensammlung

FELDMAN

FIG. 1 GRI Jacobson, 2008.R.3, T82. © Pathé

FIG. 2 Courtesy Safia Kouaci, Algiers

FIG. 3 GRI, Gloria de Herrera papers, 980024, box 5

FIG. 4 © Jacques Boissay / Roger-Viollet / The Image Works, Inc.

FIGS. 5, 6 © Elie Kagan/MHC-BDIC

LINROTHE

FIGS. 1, 2 GRI, Travel albums from Paul Fleury's trips to Switzerland, the Middle East, India, Asia, and South America, 91.R.5, album 9

FIGS. 3a, 3b, 5 Photograph by Rob Linrothe, 2009

FIG. 4 Photograph by Rob Linrothe, 2001

FIG. 6 Photograph by Rob Linrothe, 2007

FIG. 7 From Ba ku la thub bstan mchog nor, *Rang rnam padma dkar po'i phreng ba* (Leh/Delhi: Bakula Foundation/Paljor Publications, 2001), pl. 14

TAGG

FIG. 1 The Metropolitan Museum of Art. Image © The Metropolitan Museum of Art

FIG. 2 The Metropolitan Museum of Art, Gilman Collection, Purchase, Cynthia Hazen Polsky Gift, 2005 (2005.100.945). Image © The Metropolitan Museum of Art

FIG. 3 The Metropolitan Museum of Art, Gilman Collection, Purchase, Cynthia Hazen Polsky Gift, 2005 (2005.100.946). Image © The Metropolitan Museum of Art

INDEX

Titles in the ISSUES & DEBATES series